Graphis Inc. is committed to celebrating exceptional work in Design, Advertising, Photography, & Art/Illustration internationally.

Published by **Graphis** | Publisher & Creative Director: **B. Martin Pedersen**
Chief Visionary Officer: **Patti Judd** | Design Director: **Hee Ra Kim** | Senior Designer: **Hie Won Sohn** | Associate Editor: **Colleen Boyd**
Interns: **Freya Garcia, Haley Pero-Favazzo, Rachel Liza Raphy, Sophie Ward**
Account/Production: **Bianca Barnes**

Graphis Poster Annual 2024

Published by:
Graphis Inc.
389 Fifth Avenue, Suite 1105
New York, NY 10016
Phone: 212-532-9387
www.graphis.com
help@graphis.com

ISBN 13: 978-1-954632-23-3

We extend our heartfelt thanks to
the international contributors
who have made it possible to publish
a wide spectrum of the best work
in Design, Advertising, Photography,
and Art/Illustration.
Anyone is welcome to submit
work at www.graphis.com.

Printed in China

Contents

Page 3: *"Unveiled. Unbelievable.,"* designed by Mythic
Page 4: *"Hope,"* designed by Yossi Lemel

THE AMERICAS

Brooklyn Museum
www.brooklynmuseum.org
200 Eastern Parkway
Brooklyn, NY 11238
United States
Tel +1 718 638 5000

Canadian War Museum
www.warmuseum.ca
1 Vimy Place
Ottawa, ON K1A 0M8
Canada
Tel +1 800 555 5621

**Center for Italian
Modern Art**
www.italianmodernart.org
421 Broome St., 4th Floor
New York, NY 10013
United States
Tel +1 646 370 3596

Cleveland Museum of Art
www.clevelandart.org
11150 East Blvd.
Cleveland, OH 44106
United States
Tel +1 216 421 7350

Contemporary Arts Center
www.contemporaryartscenter.org
44 E. 6th St.
Cincinnati, OH 45202
United States
Tel +1 513 345 8400

George Eastman Museum
www.eastman.org
900 East Ave.
Rochester, NY 14607
United States
Tel +1 585 327 4800

Georgia Museum of Art
www.georgiamuseum.org
90 Carlton St.
Athens, GA 30602
United States
Tel +1 706 542 4662

Letterform Archive
www.letterformarchive.org
2325 3rd St., Floor 4R
San Francisco, CA 94107
United States
Tel +1 415 802 7485

Memorial Art Gallery
www.mag.rochester.edu
500 University Ave.
Rochester, NY 14607
United States
Tel +1 585 276 8900

**Museu de Arte Moderna,
São Paulo**
www.mam.org.br
Pedro Álvares Cabral, s/n° - Vila
Mariana
São Paulo - SP, 04094-000
Brazil
Tel +55 11 5085 1300

**Museum of Fine Arts,
Boston**
www.mfa.org
465 Huntington Ave.
Boston, MA 02115
United States
Tel +1 617 267 9300

Museum of Florida History
www.museumoffloridahistory.
com
500 S. Bronough St.
Tallahassee, FL 32399
United States
Tel +1 850 245 6400

**National Gallery of Art,
Washington DC**
www.nga.gov
Constitution Ave. NW.
Washington, DC 20565
United States
Tel +1 202 737 4215

Nevada State Museum
www.carsonnvmuseum.org
401 N. Carson St.
Carson City, NV 89701
United States
Tel +1 775 687 4810

North Dakota Museum of Art
www.ndmoa.com
261 Centennial Drive, Stop 7305
Grand Forks, ND 58202
United States
Tel +1 701 777 4195

Norton Simon Museum
www.nortonsimon.org
411 W. Colorado Blvd.
Pasadena, CA 91105
United States
Tel +1 626 449 6840

Penn Museum
www.penn.museum
3260 South St.
Philadelphia, PA 19104
United States
Tel +1 215 898 4000

Philadelphia Museum of Art
www.artondemand.philamuseum.
org
P.O. Box 7646
Philadelphia, PA 19101
United States
Tel +1 215 763 8100

**Philip Williams
Poster Museum**
www.postermuseum.com
122 Chambers St.
New York, NY 10007
United States
Tel +1 212 513 0313

**Pope County
Historical Society**
www.popecountymuseum.word-
press.com
809 S. Lakeshore Drive
Glenwood, MN 56334
United States
Tel +1 320 634 3293

Portland Art Museum
www.portlandartmuseum.org
1219 SW. Park Ave.
Portland, OR 97205
United States
Tel +1 503 226 2811

Poster House
www.posterhouse.org
119 W. 23rd St.
New York, NY 10011
United States
Tel +1 917 722 2439

**Pritzker Military
Museum & Library**
www.pritzkermilitary.org
104 S. Michigan Ave.
Chicago, IL 60603
United States
Tel +1 312 374 9333

RISD Museum
www.risdmuseum.org
20 N. Main St.
Providence, RI 02903
United States
Tel +1 401 454 6500

**San Diego
History Center**
www.sandiegohistory.org
649 El Prado
San Diego, CA 92101
United States
Tel +1 619 232 6203

**The Eric Carle Museum
of Picture Book Art**
www.carlemuseum.org
125 W. Bay Road
Amherst, MA 01002
United States
Tel +1 413 559 6300

The Guggenheim
www.guggenheim.org
1071 5th Ave.
New York, NY 10128
United States
Tel +1 212 423 3500

The Met
www.metmuseum.org
1000 5th Ave.
New York, NY 10028
United States
Tel +1 212 535 7710

**The Museum of
Contemporary Art**
www.moca.org
250 S. Grand Ave.
Los Angeles, CA 90012
United States
Tel +1 213 626 6222

**The Museum of
Fine Arts, Houston**
www.mfah.org
1001 Bissonnet
Houston, TX 77005
United States
Tel +1 713 639 7300

**The Studebaker
National Museum**
www.studebakermuseum.org
201 Chapin St.
South Bend, IN 46601
United States
Tel +1 574 235 9714

**Virginia Museum
of Fine Arts**
www.vmfa.museum
200 N. Arthur Ashe Blvd.
Richmond, VA 23220
United States
Tel +1 804 340 1400

Weisman Art Museum
www.weisman.emuseum.com
333 E. River Road
Minneapolis, MN 55455
United States
Tel +1 612 625 9494

EUROPE & AFRICA

**Amsterdam Museum
(Het Hart)**
www.amsterdammuseum.nl
Amstel 51
1018 EJ Amsterdam
The Netherlands
Tel +31 20 523 1822

**Basil & Elise Goulandris
Foundation**
www.goulandris.gr
Eratosthenous 13
Athina 116 35
Greece
Tel +30 21 0725 2895

**Bauhaus Archives
(Bauhaus-Archiv)**
www.bauhaus.de
Knesebeckstraße 1-2
10623 Berlin-Charlottenburg
Germany
Tel +49 30 2540020

Bratislava City Gallery
www.gmb.sk
Františkánske nám. 11
Mirbach Palace
Slovakia
Tel +421 948 315 194

**Danubiana Meulensteen
Art Museum**
www.danubiana.sk
Bratislava-Čunovo, Vodné dielo
P.O. Box 51, 851 10
Bratislava-Rusovce
Slovakia
Tel +02 62 52 85 01

Design Museum Denmark
www.designmuseum.dk
Bredgade 68
DK-1260 Copenhagen K
Denmark
Tel +45 33 18 56 56

Hungarian National Gallery
www.en.mng.hu
Szent György tér 2.
Budapest 1014
Hungary
Tel +36 1 201 9082

**Kyiv National Museum
of Russian Art**
www.kmrm.com.ua
Tereschenkivska St. 9
Kyiv 01004
Ukraine
Tel +38 044 287 73 24

Lëtzeburg City Museum
www.citymuseum.lu
14, Rue du Saint-Espirit
L-1475
Luxembourg
Tel +352 47 96 45 00

Ludwig Museum
www.museum-ludwig.de
Komor Marcell u. 1
Budapest 1095
Hungary
Tel +36 1 555 3444

**Museo Nacional Centro
de Arte Reina Sofía**
www.museoreinasofia.es
C. de Sta. Isabel, 52
Madrid 28012
Spain
Tel +34 917 74 10 00

**Museo Nacional
de Antropología**
www.culturaydeporte.gob.es
C. de Alfonso XII, 68
Madrid 28014
Spain
Tel +34 915 30 64 18

**Museum of Modern Art
of Ukraine**
www.modern-museum.org.ua
Kyrylivska St., 41
Kyiv 04080
Ukraine
Tel +38 044 454 4740

Mystetskyi Arsenal
www.artarsenal.in.ua
Lavrska St., 10-12
Kyiv 01010
Ukraine
Tel +38 098 708 7244

**National Museum of
Contemporary Art Athens
(EMST)**
www.emst.gr
Leof. Kallirróis kai Amvr. Frantzi
Athina 117 43
Greece
Tel +30 21 1101 9000

**National Museum
of Kenya**
www.museums.or.ke
Kipande Road
Nairobi
Kenya
Tel +254 721 308485

**Paris Museum
of Modern Art**
www.mam.paris.fr
11 Av. du Président Wilson
Paris 75116
France
Tel +33 1 53 67 40 00

Pinchuk Art Center
www.new.pinchukartcentre.org
1/3-2 Velyka Vasylkivska
Baseyna St., Kyiv
Ukraine
Tel +38 044 590-08-58

Robben Island Museum
www.robben-island.org.za
P.O. Box 51806, V&A Waterfront
Cape Town 8002
South Africa
Tel +27 21 413 4200

**Schule fur Gestaltung
Basel**
www.sfgbasel.ch
Freilager-Platz 6
CH-4142 Munchenstein
Switzerland
Tel +41 61 267 45 09

**Sofia Arsenal Museum
of Contemporary Art**
www.nationalgallery.bg
2, Cherni Vrah Blvd.
Sofia 1421
Bulgaria
Tel +359 879 834 030

**Staatliche Museen
zu Berlin**
www.smb.museum.com
Genthiner Str. 38
10785 Berlin
Germany
Tel +49 30 266 42 42 42

Victoria and Albert Museum
www.vam.ac.uk
Cromwell Road
London, SW7 2RL
United Kingdom
Tel +44 20 7942 2000

Wellcome Collection
www.wellcomecollection.org
183 Euston Road
London, NW1 2BE
United Kingdom
Tel +44 20 7611 2222

ASIA & OCEANIA
**Australian Centre for
Contemporary Art**
www.acca.melbourne
111 Sturt St.
Southbank, VIC 3006
Australia
Tel +61 3 9697 9999

**Asia University Museum
of Modern Art**
www.asiamodern.asia.edu.tw
No. 500號, Liufeng Road, Wufeng
Dist.
Taichung City 41354
Taiwan
Tel +886 4 2339 9981

Auckland Museum
www.aucklandmuseum.com
The Auckland Domain
Parnell, Auckland
New Zealand
Tel +09 309 0443

Fukuoka Asian Art Museum
www.faam.city.fukuoka.lg.jp
7 & 8th Floor, Riverain Center
Bldg.
3-1 Shimokawabata-machi,
Hakata-ku
Fukuoka City
Japan
Tel +81 092 263 1100

Hangaram Art Museum
www.sac.or.kr
2406 Nambusunhwan-ro
Seocho-gu, Seoul 06757
South Korea
Tel +82 2 580 1300

Heritage Transport Museum
www.heritagetransportmuseum.
org
Bilaspur, Taoru Road
Haryana 122105
India
Tel +91 11 2371 8100

Lotte Museum of Art
www.lottemuseum.com
Lotte World Tower (7F)
300, Olympic-ro, Songpa-gu
Seoul
South Korea
Tel + 82 1544 7744

**Museum of Contemporary
Art, Australia**
www.mca.com.au
140 George St.
The Rocks, NSW 2000
Australia
Tel +61 2 9245 2400

**Museum of Contemporary
Art, Shanghai**
www.mocashanghai.org
Gate 7, People's Park
231 W. Nanjing Rd., Shanghai
China
Tel +86 216 6327 9900

Museum of New Zealand
www.tepapa.govt.nz
55 Cable St., P.O. Box 467
Wellington 6011
New Zealand
Tel +64 04 381 7000

Muzium Negara
www.muziumnegara.gov.my
Jabatan Muzium
Jalan Damansara, Kuala Lumpur
50566
Malaysia
Tel +60 03 2267 1111

**National Museum of
Modern Art, Tokyo**
www.momat.go.jp
3-1 Kitanomarukoen, Chiyoda
City
Tokyo 102-8322
Japan
Tel +81 50 5541 8600

**The National Museum
of Western Art**
www.nmwa.go.jp
7-7 Ueno Park, Taito-ku
Tokyo 110-0007
Japan
Tel +81 050 5541 8600

Seoul Museum of Art
www.sema.seoul.go.kr
61 Deoksugung-gil
Jung-gu, Seoul 04515
South Korea
Tel +82 2 2124 8800

**Shanghai Propaganda
Poster Art Centre**
www.shanghaipropagandaart.
com
Rm K, 7F East Tower, Hua Min
Han Zhen International
726 Yan An Xi Road, Shanghai
China
Tel +86 021 6211 1845

Singapore Art Museum
www.singaporeartmuseum.sg
71 Bras Basah Road
189555
Singapore
Tel +65 6697 9730

**Tasmanian Museum
and Art Gallery**
www.tmag.tas.gov.au
Dunn Place
Hobart, TAS 7000
Tasmania
Tel +61 03 6165 7000

Taiwan Design Museum
www.songshanculturalpark.org
133號, Guangfu S. Road,
Xinyi District
Taipei City 110
Taiwan
Tel +886 2 27458199

Taipei Fine Arts Museum
www.tfam.museum
No. 181, Section 3
Zhongshan N. Road
Zhongshan District,
Taipei City 10461
Taiwan
Tel +886 2 2595 7656

The Art Syndicate
www.theartsyndicate.com.au
344 Bourke St.
Surry Hills, NSW 2010
Australia
Tel +61 4162 589 63

ADDITIONAL MUSEUMS:
If you are a museum that collects
posters and are not listed above,
please contact us for inclusion in our
next annual at help@graphis.com.

A Decade Past: Winners from 2014

Title: HKPPN The Portfolio 9 Exhibition | **Client:** Hong Kong Professional Photographers Network
Design Firm: A Green Hill Communications Limited

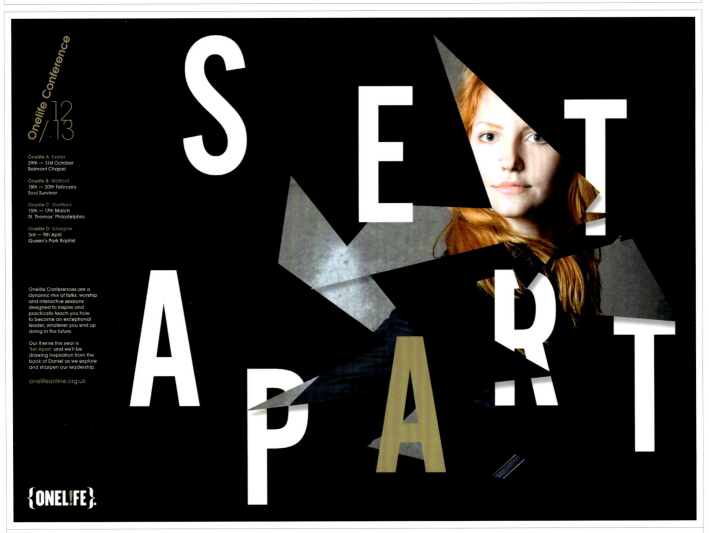

Title: Onelife: Set Apart | **Client:** Onelife | **Design Firm:** Anoo Design Consultancy

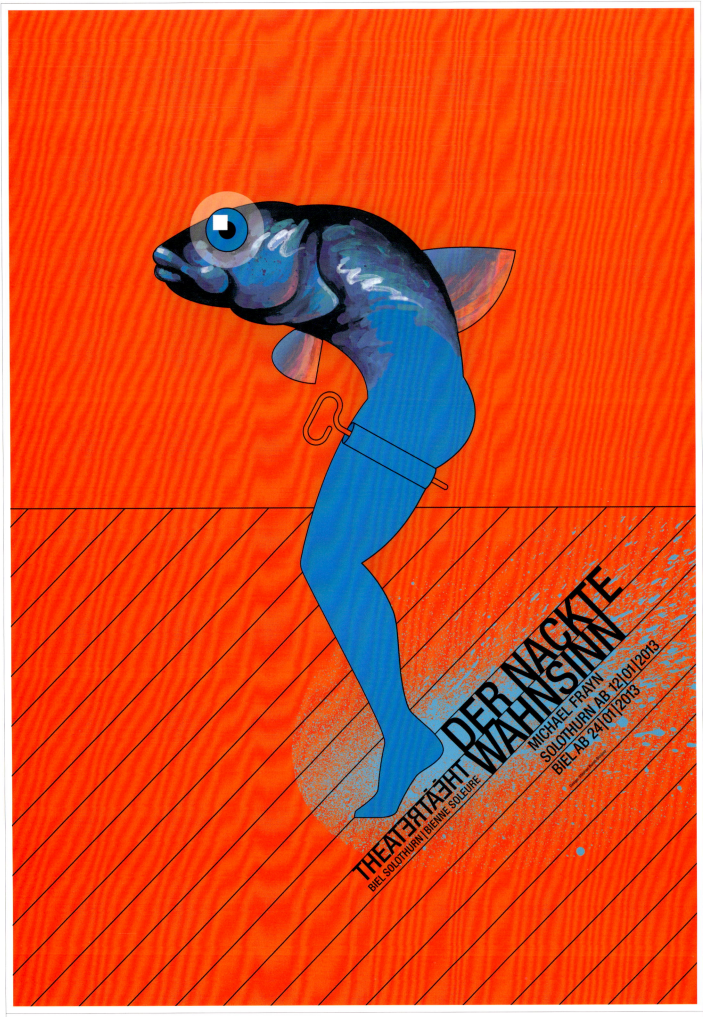

Title: Der nackte Wahnsinn | **Client:** Theater Biel Solothurn | **Design Firm:** Atelier Bundi AG

HEIMATKUNDE
Eine kosmopolitische Inventur
16.09.2011 – 29.01.2012
Jüdisches Museum Berlin
www.jmberlin.de/heimatkunde

Title: Heimatkunde | Client: Jewish Museum Berlin | Design Firm: Fons Hickmann m23

Bread instead of Missiles!

Graphic Trial 2012

"Graphic Trial" is an experiment to pursue the relationship between graphic design and printing expression in depth in order to acquire new expressions.

Title: Petinga em Azeite | **Client:** Unknowndesign | **Design Firm:** João Machado Design

PETINGA EM AZEITE

2012 © DESIGN/JOÃO MACHADO

Title: LIMITS TO GROWTH | **Client:** TOPPAN PRINTING CO., LTD. | **Design Firm:** Katsui Design Office Inc.

attainable easy reachable accommodating pleasing

universal unrestricted free to all metropolitan

city country accessible

mutual open popular social

PUBLIC

Title: Public Bike | Client: Public Bike | Design Firm: Skolos-Wedell

Romeo and Juliet
William Shakespeare

Title: Romeo and Juliet | **Client:** Self-initiated | **Design Firm:** Tetsuro Minorikawa

Peter Bankov | Bankov Posters | Designer
Biography: Peter Bankov was born in Belarus to a family of artists. He studied in Minsk as a sculptor and in Moscow as a book designer and illustrator. He currently lives in Prague and works as a designer and teacher. Peter has received numerous international awards and has been a judge for many global competitions. His art projects are part of private collections in Moscow, London, and Beijing. He has written and presented a cycle of lectures on designs in Russia, the CIS (The Commonwealth of Independent States), and Europe. His work is among collections featured at the MoMA (New York), Klingspor Museum Offenbach (Germany), MOTI (Netherlands), Les Arts Décoratifs (France), and the Lahti Poster Museum (Finland). Peter is a member of the AGI (Alliance Graphique Internationale) and the I-Code International Consule of Design.
Commentary: Life is full of discoveries, and the posters of this contest confirm this idea. The most interesting thing in a designer's life is to be in the center of an open, professional, and creative community.

John Gravdahl | Gravdahl Design | Designer & Professor
Biography: John Gravdahl has been an exhibitor in many juried and invitational design events across the globe. He has also been a design competition judge/juror, workshop leader, conference speaker, book illustrator, and academic consultant on design leadership and archival preservation. Other positions he holds are the curator/co-director of the Colorado International Invitational Poster Exhibition (CIIPE) at Colorado State University in Fort Collins and professor of graphic design in the Department of Art and Art History at the same institution. He served as leader of study abroad semesters and workshops on four continents.
Commentary: Graphis annuals and journals were on the tables anyplace I ever studied, worked, or taught design. I am always inspired by the unique creative forum of experimentation, innovation, artistry, and surprise that poster designers provide internationally.

Carmit Makler Haller | Carmit Design Studio | Visual Communications Designer & Owner
Biography: Carmit Haller is a visual communications designer and the owner of Carmit Design Studio. For the past two decades, she has been a leading graphic designer in the fields of consumer markets, high-tech startups, and luxury real estate. Her passion lies in poster design and typography. Carmit addresses cultural, social, and political topics with a strong and thought-provoking view. She is the recipient of worldwide prestigious awards from organizations such as Graphis and Rockport Publishing and has taken part in international exhibitions such as The Tolerance Poster Show, What Unites Us, The International Reggae Poster Contest, Designers for Peace, and PosterPoster.org. Carmit has been a member of AIGA since 2007, and a mentor since 2020. Originally from Israel, Carmit holds a BA in social work from Tel Aviv University, and a BFA in new media from The Academy of Art University, San Francisco. She currently resides in San Francisco, California.
Commentary: This is my second time on Graphis, and I can see how the level of work is getting more professional, profound, sophisticated, and witty. It is a collection of masterful designers displaying their very best ideas and execution.

Noriyuki Kasai | Nihon University College of Art | Graphic Designer & Associate Professor
Biography: Born in 1972, Noriyuki Kasai is a graphic designer and associate professor at the Nihon University College of Art, from which he graduated. He then joined the Nippon Design Center, where he worked until 2007. His designs have won him awards such as the Asahi Advertising Award, the SDA Award, a Graphis Platinum Award, the ASIA DESIGN Prize in 2019, the 2022 Grand Prix, and the "Best Work Award" from Applied Typography 22. His work has also been selected by the NY TDC and Tokyo TDC.
Commentary: Posters from all over the world are entered into the Graphis Poster Competition. I was able to get a bird's eye view of the latest poster designs. Various subjects, from entertainment to social issues, were addressed with these posters. The range of informational expression with posters is wide, with possibilities arising from multidimensional approaches, not just a unified approach. With work that is expressive and persuasive, I felt the goodness transmitted through the monitor. Throughout this competition, I felt the potential of posters in the future. I am happy to be judging posters.

Viktor Koen | School of Visual Arts | Artist, Designer, & Chair, BFA Comics, BFA Illustration
Biography: Viktor Koen is an award-winning artist, designer, and chair of BFA Illustration and BFA Comics at SVA. He holds a BFA from the Bezalel Academy of Arts & Design in Jerusalem and an MFA in illustration with honors from SVA. Clients include *The New York Times, The Wall Street Journal, Nature, Economist, TIME, Bloomberg*, Penguin Random House, Harper Collins, and BBC. Regularly featured in books and publications, his prints and posters are exhibited in galleries and museums around the world. A TED speaker, Viktor lectures for academic institutions and international conferences while serving, among others, on the Adobe Photoshop Advisory Council and the Photoville Board of Directors.
Commentary: Judging the Graphis poster competition gives one the rare opportunity of a bird's eye view of some of the best designs there are. This massive dose of excellence not only showcases creative fluency in concept and craft but also meaningfully contributes to our collective social consciousness. I was particularly impressed by compositions that, despite their strict institutional mission, managed to escape what was predictable and delivered surprising solutions that resonated in multiple depths. Successfully disrupting the industry balance can be done by smashing aesthetic conventions but also by turning traditional mastery on its head. Both were amply represented in this year's competition.

Mi-Jung Lee | Namseoul University | Designer & Assistant Professor
Biography: Mi-Jung Lee was born in 1975 in South Korea. She received her Ph.D. in design at the graduate school of Hongik University. From 2016 to 2021, she worked at Woosuk University, and she is currently an assistant professor in the Department of Visual Information Design at Namseoul University as well as an invited artist and jury member for the Korea International Design Award. She has won more than 60 international awards, including the Red Dot Design Award, Graphis Annual, Lahti Poster Triennale, Trnava Poster Triennale, Ukraine 4th Block Poster Triennale, Sofia Poster Triennale, Mexico Poster Biennale, Moscow Golden Bee Graphic Biennale, Lublin Poster Biennale, Bolivia Poster Biennale, Peru Design Biennale, China Poster Biennale, Tehran Poster Biennale, Taiwan Design Award, and more. Domestic awards include the Korea International Design Award Silver and Bronze prizes, among others.
Commentary: As befits a traditional poster award, there were many high-quality posters. Artists seem to have put a lot of thought into their presentation and message. The diversity of the categories and the identity of the entrants were particularly impressive. I applaud the Graphis Annual for being a messenger of empathy and communication.

Marlena Buczek Smith | Designer
Biography: Marlena Buczek Smith moved to the US from Poland in the early 1990s, where she attended the School of Visual Arts in New York. Her body of work includes posters, commercial graphic design, and paintings. Her posters have been printed in various publications, including Graphis and Print Quarterly. Marlena's posters have been exhibited globally in countries such as the US, Germany, Italy, Poland, and Russia in exhibits such as the 8th International Biennale of the Socio-Political Poster, the 14th International Triennial of Political Posters, What Unites Us 2, and the 2021 New Jersey Arts Annual: Revision and Respond.
Commentary: Once desire is there to create, one will find a way to express oneself through the most essential qualities of the work.

For judges who were also entrants and winners, special care was taken to insure that they did not judge their own work.

RESIST

Title: RESIST | **Client:** Posters for Peace | **Design Firm:** Gravdahl Design

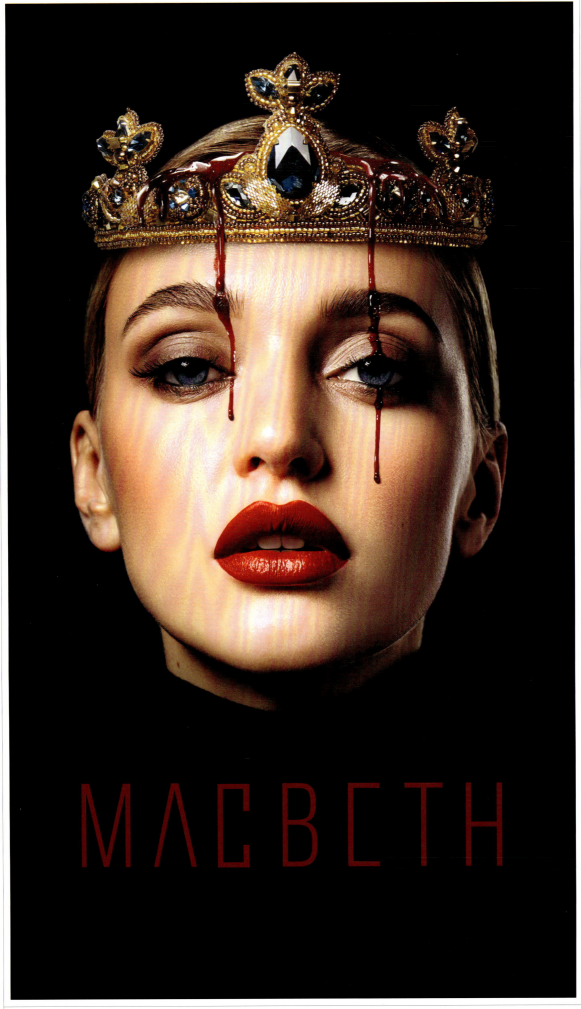

Title: Macbeth | **Client:** Self-initiated | **Design Firm:** Carmit Design Studio

BIRTH AND DEATH

The birth and the death are one and indivisible.

Title: Birth & Death | **Client:** Visual Information Design Association of Korea | **Design Firm:** Noriyuki Kasai

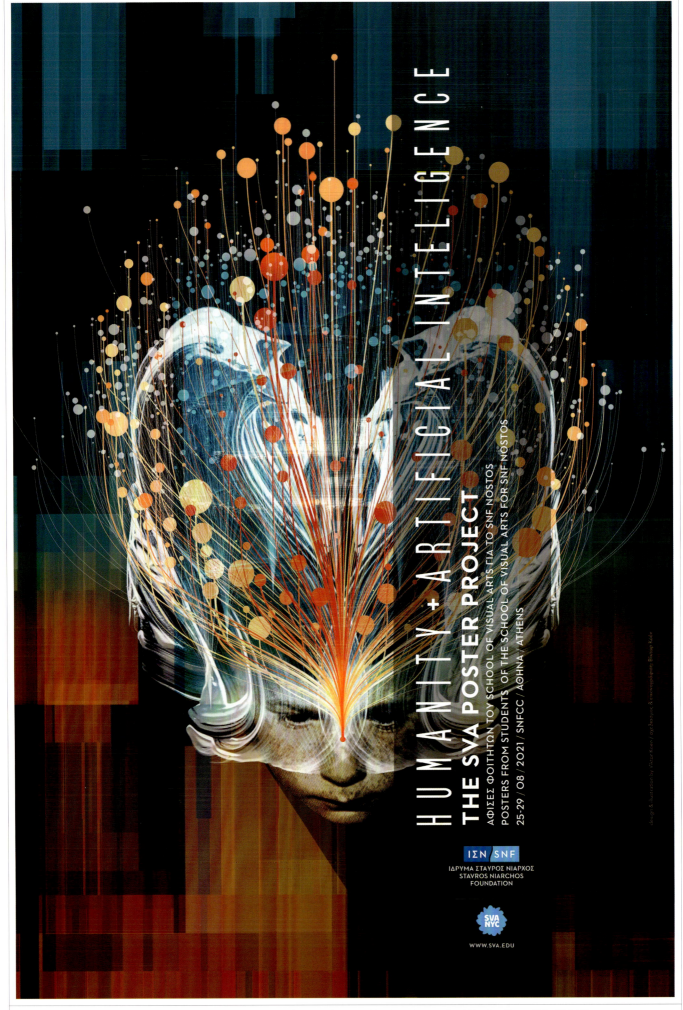

Title: SNF/SVA Humanity and Artificial Intelligence | **Client:** Stavros Niarchos Foundation | **Design Firm:** Attic Child Press, Inc.

READY...TO...CHANGE?

BEAT...PLASTIC...POLLUTION?

Title: Ready to Change? | **Client:** Ministry of Environment | **Design Firm:** Namseoul University

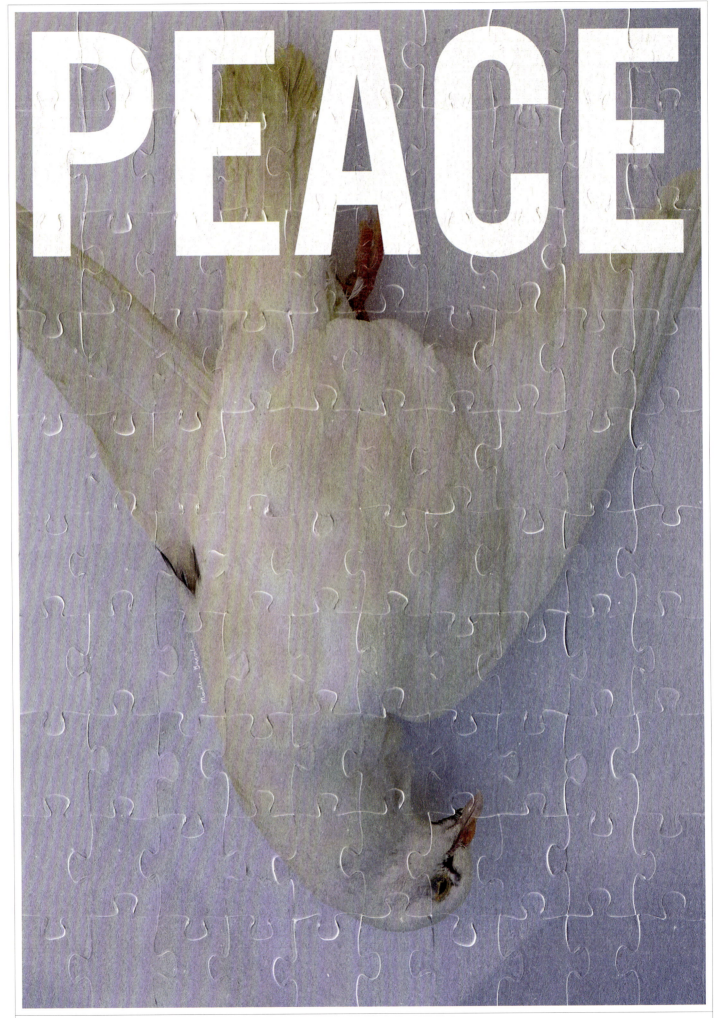

PEACE

Title: **Peace** | Client: **Self-initiated** | Design Firm: **Marlena Buczek Smith**

Kiyoung An | **Kiyoung An Graphic Art Course Laboratory** | Graphic Designer & Professor
Page: 34 | www.facebook.com/ANkiyoung
Biography: Born in South Korea, Kiyoung An moved to Japan in 2000, where he graduated from the Tokyo University of the Arts after studying a doctoral course in design. He is now a professor at KINDAI University and is part of the Department of the Arts. He is also an established designer and was a judge for the Korea Design Exhibition Award (KIDP). Other competitions he has judged include the Daegu City C.I. Design, the Daedong Bank C.I. Design, the Miyazaki National University Logo Design, and the Etajima City Logo Design.

The Refinery | **Page: 35** | www.therefinerycreative.com
Biography: The Refinery is an industry-leading entertainment marketing agency behind everyone's favorite posters, trailers, and digital campaigns. They help their clients tell their stories and empower their employees to do the same since kindness is what defines people, culture, and community. Clients include AMC, Bravo, Dimension Films, Disney, Focus Features, 20th Century, Genius Products, HBO, Oxygen, Paramount, Sony, TNT, Universal, and Warner Bros.

Roman Postovoy | **Supremat** | Graphic Designer, Curator, & Lecturer | **Pages: 36, 37**
Biography: Roman Postovoy (born May 31, 1996) graduated from the College of Graphic Design in Moscow in 2017. In 2018, he worked in an advertising department as a web designer while at the same time posting non-commercial posters on his Instagram. Studying the subtleties of graphic programs, he created posters because, in his opinion, this format is ideal for design and creative experiments. In 2020, he left his job to start working as a freelancer and began creating his own fonts. In 2021, he won one of the largest prize-winning creative contests, Dreams & Nightmares, from Valve. Since 2022, he has been living in Bishkek, Kyrgyzstan. Having accumulated experience and a portfolio of several hundred posters, Roman mainly accepts orders from musicians and organizers of musical events.

Radovan Jenko | **Atelier Radovan Jenko** | Graphic Designer, Professor, & Co-founder of the Brumen Foundation
Page: 38 | www.radovanjenko.si
Biography: Radovan Jenko was born in Slovenia. He is co-founder of the Brumen Foundation, an institution that seeks to encourage high-quality visual communications, and has been organizing the Slovenian Biennial of Visual Communications since 2003. Today, Jenko is a professor of visual communications and illustration at Ljubljana University's Academy of Fine Arts and Design and runs a studio in a big one-hundred-year-old building in Ljubljana. He designs and illustrates posters, books, calendars, various identities, and murals, primarily for cultural institutions and private clients. He works in a range of media, but all that he does bears the mark of his hand in the form of hand-drawn type, the painterly quality of his line, the rough cut edge of a collage component, and sometimes, very literally, through the incorporation of his finger and thumbprints. He is a member of the Alliance Graphique Internationale.

Antonio Castro | **Antonio Castro Design** | Graphis Designer & Associate Professor | **Page: 39** | www.acastrodesign.net
Biography: Antonio Castro H. teaches graphic design and illustration at the University of Texas at El Paso, where he is an associate professor in the Department of Art. He received a BFA in graphic design and printmaking from UTEP and an MFA in visual communications from the Tyler School of Art in Philadelphia. Before teaching, he was a designer with MithoffBurton Inc. in El Paso and later a senior designer/art director at Parham Santana Design in New York City. Antonio's work has received numerous awards, and it has been exhibited widely in exhibitions such as at the BICeBé International Poster Biennial in Bolivia, CIIPE Biennial Colorado International Invitational Poster Exhibition, BICM the International Poster Biennial in Mexico, the Golden Bee International Poster Exhibition in Moscow, and the traveling exhibition Graphic Advocacy: International Posters for the Digital Age 2001-2012. He has been a guest lecturer and a member of the International Jury at several of these events, where he has also hosted design workshops. He is co-founder and co-organizer of Posters Without Borders, an invitational poster exhibition featuring work from internationally recognized designers. His work has been featured in several design publications, including the Print Regional Design Annual and Graphis New Talent Annual. Most recently, he was featured in the 2021 and the 2022 Graphis Poster Annuals, for which he won Gold. His experience covers a range of design expertise, including book design, packaging, graphic identity, posters, illustration, and more.

Peter Diamond | **Peter Diamond Illustration** | Illustrator | **Page: 40** | www.peterdiamond.ca
Biography: Peter Diamond is an illustrator based in Vienna. He specializes in posters, prints, and publishing and has also drawn for editorial, advertising, album covers, and comics since he began working in the early 2000s. Born in England, raised in Canada, and now living in Austria, he explores his attachments to his three homelands in different ways throughout his work, be it through style, subject matter, or interpretation. The son of a biologist and an archivist, he takes most of his inspiration from history and the natural world. He works in both traditional and digital media, often using Photoshop or Procreate to glaze colors over mixed-media paintings.

Ivan Kashlakov | **Kashlak** | Visual Artist | **Page: 41** | www.instagram.com/ivankashlak
Biography: Ivan Kashlakov was born in 1993 in Sliven, Bulgaria, and is a visual artist working in web and graphic design, UX, UI, branding, poster, postage stamp, painting, and drawing. He has taken part in 350 international exhibitions, exhibiting posters, paintings, and drawings in South Korea, China, Japan, Taiwan, Spain, Poland, Estonia, Belgium, Germany, USA, Dubai, Peru, Mexico, and more. He is also the author of three solo exhibitions. Ivan is an executive director and member of the United Designs Alliance (UDA) and an honorary member of the China Europe International Design Culture Association (CEIDA). He is the winner of 65 international awards, and his works are in the collections of museums such as the Toyama Museum of Modern Art, the Retroavantgarda Gallery in Warsaw, Poland, the Reece Museum in Johnson City, Tennessee, USA, and the OSTEN Drawing Museum in Skopje, Macedonia.

Chemi Montes | **Chemi Montes** | Graphis Designer & Professor | Page: **42**

Biography: Once upon a time, Chemi Montes was born in Spain, where he studied fine arts and graphic design at the University of Salamanca, where his headshot was taken. He later crossed an ocean to complete his MFA in graphic design at Pennsylvania State University and has been bound to this hemisphere ever since. His design career includes professional practice and a long-term dedication to higher education. He currently teaches graphic design at American University in Washington DC, where he tries to keep artificial intelligence at bay by pushing for the engagement of natural intelligence. He appreciates design accolades, whether they be from Graphis, Communication Arts, Creativity Awards, or, back in the day, *HOW Magazine, Print Magazine, Applied Arts,* and a variety of books. He has also published writings about semiotics in relation to design and its cousin, advertising, and found writing about himself in the third person stylistically odd but seemingly appropriate for this paragraph.

Šesnić&Turković | Page: **43** | **www.sesnicturkovic.com**

Biography: Šesnić&Turković Studio was founded in 2006 and has been working in the field of graphic design and visual communications ever since then. They approach every project with the same fundamental mission: find the best creative solution which will give the project its communicative strength and longevity and set it apart from the competition. They apply that approach in all fields of work: visual identities, signage, exhibition designs, stand designs, publications, advertisements and promo materials, gift shops, and more. They carry out and control various projects from the beginning to the end with the help of their partners, who are architects, product designers, stage designers, animators, programmers, and print studios. The studio has received numerous awards at international and national competitions, and their works were presented at the most relevant exhibitions in the region, as well as many professional publications.

Underline Studio | Page: **44** | www.underlinestudio.com

Biography: Underline Studio is a design and strategic branding agency based in Toronto, Canada that takes on a wide range of projects in brand, digital, corporate, and marketing communications for companies and institutions such as Google, the University of Toronto, the National Gallery of Canada, and Canada Post. They are committed to meaningful collaboration, and they seek out clients who, like them, have a genuine passion for what they do.

Holger Matthies | Graphis Designer & Professor | Page: **45** | www.matthiesholger.com

Biography: Holger Matthies was born in 1940 in Hamburg. From 1947-1957, he studied at the School in Hamburg, then from 1957-1961, he apprenticed in color lithography. Later on, he studied at the Works School of Art and Form and the University of Formative Art in Hamburg from 1961-1966 before becoming a freelance graphic designer. In 1994, he was appointed as a professor of visual communication at the University of Arts in Berlin. He has taught and hosted workshops in Singapore, Hong Kong, China, Chile, Spain, Jordania, Japan, Syria, France, Belgium, Hungary, Iran, and Germany. He has been a jury member for all international poster biennials and triennials, and his posters are in museums and collections worldwide. Holger is a member of AGI (Alliance Graphique Internationale), the Poster Society in New York, and the Free Akademie of Fine Arts in Hamburg.

Nathaniel Wheeler | **MOCEAN** | Graphic Designer & Creative Director | Page: **46** | www.moceanla.com

Biography: Nathaniel Wheeler, a California native, is a creative director and graphic designer with over two decades of experience in the film and television industry. Since graduating from Platt College for Graphic Design and Multimedia, Nathaniel has pursued his passion for making art in entertainment, creating captivating packaging and key art. Beyond his professional achievements, Nathaniel finds joy in exploring various artistic pursuits. Whether playing drums or immersing himself in woodworking projects, he seeks to continuously nurture his creativity. Throughout his career, Nathaniel has received recognition for various projects and campaigns, fueling his dedication to delivering even more captivating visual experiences. He remains committed to pushing boundaries, leaving a lasting impression through his work, and embracing the ever-evolving nature of his craft.

Mirko Ilic | **Mirko Ilic Corp.** | Graphic Designer, Author, & Founder | Page: **47** | www.mirkoilic.com

Biography: Mirko Ilic was born in Bosnia. In Europe, he drew comics, illustrations, and art-directed posters, books, and record covers. In 1991, he became the art director of *Time Magazine* International Edition. In 1992, he became the art director of the Op-Ed pages of *The New York Times*. In 1995, he established his firm, Mirko Ilic Corp. His company designs for a wide range of clients, from pro bono organizations to high-luxury hospitality. His work is in collections of institutions such as the Smithsonian Museum, MoMA San Francisco, and MoMA New York. He is the co-author of the book *The Design of Dissent* with Milton Glaser and the co-author of 10 books with Steven Heller. He also organizes and curates shows and lectures around the world. The most well-known of them is the Tolerance Poster Show, which appeared more than 160 times in over 45 countries. He taught advanced design classes at Cooper Union with Milton Glaser and at the School of Visual Arts in New York.

This is a collection of masterful designers displaying their very best ideas and execution.

Carmit Makler Haller, *Visual Communications Designer & Owner, Carmit Design Studio*

P231: Credit & Commentary Title: Music Reactions Event | Client: Music Reactions | Design Firm: Supremat

P231: Credit & Commentary **Title:** CJ Bolland Music Reactions Event | **Client:** Music Reactions | **Design Firm:** Supremat

Title: Retour à la Nature; Le Petit Festival du Théâtre, Dubrovnik, 2022 | **Client:** Le Petit Festival du Theatre
Design Firm: Atelier Radovan Jenko | **P231:** Credit & Commentary

AMIGOS

Colección de carteles / Taiwán México

Title: Pearl Jam, PinkPop '22 Poster | Client: Pearl Jam / TSurt
Design Firm: Peter Diamond Illustration | P231: Credit & Commentary

HAPPY INTERNATIONAL JAZZ DAY!

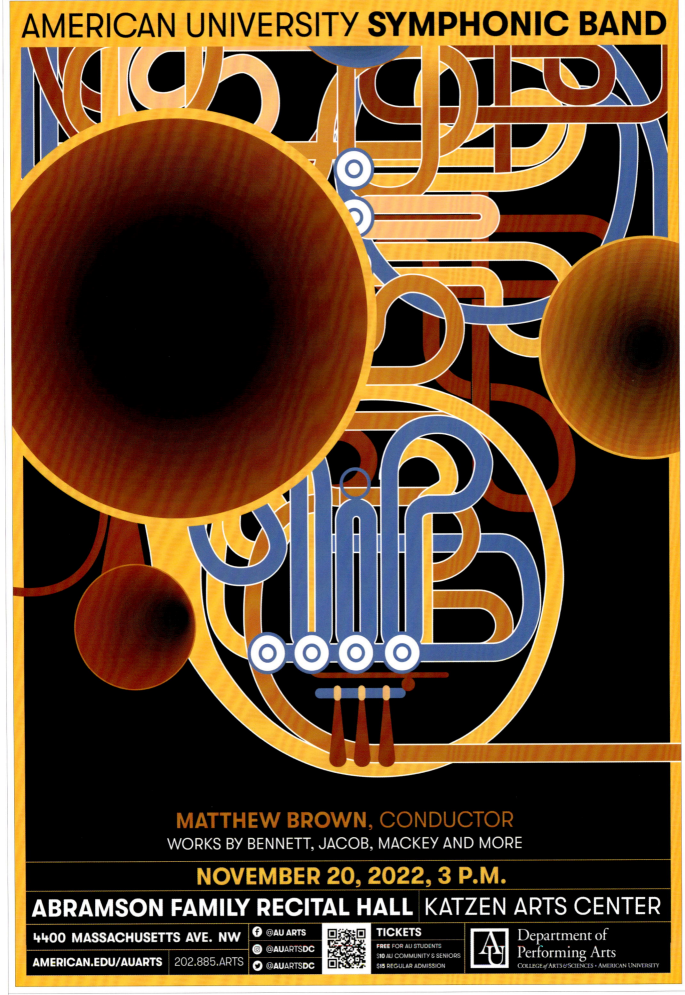

Title: American University Symphonic Band | **Client:** American University, Department of Performing Arts
Design Firm: Chemi Montes | **P231:** Credit & Commentary

The Red Devils

First Round
BEL-CAN 11.23.22 2:00pm EST
BEL-MAR 11.27.22 8:00am EST
BEL-HRV 12.01.22 10:00am EST

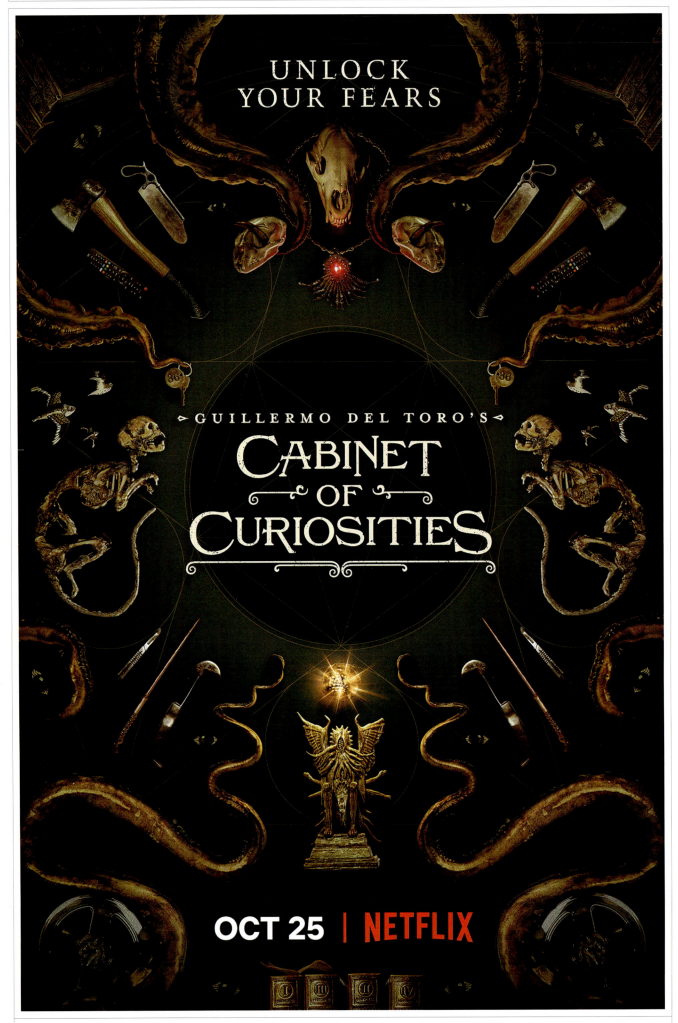

P231: Credit & Commentary **Title:** Cabinet of Curiosities Teaser Poster | **Client:** Netflix | **Design Firm:** MOCEAN

Title: Slip Joint Pliers Product Launch | **Client:** Snap-on Tools
Design Firm: Traction Factory | **P231:** Credit & Commentary

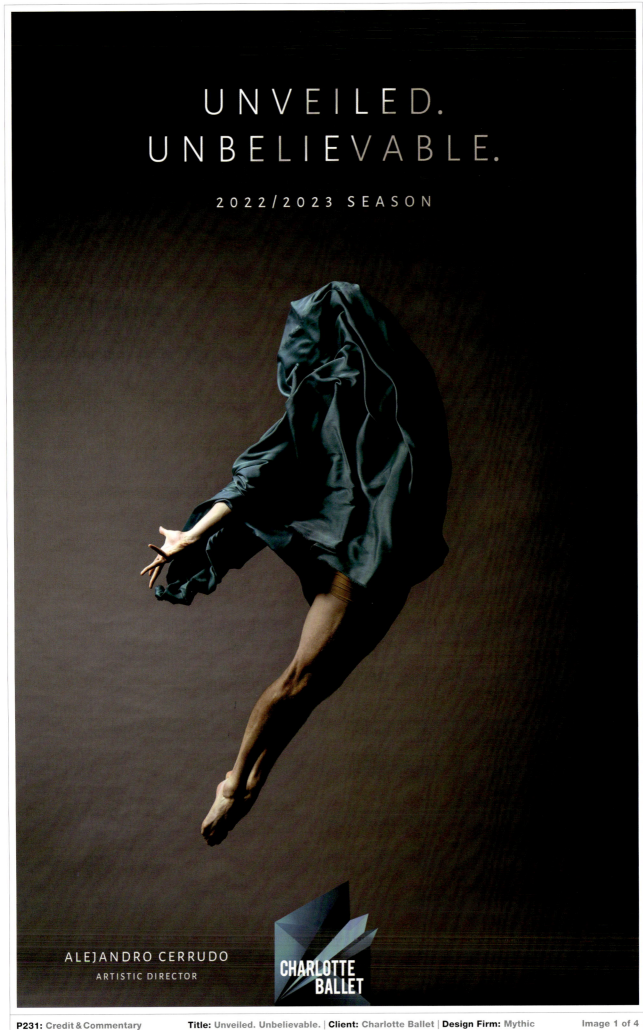

Michael Braley
Braley Design
Hashimoto Seminar
Visiting Artist

Utah State University
Caine College of the Arts
March 31, 2022

Fine Arts Visual Building | Room 150 | 7:00pm

Michael Braley
Creative Director
Braley Design

Pratt Institute
Brooklyn, New York
April 28, 2022

Title: Utah State Typographic Poster Workshop | Clients: Self-initated, Utah State University
Design Firm: Braley Design | P232: Credit & Commentary

Title: KINDAI Graphic Art Course | **Client:** Kindai University, Department of Arts
Design Firm: Kiyoung An Graphic Art Course Laboratory | **P232:** Credit & Commentary

Title: Carnival Row, Final Season, Character Posters | **Client:** Amazon Studios | **Design Firm:** The Refinery
P232: Credit & Commentary | Image 1 of 3

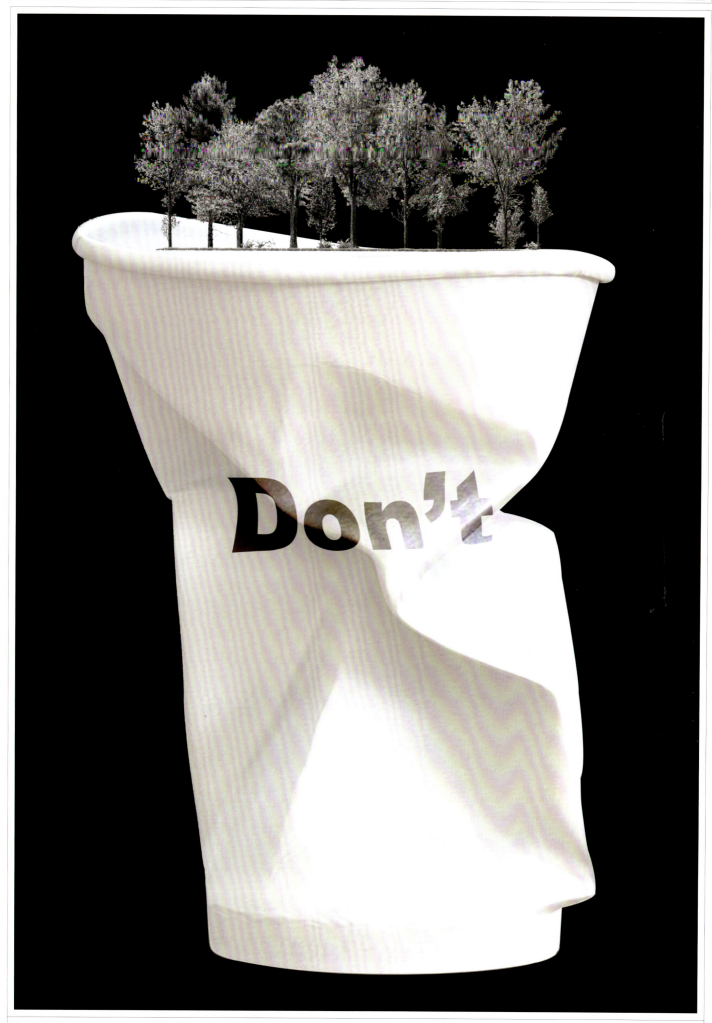

Title: Don't | Client: Dcuve Art Center | Design Firm: Sun Design Production

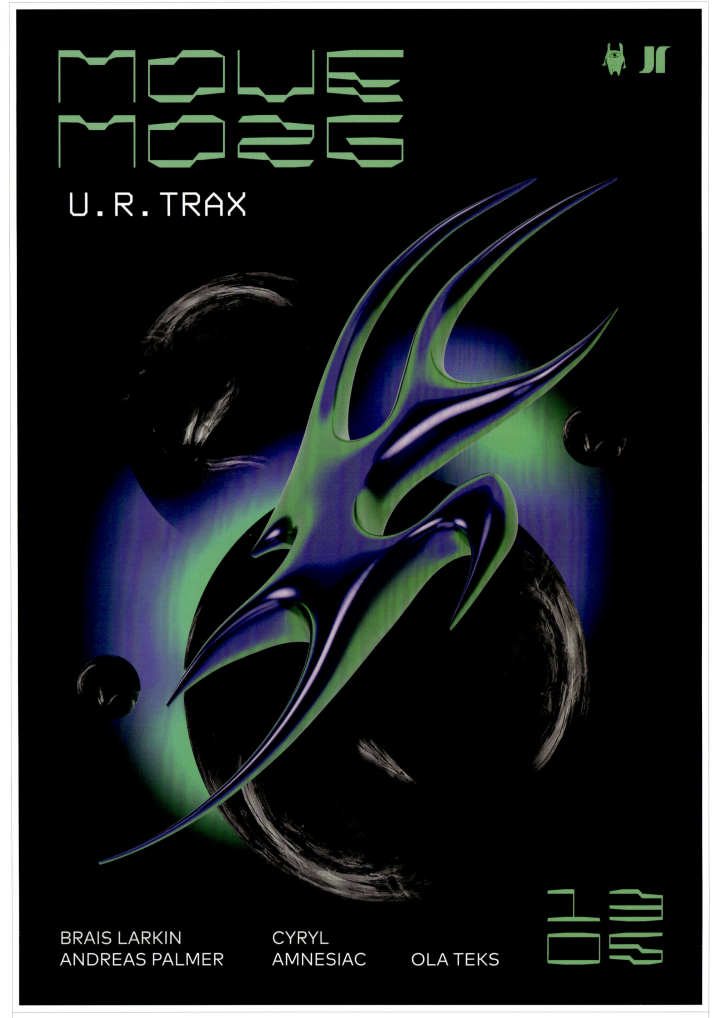

MOVE MÓZG

U.R. TRAX

BRAIS LARKIN CYRYL
ANDREAS PALMER AMNESIAC OLA TEKS

13
05

P232: Credit & Commentary Title: Move Mózg / U.R. Trax | Clients: Ola Teks, Mateusz Cyryl | Design Firm: Ola Procak

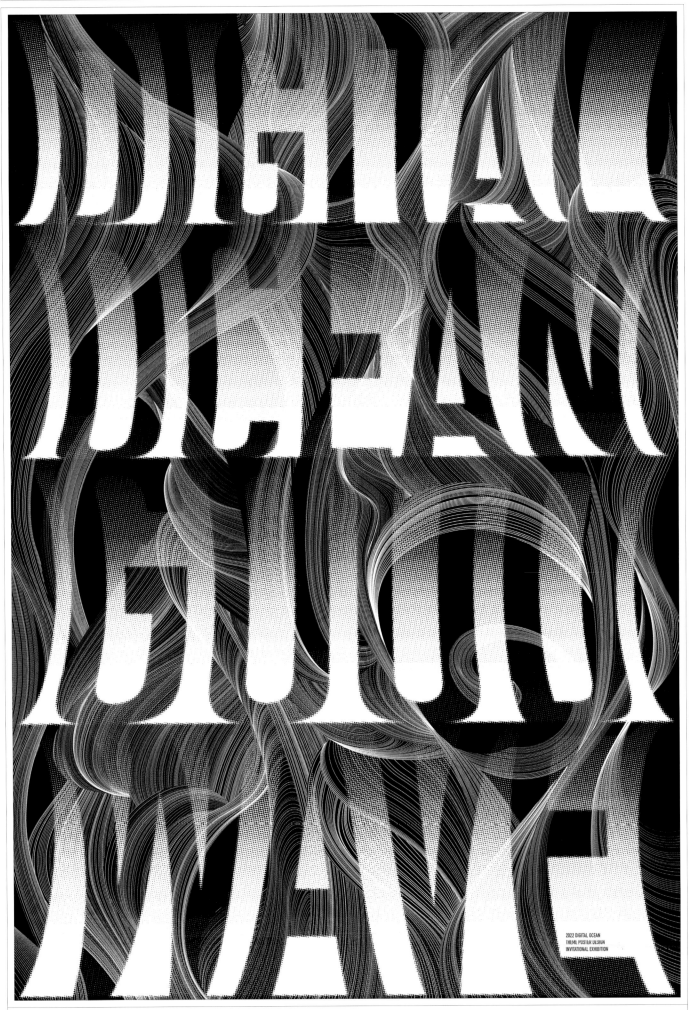

2022 DIGITAL OCEAN
THEME POSTER ULSHUN
INVITATIONAL EXHIBITION

Title: GOOD WAVE | **Client:** "Digital Ocean" International Poster Invitation Exhibition Organizing Committee
Design Firm: Tsushima Design | **P233: Credit & Commentary**

Title: Free Wifi, Free Coffee, Free Work | Client: Raum für drastische Maßnahmen
Design Firm: Studio Lindhorst-Emme+Hinrichs | P233: Credit & Commentary

Title: AGI Special Project 2022 «Together» | Client: AGI Congress Trieste, Italy
Design Firm: Imboden Graphic Studio | P233: Credit & Commentary

SPIRIT OF THE SILK ROAD

Silk comes from a long history of thousands of years of silkworm culture, and is a treasure of the Chinese nation. In major

In the eyes of the ancients, the silkworm was a holy, great creature. It breaks its eggs, eats mulberry and grows for five years,

spits silk into a cocoon and then turns into a flying spirit, a beautiful, complete cycle of life that adds a mysterious

and noble human dimension to silk.

Title: SPIRIT OF THE SILK ROAD | **Client:** International Poster Design Exhibition of Silkworm Culture Organizing Committee
Design Firm: Tsushima Design | **P233:** Credit & Commentary

Title: dGwaltneyArt / Carousel | **Client:** Self-initiated
Design Firm: dGwaltneyArt | **P233:** Credit & Commentary

Mutopia

Machine Learning

Visualizing the unseen

Individualized mode of making

Beyond human perspectives

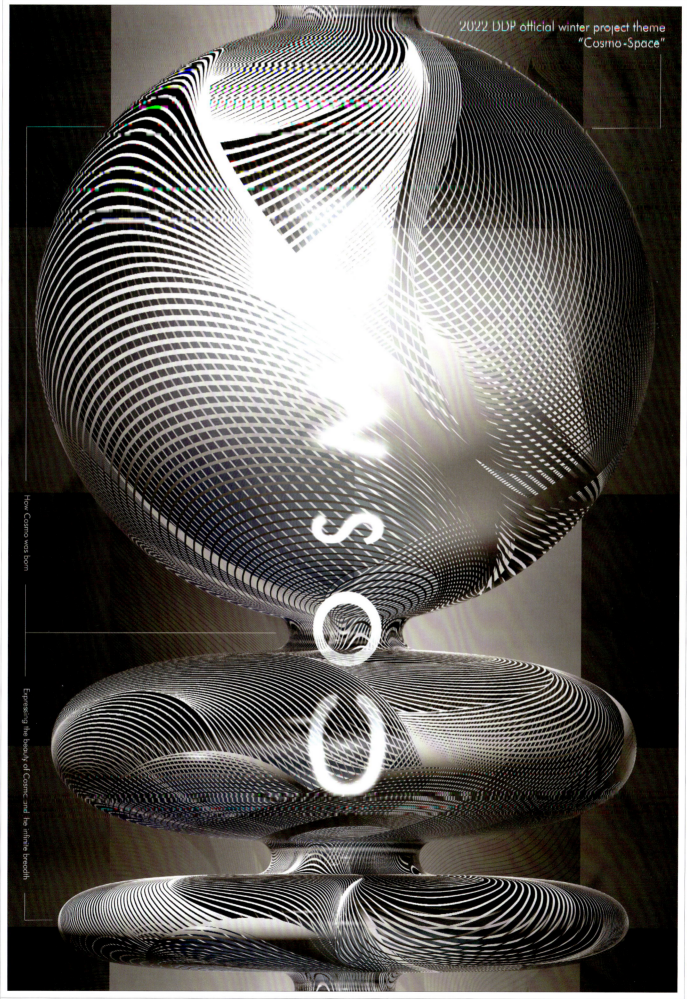

2022 DDP official winter project theme
"Cosmo-Space"

How Cosmo was born

Expressing the beauty of Cosmo and the infinite breadth

Title: COSMO | Client: Visual Information Design Association of Korea
Design Firm: Tsushima Design | P233: Credit & Commentary

Title: Future Forward | **Client:** 4th Emirates International Poster Festival
Design Firm: Elevate Design | **P233:** Credit & Commentary

Hangeul by genius poet Yi Sang

Title: Designers for Peace | **Client:** Graphis Designers for Peace Poster Competition
Design Firm: Hansung University, Design & Arts Institute | **P233:** Credit & Commentary

PRESENTED BY
THAT PHOTO SCHOOL
@THATPHOTOSCHOOL

FRIDAY
AUGUST 19
6–9PM

a vibrant gallery experience celebrating the creative excellence
of the 2022 That Photo School photography members

IMAGES AWAKEN EMOTIONS
WITHIN US. THEY ROUSE US
& BRING FORTH FEELINGS.

FLOCC STUDIO
606 N EDGEFIELD AVE
DALLAS, TX 75208

Title: That Photo School AWAKEN Show | **Client:** That Photo School
Design Firm: MARK | **P233:** Credit & Commentary | Image 1 of 7

TOLERANCE

寛容　寛容

TOLERANCE has the meaning and word of "寛容する" "KANYOU₂ in Japanese." Have a broad heart and accept others. The heart is "心の" "KOKORO₂ in Japanese."

TOLERANCE

"Face to face" people face each other we talk
we understand each other.
We love each other.

Más
Massi
Massimo
Massimo
Massimo
Massimo
Massimo
Massimo

Más Massimo. More Massimo.

Vignelli at 90 by Underline Studio.

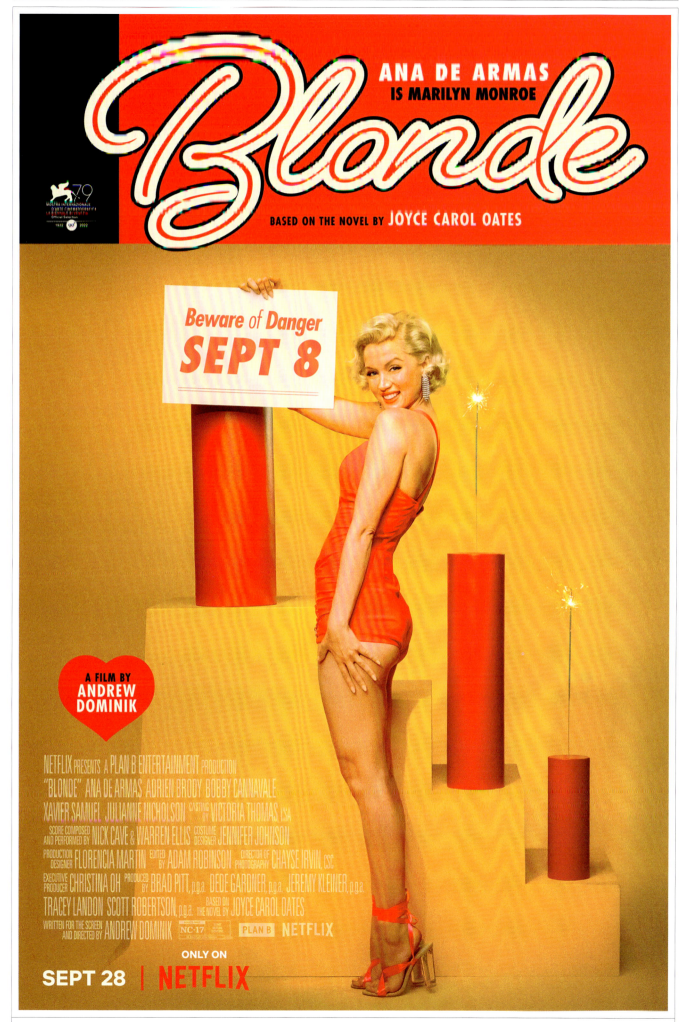

A FILM BY TODD FIELD

BLANCHETT

TÁR

ONLY IN THEATERS OCTOBER 7

P234: Credit & Commentary **Title:** TÁR - Payoff Poster | **Client:** Focus Features | **Design Firm:** AV Print

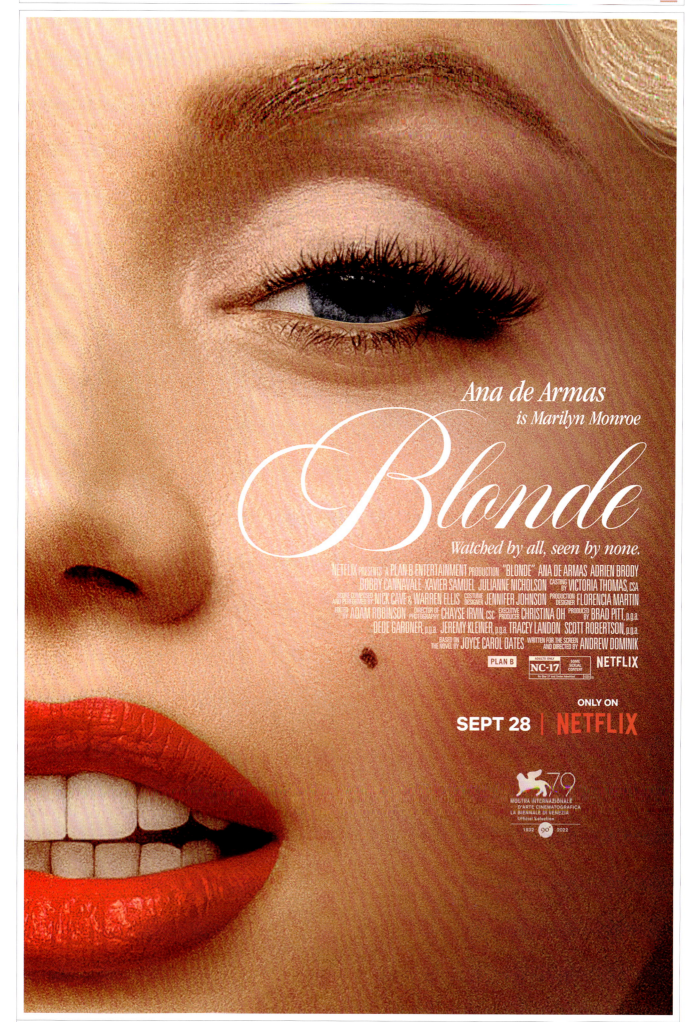

Ana de Armas
is Marilyn Monroe

Blonde

Watched by all, seen by none.

NETFLIX PRESENTS A PLAN-B ENTERTAINMENT PRODUCTION "BLONDE" ANA DE ARMAS ADRIEN BRODY
BOBBY CANNAVALE XAVIER SAMUEL JULIANNE NICHOLSON CASTING BY VICTORIA THOMAS, CSA
SCORE COMPOSED AND PERFORMED BY NICK CAVE & WARREN ELLIS COSTUME DESIGNER JENNIFER JOHNSON PRODUCTION DESIGNER FLORENCIA MARTIN
EDITED BY ADAM ROBINSON DIRECTOR OF PHOTOGRAPHY CHAYSE IRVIN, CSC EXECUTIVE PRODUCER CHRISTINA OH PRODUCED BY BRAD PITT, p.g.a.
DEDE GARDNER, p.g.a. JEREMY KLEINER, p.g.a. TRACEY LANDON SCOTT ROBERTSON, p.g.a.
BASED ON THE NOVEL BY JOYCE CAROL OATES WRITTEN FOR THE SCREEN AND DIRECTED BY ANDREW DOMINIK

PLAN B NC-17 NETFLIX

ONLY ON
SEPT 28 | NETFLIX

79
MOSTRA INTERNAZIONALE
D'ARTE CINEMATOGRAFICA
LA BIENNALE DI VENEZIA
Official Selection
1932 · 90° · 2022

Title: Demonic Payoff Poster | **Client:** IFC Films | **Design Firm:** MOCEAN

CRAZY CAJUN.

Send Your Taste Buds South & West Then Bite Into The Gumbo of Chicken Sausage.

STAN'S SECRET STASH

Title: Send Your Taste Buds South & West, Then Bite Into The Gumbo of Chicken Sausage
Client: BOBAK Sausage Company | **Design Firm:** Michael Pantuso Design | **P234:** Credit & Commentary

Title: There's Always Room to Do More Shrooms! Especially When They're Big, Meaty, Flavorful Portobello Mushrooms—At the Top of the Mushroom Food Chain | **Client:** BOBAK Sausage Company | **Design Firm:** Michael Pantuso Design | **P234:** Credit & Commentary

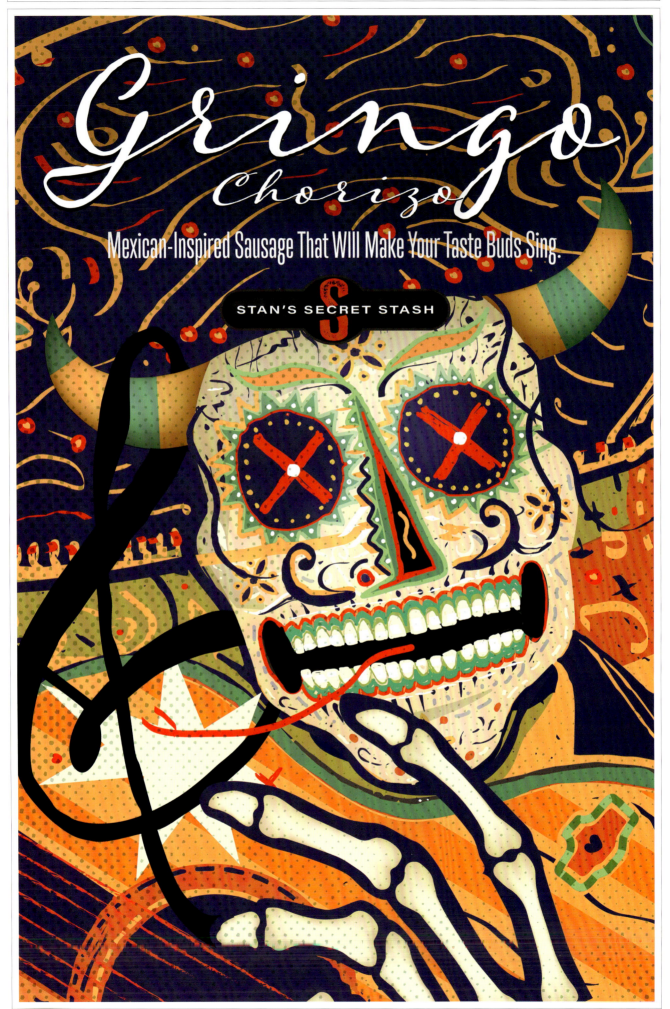

Title: Mexican-Inspired Sausage That Will Make Your Taste Buds Sing | **Client:** BOBAK Sausage Company
Design Firm: Michael Pantuso Design | **P234:** Credit & Commentary

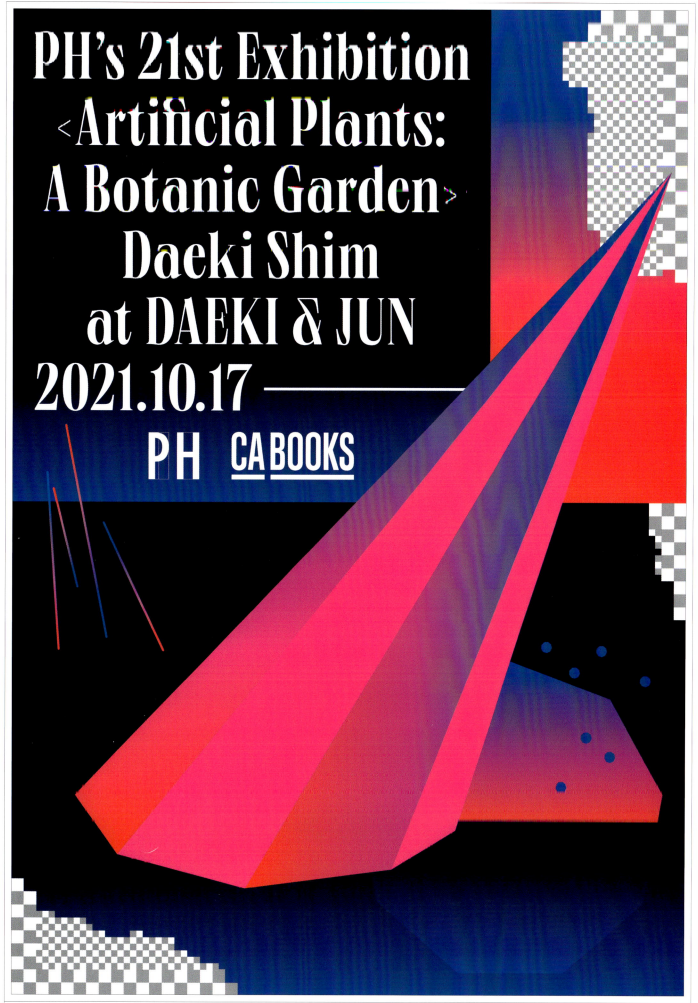

PH's 21st Exhibition
‹Artificial Plants:
A Botanic Garden›
Daeki Shim
at DAEKI & JUN
2021.10.17 ——————

PH CA BOOKS

Title: Artificial Plants: A Botanic Garden | **Clients:** Sikmulgwan PH Gallery, Design Magazine CA (Korea)
Design Firm: DAEKI and JUN | **P234:** Credit & Commentary

Johann Wolfgang von Goethe, Zahme Xenien, 1824

P234: Credit & Commentary **Title:** RESTART - Montreux Jazz Festival 2021 | **Client:** Montreux Jazz Festival | **Design Firm:** Primoz Zorko

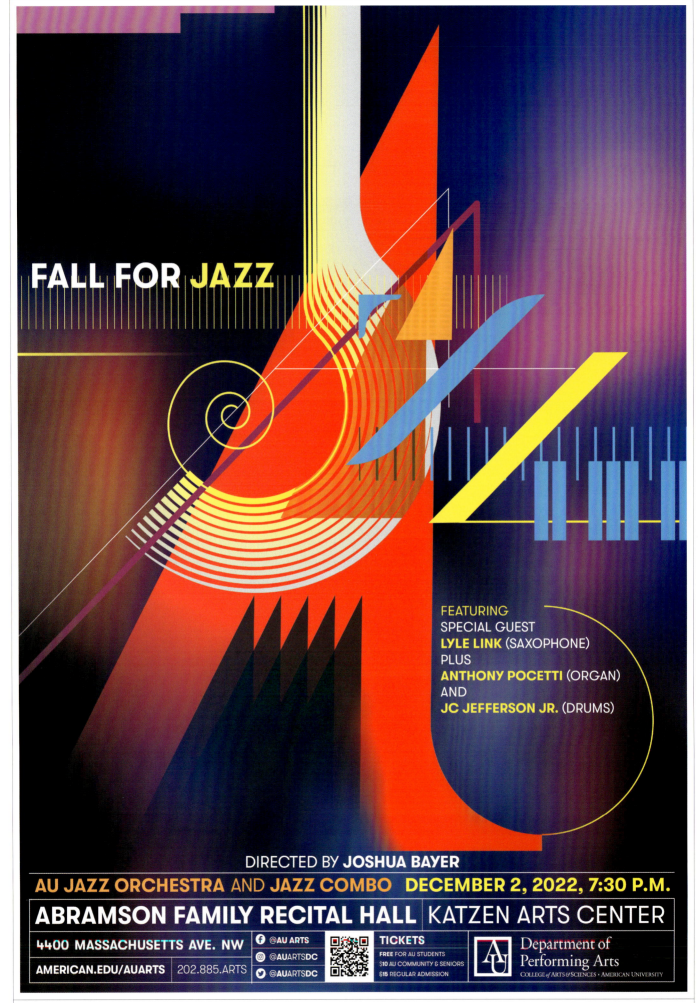

Title: Fall for Jazz | **Client:** American University, Department of Performing Arts
Design Firm: Chemi Montes | **P235:** Credit & Commentary

ANNUAL FESTIVAL CONCERT

PHILADELPHIA YOUTH ORCHESTRA

Louis Scaglione • Conductor

Zarb-Cousin: Symphonic Prelude • World Premiere

Bartók: *Concerto for Orchestra*

Prokofiev: Symphony No. 5

02 June • 3 PM
Verizon Hall
Kimmel Center for the Performing Arts
Tickets: $20 – $30
Ticket Philadelphia: 215 893 1999

design + photography - paone design associates

Title: **Philadelphia Youth Orchestra Annual Festival Concert Poster** | **Client:** **Philadelphia Youth Orchestra**
Design Firm: **Paone Design Associates** | **P235: Credit & Commentary**

WYNTON
MARSALIS
SEPTET
NEW ENGLAND · SUMMER 2022

JULY 8 THE HANOVER THEATRE and CONSERVATORY for the PERFORMING ARTS / WORCESTER, MA

JULY 9 JIMMY'S JAZZ & BLUES CLUB / PORTSMOUTH, NH

JULY 10 RIDGEFIELD PLAYHOUSE / RIDGEFIELD, CT

WYNTON

Title: Wynton Marsalis Summer Tour | **Client:** Wynton Marsalis Enterprises
Design Firm: Paul Rogers Studio | **P235:** Credit & Commentary

京剧艺术国际

Beijing Opera Art
International 2022

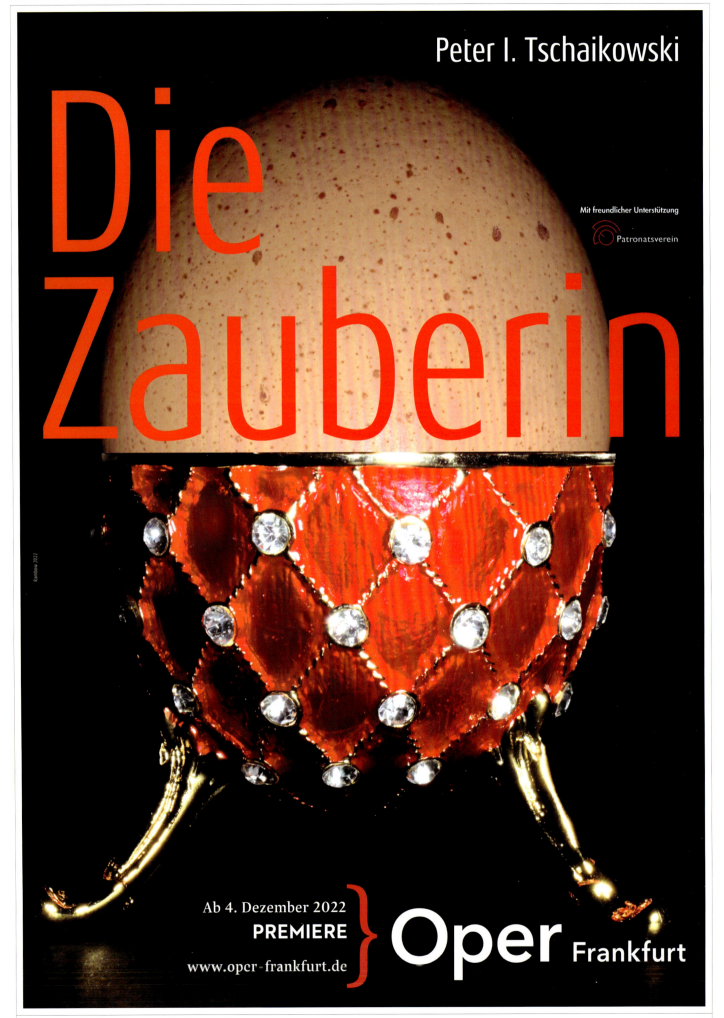

P235: Credit & Commentary Title: Die Zauberin / The Charming | Client: Oper Frankfurt | Design Firm: Gunter Rambow

BEIJING OPERA ART
INTERNATIONAL POSTER BIENNALE 2022

Title: Vowels | Client: Beijing Opera Art International Poster Biennale
Design Firm: Wesam Mazhar Haddad | P235: Credit & Commentary

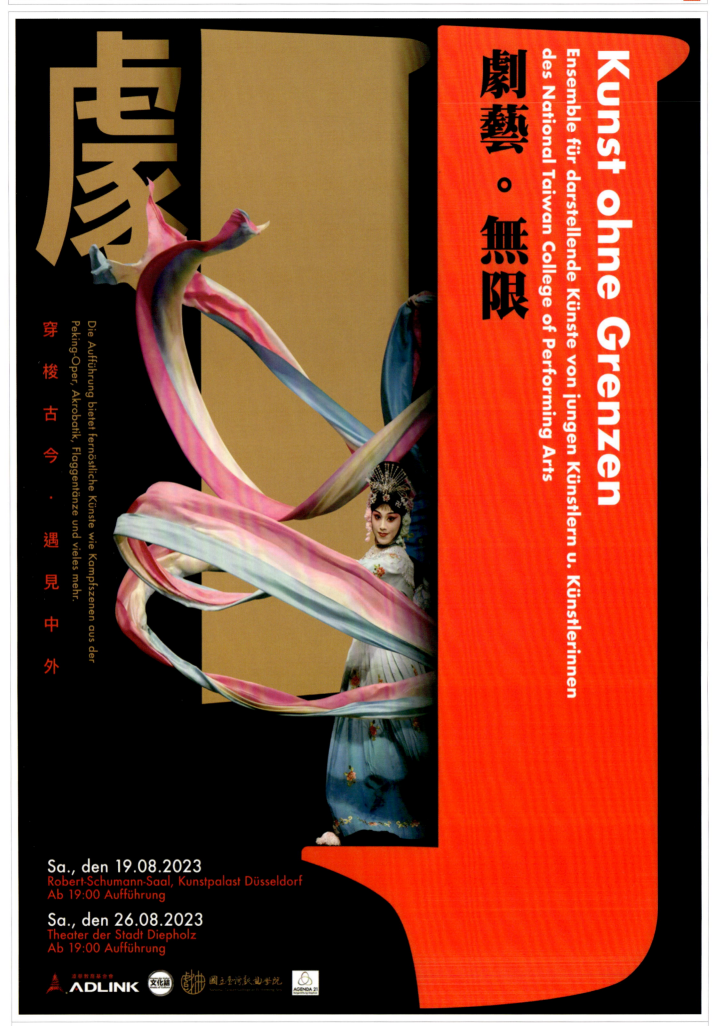

Title: The World of Fun is Created by Those Who Enjoy It | **Client:** Taiyo Holdings
Design Firm: PEACE Inc. | **P235:** Credit & Commentary

Title: TIJUANA Industrial Promotion Poster | **Clients:** Ayuntamiento de Tijuana, Jorge Astiazaran | **Design Firm:** Freaner Creative

boltbolt.io

//bōlt/ //bōlt/ Extreme products that exist physically and virtually for you to flaunt.

NEBULA MYSTERY BOX

BOLTBOLTIbust res milla doloratia doloreped utatia sequam enis et lant, et, siti iliquo que se volupic tempore, tenditi busdae optatqu iandame pos magnimi, sandeni hitaquis sit quia incturi nonsequo verum que si dolor sunt eateniet doluptas eum illia int. Ti accusaped quodign atatium, utem que intur at fuga. Nisitatur, totati tem sus, invelen dipicae lis aut lant periam as venda nonsedi ossimus solo voloria vendis ium hici rem dite min nos minis que nusciur aut aut volor at quam lataquae pra quis ilitatem invent. Ab iniatiis venti dolupta volorerates dolest et facerit exereptati offic tem quia deriam, eribus mo et veliquos rest latib

BOLT BOLT

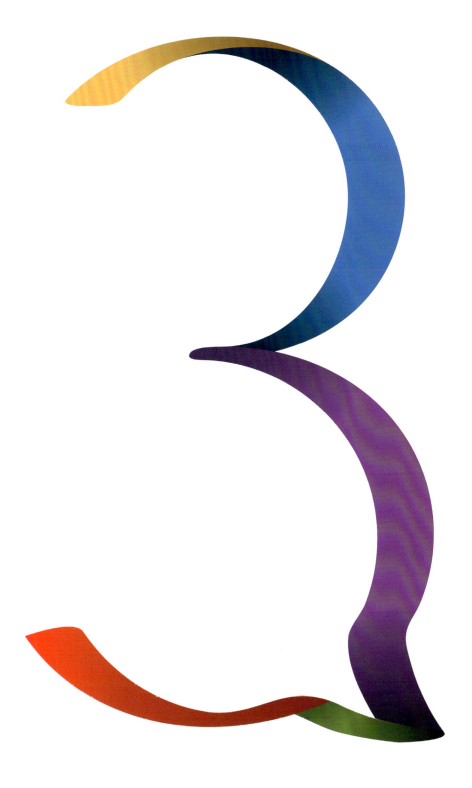

TRES Y CONTANDO | NOVIEMBRE 6

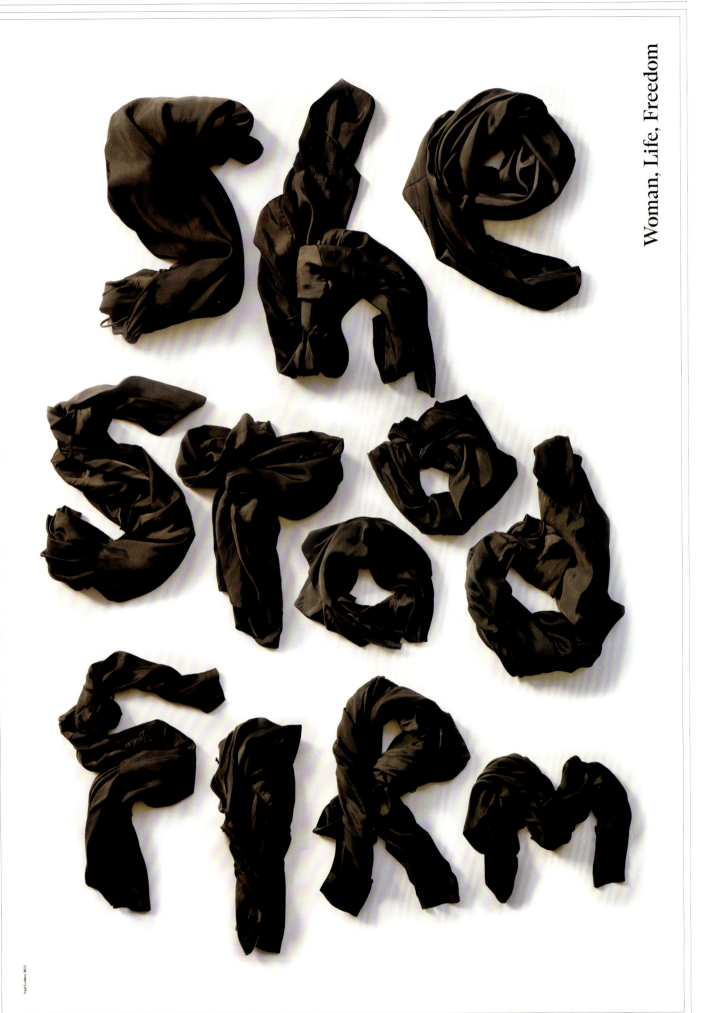

Woman, Life, Freedom

Paul Garbett 2022

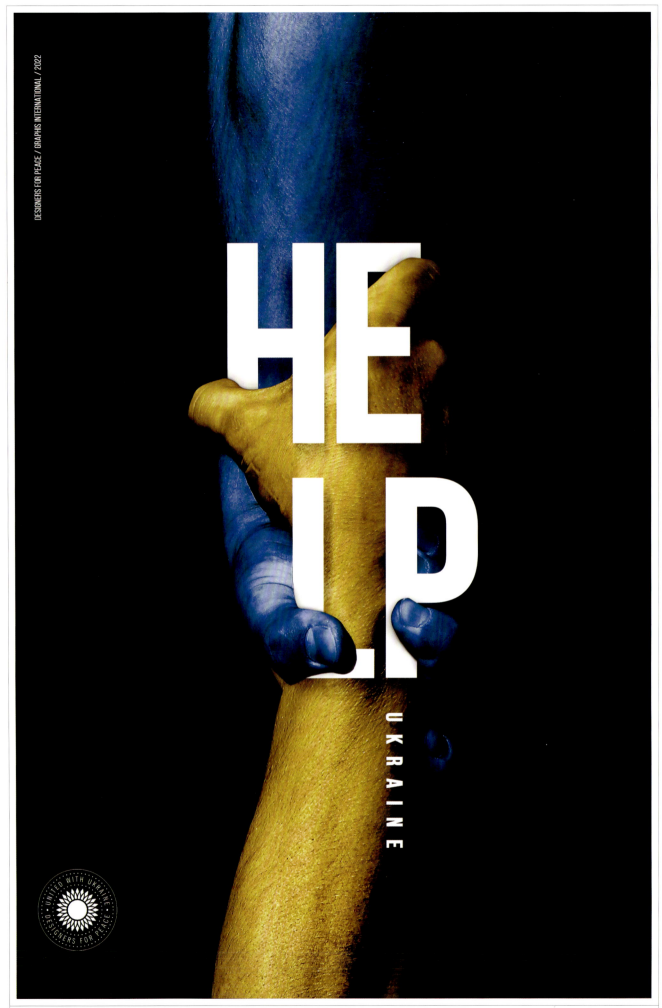

DESIGNERS FOR PEACE / GRAPHIS INTERNATIONAL / 2022

**Title: Help Ukraine | Client: Graphis Designers for Peace Poster Competition
Design Firm: Carmit Design Studio | P236: Credit & Commentary**

RUSSIA.
STOP THE KILLING!

KIT HINRICHS USA © 2022 / GRAPHIS / DESIGNERS FOR PEACE.

NO WAR

PEACE

MORE PEACE PLEASE If you make peace, you will receive peace.

P236: Credit & Commentary **Title:** MORE PEACE PLEASE | **Client:** Ministry of Unification | **Design Firm:** Namseoul University

Title: Woman, Life, Freedom | **Clients:** Morteza Majidi, Movement for Women of Iran
Design Firm: BEK Design | **P235:** Credit & Commentary

TOLERANCE
is a *bridge*
built of
empathy,
intelligence,
bravery
and
strength.

Title: Ceasefire in Ukraine | Client: Graphis Designers for Peace Poster Competition
Design Firm: Harris Design | P236: Credit & Commentary

May the skies rain peace on Ukraine

Title: Pray for Peace | Client: Mankind | Design Firm: Dalian RYCX Design

the COST

Title: The Cost | Client: Communication and Convergence of the Non-Contact Era International Conference
Design Firm: Purdue University | P236: Credit & Commentary

Title: Posters for Freedom | **Client:** Self-initated | **Design Firm:** Anet Melo

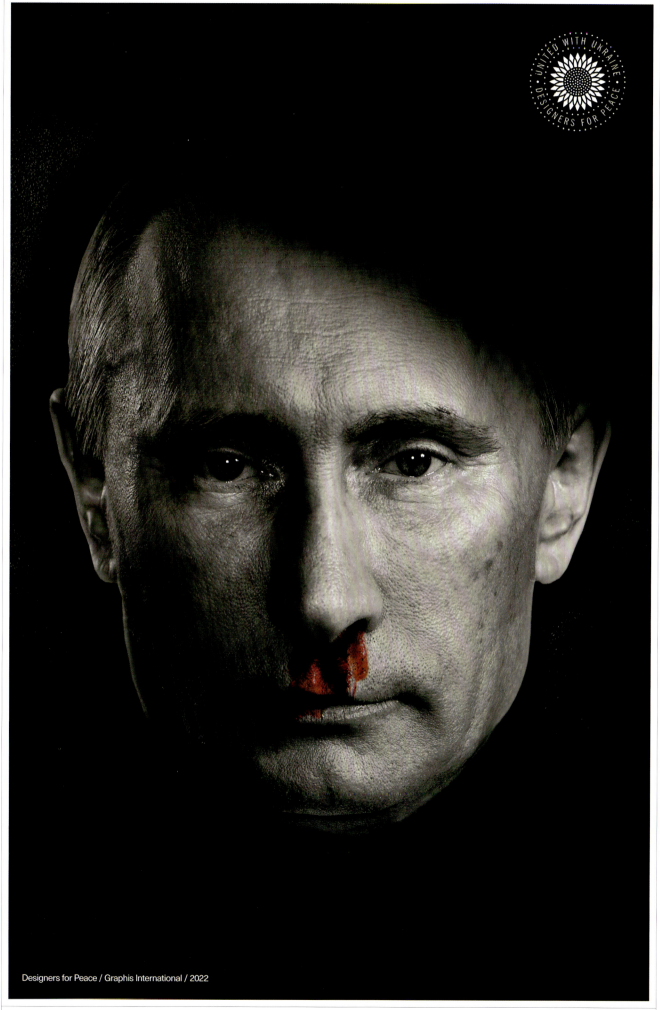

Designers for Peace / Graphis International / 2022

P237: Credit & Commentary Title: War Criminal | **Client:** Graphis Designers for Peace Poster Competition | **Design Firm:** Code Switch

Paul Garbett 2022

Woman, Life, Freedom

BLOOD WILL HAVE BLOOD

William Shakespeare

Title: Blood Will Have Blood | **Client:** Graphis Designers for Peace Poster Competition
Design Firm: Harris Design | **P237:** Credit & Commentary

LET'S MAKE 2023 EXTRAORDINARY

Title: Let's Make 2023 Extraordinary! | **Client:** Self-initiated
Design Firm: Goodall Integrated Design | **P237:** Credit & Commentary

ESSENTIAL FREEDOM

Title: LIFE. ESSENTIAL FREEDOM. | Client: Women, Life, Freedom
Design Firm: Marlena Buczek Smith | P237: Credit & Commentary

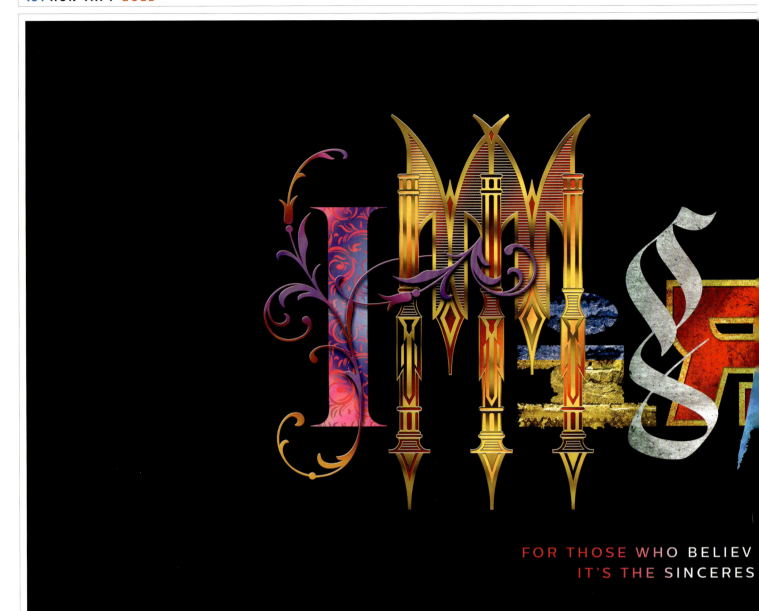

FOR THOSE WHO BELIEV
IT'S THE SINCERES

THE AMERICAN DREAM,
ORM OF FLATTERY.

Title: Flattery | **Client:** Planet365 | **Design Firm:** Ron Taft Brand Innovation & Media Arts

REPRESSED

Title: United With Ukraine / Designers for Peace | **Client:** Graphis Designers for Peace Poster Competition
Design Firm: João Machado Design | **P237:** Credit & Commentary

WATCH OUT FOR
LiArs

NEW SERIES
STREAMING JULY 28

HBO max

LJUDMILA RASUMOWSKAJA
LIEBE
JELENA SERGEJEWNA
THEATER SOLOTHURN AB 11|03|2023
THEATRE BIEL/BIENNE AB/DES 28|03|2023
WWW.TOBS.CH

Title: Liebe Jelena Sergejewna (Dear Elena Sergeyevna) | **Client:** Theater Orchester Biel Solothurn
Design Firm: Atelier Bundi AG | **P237:** Credit & Commentary

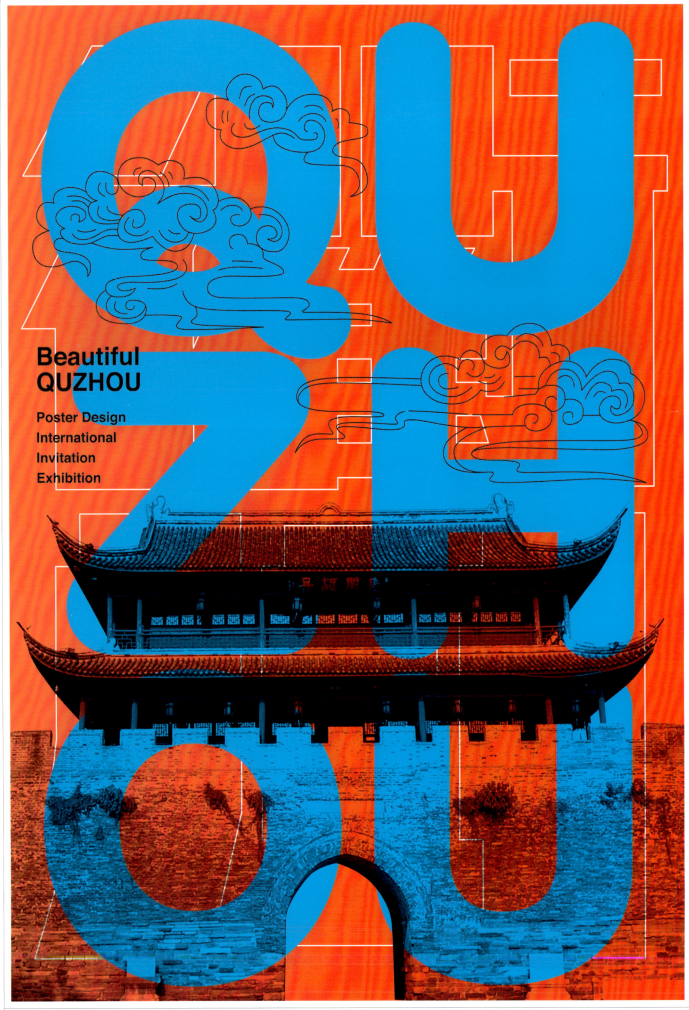

Beautiful
QUZHOU

Poster Design
International
Invitation
Exhibition

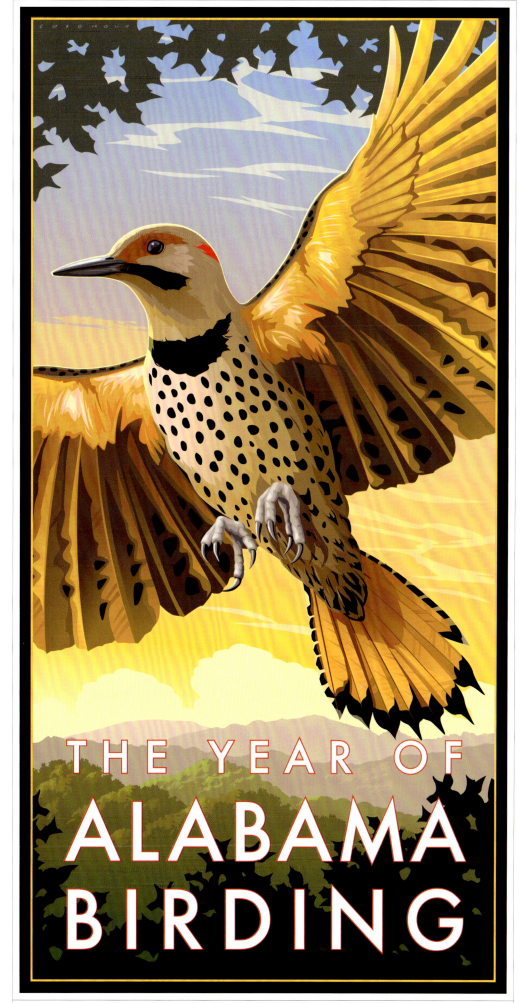

Title: The Year of Alabama Birding | **Client:** Alabama Tourism
Design Firm: Dan Cosgrove Design LLC | **P237:** Credit & Commentary

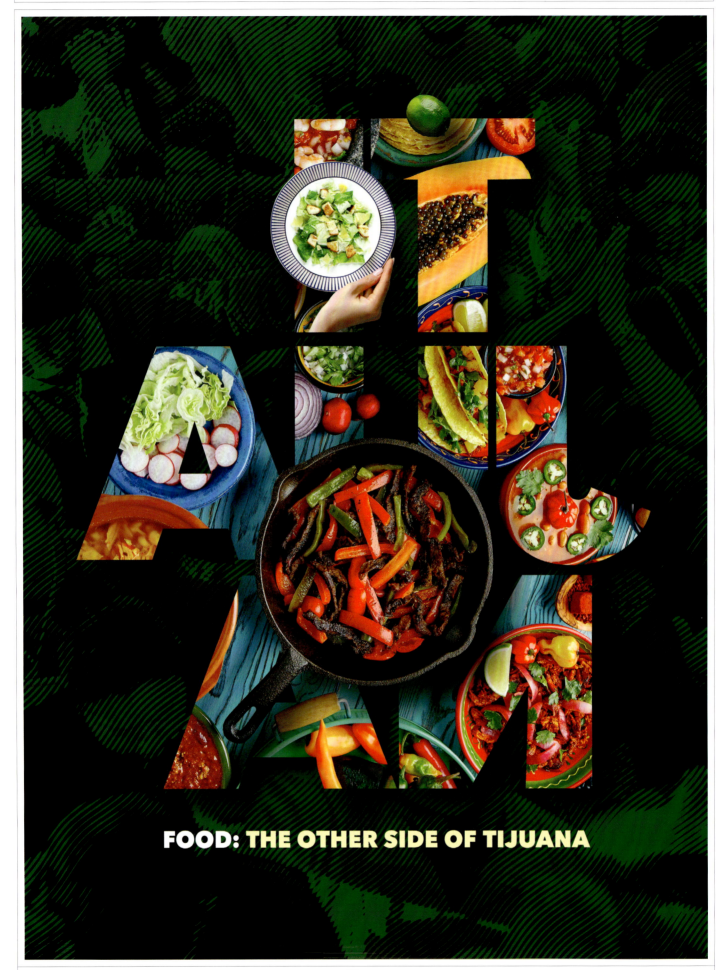

FOOD: THE OTHER SIDE OF TIJUANA

Title: The Other Side of Tijuana | **Clients:** City of Tijuana, Jorge Astiazaran
Design Firm: Freaner Creative | **P237:** Credit & Commentary | Image 1 of 5

[TAO TE CHING]

水

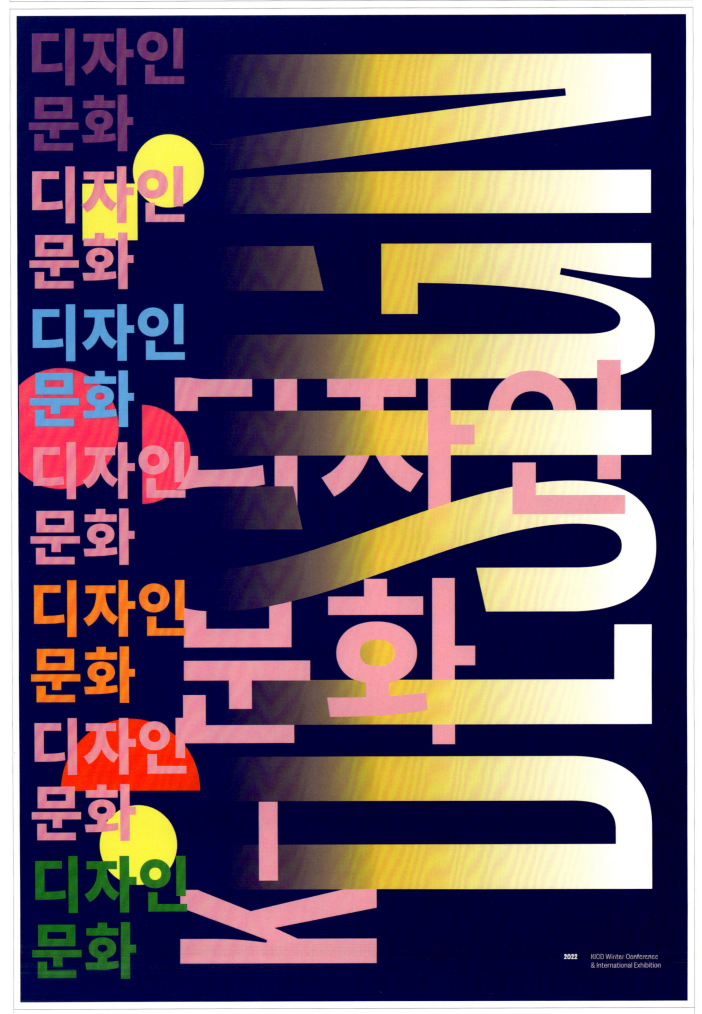

Title: Harmony | Client: KICD Winter International Invitational Exhibition
Design Firm: Lisa Winstanley Design | **P138: Credit & Commentary**

THOMAS WEDELL, NANCY SKOLOS 🇺🇸

Title: 2023 Lyceum Fellowship Competition Call for Entries Poster
Client: Lyceum Fellowship Committee | **Design Firm:** Skolos-Wedell

KIT HINRICHS 🇺🇸

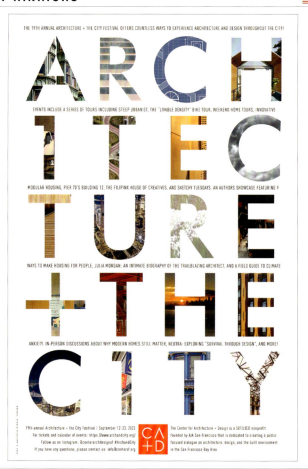

Title: 19th Annual Architecture + The City Festival | **Clients:** Center for Architecture + Design, AIA San Francisco | **Design Firm:** Studio Hinrichs

STEPHAN BUNDI 🇨🇭

Zirkuläres
Bauen
Vortragsreihe
Im Stadtsaal
Kornhausforum Bern
25|10|2022
bis 01|11|2022
Mehr: afb-bern.ch

Architektur
Forum Bern

Title: Zirkuläres Bauen (Circular Building)
Client: Architekturforum Bern | **Design Firm:** Atelier Bundi AG

DOUGLAS MAY 🇺🇸

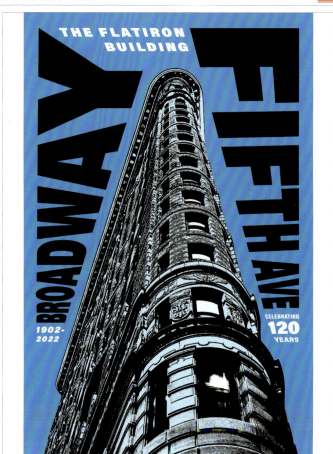

Title: The Flatiron Building – 120th Anniversary
Client: Self-initiated | **Design Firm:** May & Co.

SCOTT LASEROW

Title: Saw Bass | **Client:** International Invitational Poster Exhibition:
National Design Legends | **Design Firm:** Scott Laserow Posters

CRAIG FRAZIER

Title: Paulson Fontaine Press—Printing Art on Paper Since 1996
Client: Paulson Fontaine Press | **Design Firm:** Craig Frazier Studio

CHRISTOPHER SCOTT

Title: Vignelli Legacy Map | **Clients:** The Vignelli Center for Design
Studies, The Vignelli Archive | **Design Firm:** Christopher Scott Designer

MICHAEL BRALEY

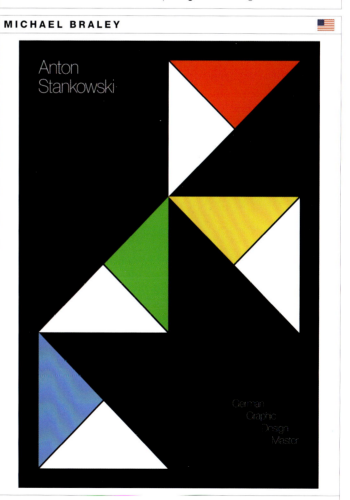

Title: Anton Stankowski Homage | **Client:** Golden Bee Biennale
Design Firm: Braley Design

PEP CARRIÓ

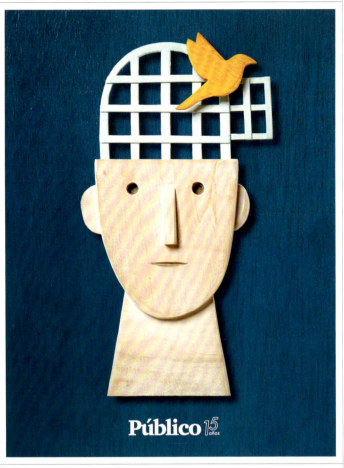

Title: Diario Público. 15 Aniversario. | **Client:** Diario Público
Design Firm: Estudio Pep Carrió

PETER BENCE SIMON

Title: GRAFFITI / Constructivism 100 | **Client:** Golden Bee Biennale
Design Firm: Simon Peter Bence

JOHN GRAVDAHL

Title: Year of the Rabbit 2023 | **Client:** Self-initiated
Design Firm: Gravdahl Design

MARTIN FRENCH

Title: Harlem Urban Dance Festival | **Client:** Harlem Swing Dance Society
Design Firm: Martin French Studio

HYUNGJOO A. KIM

Title: WINTER DANCE WORKS 2022 | Client: Purdue Contemporary
Dance Company | Design Firm: Hyungjoo Kim Design Lab

R.P. BISSLAND

Title: Put in Pull Out | Client: Self-initiated
Design Firm: Design SubTerra

MICHAEL BRALEY

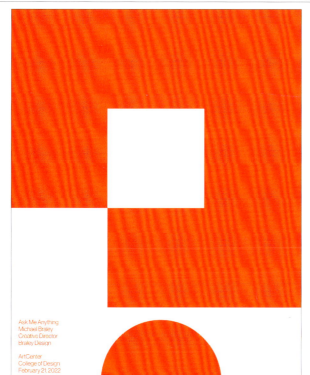

Title: ArtCenter: Ask Me Anything Lecture Poster
Client: ArtCenter School of Design | Design Firm: Braley Design

VIKTOR KOEN

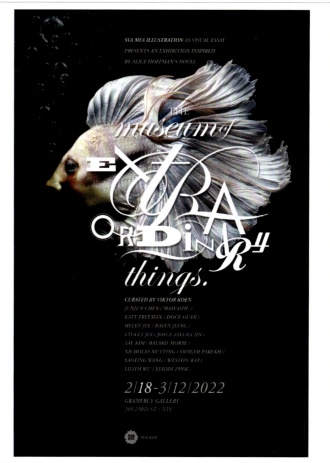

Title: The Museum of Extraordinary Things Exhibition Poster
Client: School of Visual Arts | Design Firm: Attic Child Press, Inc.

CARLOS CASIMIRO COSTA, JACINTA COSTA

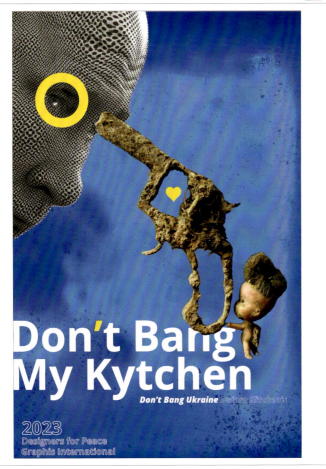

Title: Don't Bang My Kytchen. Don't Bang Dnipro Kytchen's. | Client: Polytechnic Institute of Bragança | Design Firm: CCC + JC. Jacinta & Carlos

RES EICHENBERGER

Title: 1 Tag 1 Thema (1 Day 1 Topic) | Client: Kantonsschule Baden
Design Firm: Res Eichenberger Design

BOB AUFULDISH

Title: CCA Design Lecture Series Fall 2022 | Client: California College of the Arts, Design Division | Design Firm: Aufuldish & Warinner

YANMING CHEN

Title: Runaway From The City | Client: Self-initiated
Design Firm: Yanming Chen

COURTNEY CAMPERELL

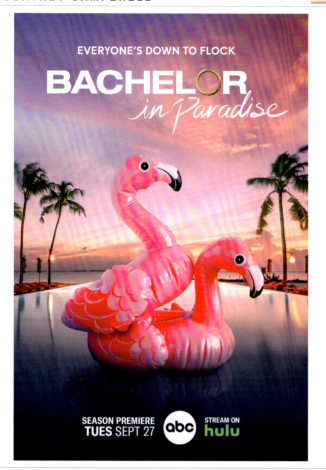

Title: **Bachelor in Paradise** | Clients: **ABC, Gennifer Leong, Grace Ewy, Michelle Yu** | Design Firm: **Cold Open**

SJI ASSOCIATES

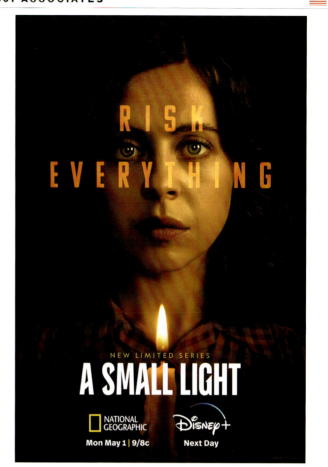

Title: **A SMALL LIGHT** | Client: **National Geographic**
Design Firm: **SJI Associates**

ARSONAL, AMC

Title: **MAYFAIR WITCHES S1** | Client: **AMC**
Design Firm: **ARSONAL**

THE REFINERY

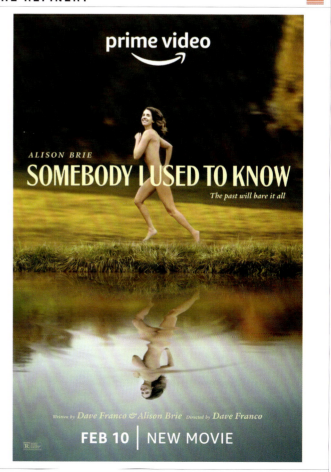

Title: **Somebody I Used to Know Key Art** | Client: **Amazon Studios**
Design Firm: **The Refinery**

THE REFINERY 🇺🇸

Title: Love, Lizzo Key Art
Client: HBO Max
Design Firm: The Refinery

CRAIG HENNIE 🇺🇸

Title: Brian and Charles
Client: Focus Features
Design Firm: Cold Open

THE REFINERY 🇺🇸

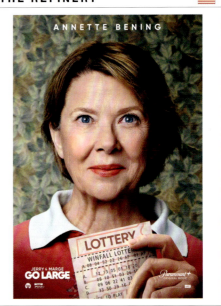

Title: Jerry and Marge Go Large Character Posters
Client: Paramount+
Design Firm: The Refinery

CLARE D'ARCY 🇦🇺

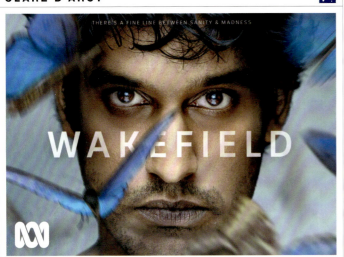

Title: Wakefield | **Client:** Jungle Entertainment | **Design Firm:** ABC Made

CLARE D'ARCY 🇦🇺

Title: Total Control | **Client:** Blackfella Films | **Design Firm:** ABC Made

THE REFINERY 🇺🇸

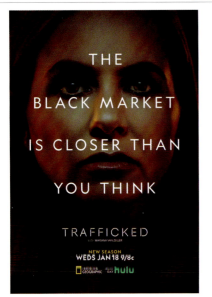

Title: Trafficked with Mariana Van Zeller Season 3 Key Art | **Client:** National Geographic
Design Firm: The Refinery

SJI ASSOCIATES 🇺🇸

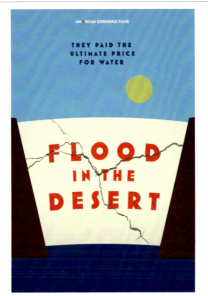

Title: FLOOD IN THE DESERT
Clients: Chika Offurum, American Experience Films | **Design Firm:** SJI Associates

SJI ASSOCIATES 🇺🇸

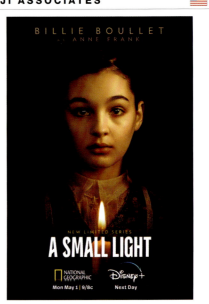

Title: A Small Light – Character Poster Series
Client: National Geographic
Design Firm: SJI Associates

VAL LOPEZ

Title: Chris Rock: Selective Outrage (Teaser) | **Client:** Netflix
Design Firm: Cold Open

GARDNER DEFRANCEAUX

Title: Tokyo Vice | **Client:** HBO
Design Firm: Cold Open

THE REFINERY

Title: Hocus Pocus 2; Character Posters | **Client:** The Walt Disney Studios
Design Firm: The Refinery

COURTNEY CAMPERELL

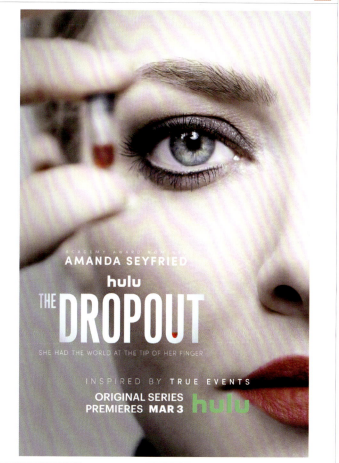

Title: The Dropout | **Client:** Hulu
Design Firm: Cold Open

SJI ASSOCIATES

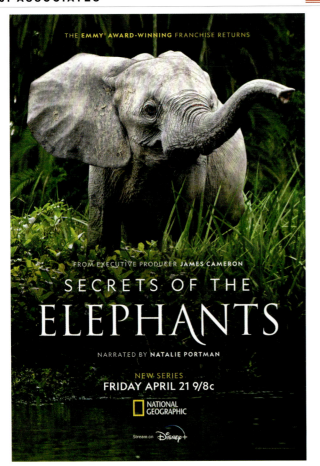

Title: **Secrets of the Elephants** | Client: **National Geographic**
Design Firm: **SJI Associates**

ANNE KELLY

Title: **Mrs. Harris Goes to Paris (Int'l)** | Client: **Focus Features**
Design Firm: **Cold Open**

THE REFINERY

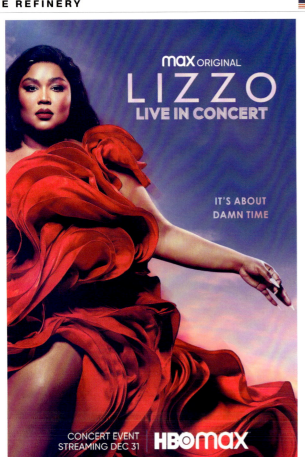

Title: **Lizzo Live in Concert Key Art** | Client: **HBO Max**
Design Firm: **The Refinery**

THE REFINERY

Title: **Carnival Row Final Season Print Campaign** | Client: **Amazon Studios**
Design Firm: **The Refinery**

ARSONAL

Title: Schmigadoon S2 | **Client:** Apple TV+
Design Firm: ARSONAL

KEVIN WIENER

Title: Blumhouse's Compendium of Horror | **Client:** MGM+
Design Firm: Cold Open

ALEX VILLA

Title: The Handmaid's Tale | **Client:** Hulu
Design Firm: Cold Open

PAUL PRATO

Title: Dying For Soup | **Client:** Animal Welfare Institute
Design Firm: PPK USA

MICHAEL BRALEY 🇺🇸

Title: Open Cities: Where Anything Is Possible | **Clients:** Self-initated, Madrid Grafica 2022 | **Design Firm:** Braley Design

DERWYN GOODALL 🇨🇦

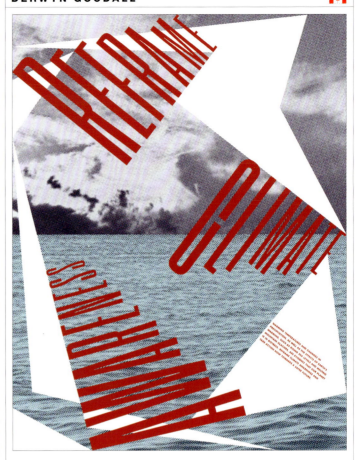

Title: Reframe Climate Awareness | **Client:** Self-initiated
Design Firm: Goodall Integrated Design

XINDI LYU 🇺🇸

CONSERVE
CORAL REEFS
PROTECT MARINE
ECOLOGY

Title: Coral Reef Protection Poster Series | **Client:** Self-initiated
Design Firm: Xindi Lyu

LI ZHANG 🇺🇸

PROTECT
MOTHER
LAND

Title: Protect Motherland | **Client:** Florida A&M University
Design Firm: Purdue University

PEKKA LOIRI

MICHAEL BRALEY

Title: (SOS) Earthquake in Türkiye and Syria | Client: Giresun University Görele, Faculty of Fine Arts, Turkey | Design Firm: Studio Pekka Loiri

Title: Nature Connects Us | Client: Anfachen Awards VI
Design Firm: Braley Design

RIKKE HANSEN

TOYOTSUGU ITOH

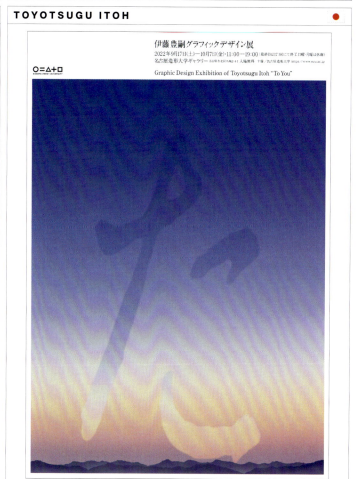

Title: Bom – Spring is Coming | Client: Visual Information
Design Association of Korea | Design Firm: Rikke Hansen

Title: Graphic Design Exhibition of Toyotsugu Itoh "To You"
Client: Nagoya Zokei University | Design Firm: Toyotsugu Itoh Design Office

ARIANE SPANIER 🇩🇪

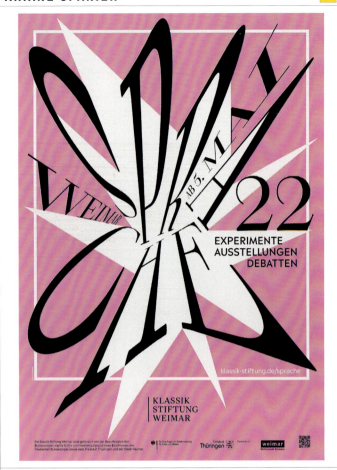

Title: Year of Language 2022 | **Client:** Klassikstiftung Weimar
Design Firm: Ariane Spanier Design

TAKASHI MATSUDA 🇯🇵

Title: Drop.Crack.Pungent. | **Client:** Shizuoka Institute
of Science & Technology | **Design Firm:** 246 Graphics.

ALAN RELLAFORD 🇺🇸

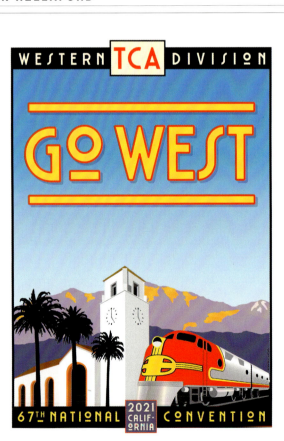

Title: 2021 TCA National Meeting | **Client:** Train Collectors Association
Design Firm: Alan Rellaford Design

MAYUMI KATO 🇺🇸

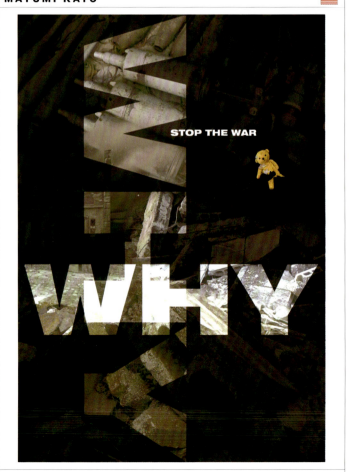

Title: STOP THE WAR | **Client:** NM Designers Club
Design Firm: Legis Design

AYKUT GENÇ

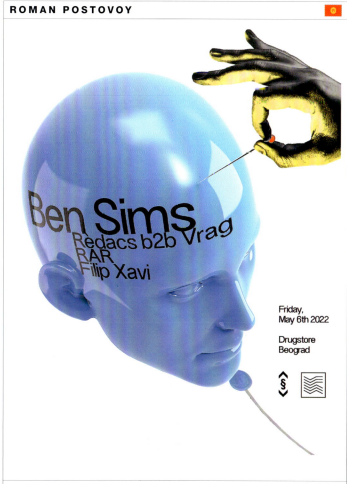

Title: Hamamname Etrafında | **Client:** M. Melih Güneş - Murathan Mungan
Design Firm: Müessese

ROMAN POSTOVOY

Ben Sims
Redacs b2b Vrag
RAR
Filip Xavi

Friday,
May 6th 2022

Drugstore
Beograd

Title: Ben Sims Music Reactions Event | **Client:** Music Reactions
Design Firm: Supremat

OLA PROCAK

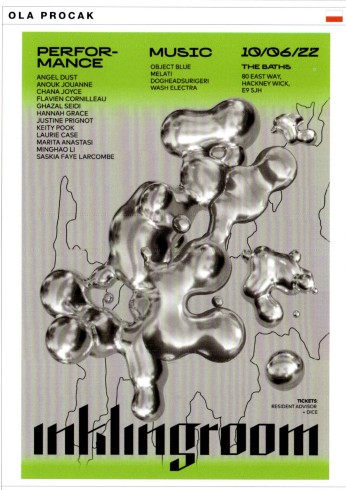

Title: Inklingroom | **Client:** Wash Electra
Design Firm: Ola Procak

ROMAN POSTOVOY

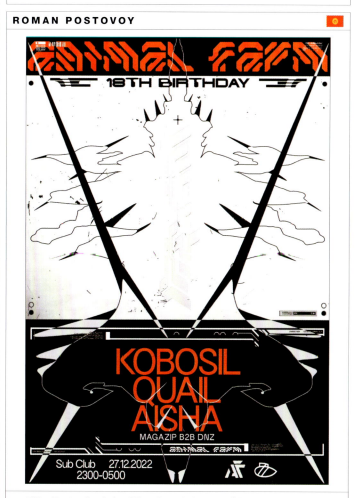

Title: Poster for Animal Farm's 18th Birthday | **Client:** Animal Farm
Design Firm: Supremat

JOHN NORDYKE

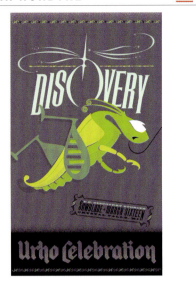

Title: Yooper Discovery Stories: Urho Celebration
Client: Town of Crystal Falls
Design Firm: Nordyke Design

CARTER WEITZ

Title: Under The Surface
Client: Special Olympics Nebraska
Design Firm: Bailey Lauerman

JAMES LACEY

Title: The DSVC Presents the 54th Dallas Show
Client: Dallas Society of Visual Comm. - The Dallas Show | **Design Firm:** Dennard, Lacey & Associates

ALLISON INOUYE, RYAN OWENS

Title: 25th Annual Wienerschnitzel Wiener Nationals
Client: Wienerschnitzel | **Design Firm:** INNOCEAN USA

BÜLENT ERKMEN

Title: Kıraathane* Book Fair
Client: Kıraathane Istanbul Literature House | **Design Firm:** BEK Design

CAM DUNNET

Title: Wynsideout
Client: NSW Government
Design Firms: Hoyne, Premium Media

HANYUE SONG

Title: Women in Motion at West Bund | **Clients:** West Bund Museum, Centre Pompidou; Kerning
Design Firm: Jihe Culture & Art Planning Co., Ltd.

R.P. BISSLAND

Title: Gardener's Market 2022
Client: Cache Valley Gardener's Market Association
Design Firm: Design SubTerra

ARIANE SPANIER

Title: Wohnen 2023 (Living 2023) - Experiments, Exhibitions, Debates
Client: Klassikstiftung Weimar | **Design Firm:** Ariane Spanier Design

TOSHIAKI IDE

Title: Stockade Faire '22
Client: Stockade Faire | **Design Firm:** IF Studio

CARTER WEITZ

Title: Nebraska Storytelling Festival | **Clients:** Nebraska Storytelling Festival, Rich Claussen | **Design Firm:** Bailey Lauerman

HAO WEN (CLAUDIA) CHUNG

Title: Dusk II Dawn - A Fundraising Event for Abortion Access
Client: HaiLife | **Design Firm:** Claudia Chung

PETER BENCE SIMON

Title: TYPO LANTERNS / Beautiful Seoul | **Client:** KECD (Korea Ensemble of Contemporary Design Association) | **Design Firm:** Simon Peter Bence

MOMOE SATO

Title: Warm Flower | **Client:** Self-initiated
Design Firm: Terashima Design Co.

LISA WINSTANLEY

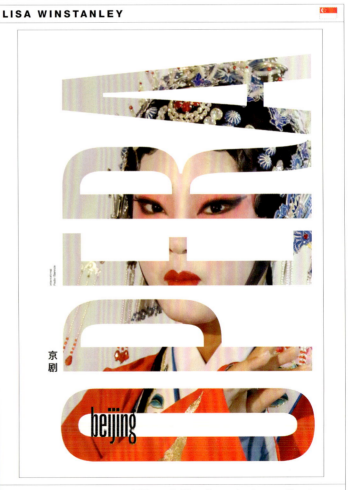

Title: Dan Fan Dance | **Client:** Beijing Opera Art International Poster Biennale | **Design Firm:** Lisa Winstanley Design

LISA WINSTANLEY

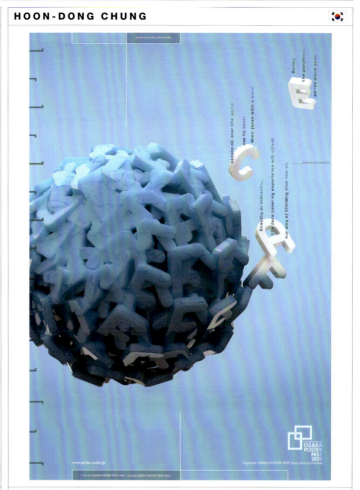

Title: WO[man] | Client: International Poster Biennial in Mexico
Design Firm: Lisa Winstanley Design

HOON-DONG CHUNG

Title: F for Face | Client: International Osaka Poster Fest
Design Firm: Dankook University

HAJIME TSUSHIMA

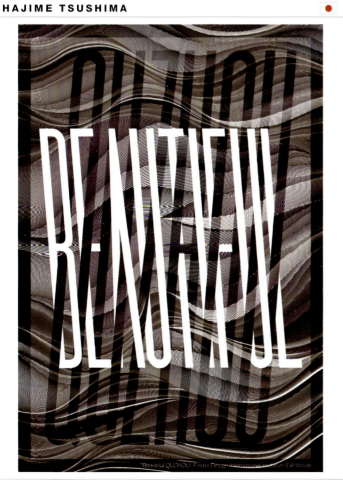

Title: BEAUTIFUL | Client: 2022 "Beautiful QUZHOU" Poster Design
International Invitation Exhibition | Design Firm: Tsushima Design

BÜLENT ERKMEN

Title: Framenelli | Client: Vignelli 90 Poster Exhibition
Design Firm: BEK Design

MARKO ŠESNIĆ, GORAN TURKOVIĆ

Title: **2122 - The Exhibition of Croatian Design**
Client: **Croatian Designers Association** | Design Firm: **Šesnić&Turković**

ANDREA SZABÓ

Title: **23rd Graphic Design Biennale** | Client: **Association of Hungarian Fine and Applied Artists** | Design Firm: **Andrea Szabó**

MARK BAKER-SANCHEZ

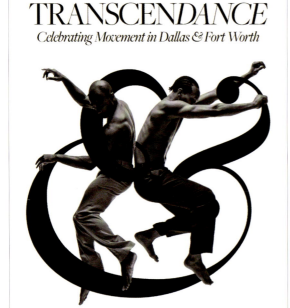

Title: **TRANSCENDANCE** | Client: **Kent Barker**
Design Firm: **MARK**

ANDREA SZABÓ

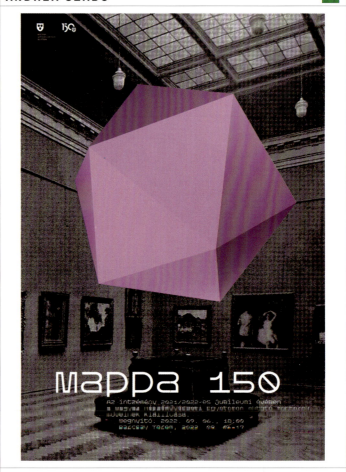

Title: **Mappa 150** | Client: **Hungarian University of Fine Arts**
Design Firm: **Andrea Szabó**

HAJIME TSUSHIMA

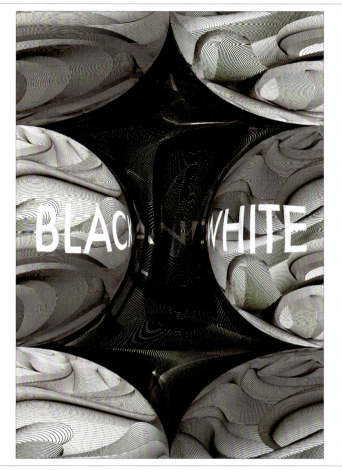

Title: BLACK & WHITE | Client: Design Education Committee of CIDA
Design Firm: Tsushima Design

SVEN LINDHORST-EMME

Title: Elusive Grounds | Client: Raum für drastische Maßnahmen
Design Firm: Studio Lindhorst-Emme+Hinrichs

DANYANG MA

Title: Beginning of The Spring Exhibition Poster Design | Client: 2022 Typeface
Design Exhibition & Typography Workshop | Design Firm: Danyang Ma

TED WRIGHT

Title: GOOD BOY - Faithful and True | Client: Furminator
Design Firm: Ted Wright Illustration & Design

HIROYUKI MATSUISHI ●

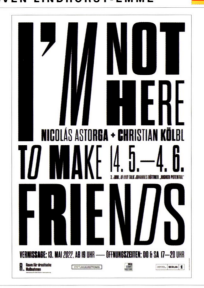

Title: No Gun No Trigger
Client: Self-initiated
Design Firm: Hiroyuki Matsuishi Design Office

SVEN LINDHORST-EMME 🇩🇪

Title: I'm Not Here to Make Friends
Client: Raum für drastische Maßnahmen
Design Firm: Studio Lindhorst-Emme+Hinrichs

NORIYUKI KASAI ●

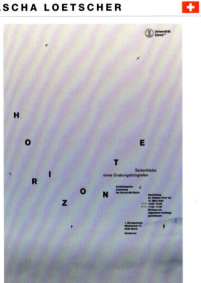

Title: Make Future - UAE Centennial 2071
Client: The Culture and Science Association
Design Firm: Noriyuki Kasai

SASCHA LOETSCHER 🇨🇭

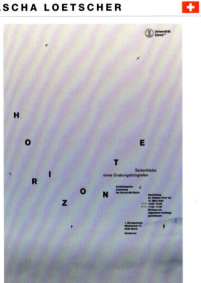

Title: Horizonte | **Client:** University of
Zurich Archaelogical Collection
Design Firm: Gottschalk+Ash Int'l

RON TAFT 🇺🇸

Title: The Art of Desire | **Client:** VOX CUPIO
Design Firm: Ron Taft Brand Innovation
& Media Arts

RANDY CLARK 🇨🇳

Title: Bye Bye China
Client: Chen Tianlong Art Museum
Design Firm: Randy Clark

CHIHIRO OTSUKI ●

Title: Darkness and Light: A Deep-coiled Tension
Clients: National Institute of Japanese Literature,
NIJL Arts Initiative | **Design Firm:** Diotop

SVEN LINDHORST-EMME 🇩🇪

Title: Richtfest – Lena Schramm
Client: Raum für drastische Maßnahmen
Design Firm: Studio Lindhorst-Emme+Hinrichs

LUIS ANTONIO RIVERA RODRIGUEZ 🇲🇽

Title: Rebellion
Client: Red Interuniversitaria de Cartel
Design Firm: Monokromatic

PEP CARRIÓ

Title: Woman, Life, Freedom | **Client:** Woman, Life, Freedom
Design Firm: Estudio Pep Carrió

SAKI KOGENJI

Title: Baw-wow | **Client:** Self-initiated
Design Firm: Terashima Design Co.

ANDREA SZABÓ

Title: Young Voices | **Client:** Hungarian University of Fine Arts
Design Firm: Andrea Szabó

RYAN SLONE

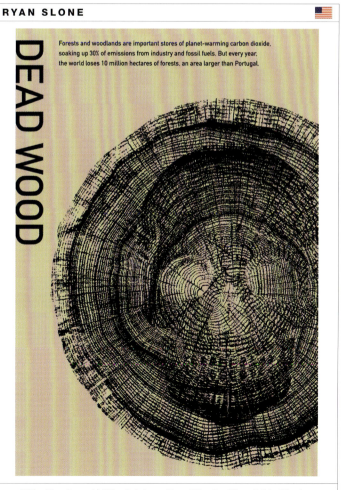

Title: Deadwood | **Client:** International Poster Biennial in Mexico
Design Firm: Ryan Slone Design

NGADHNJIM MEHMETI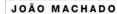

Title: Tirana International Film Festival 2021
Client: Tirana International Film Festival | **Design Firm:** EGGRA

JOÃO MACHADO

Title: Cinanima 2023 | **Client:** Cooperativa Nascente
Design Firm: João Machado Design

DAEKI SHIM, HYO JUN SHIM

Title: 2022 Gangwon Design Festa (Gdf)_C | **Client:** Gangwon State /
Gangwon Institute of Design Promotion (GIDP) | **Design Firm:** DAEKI and JUN

DAEKI SHIM, HYO JUN SHIM

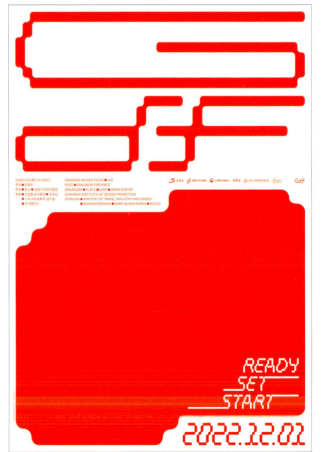

Title: 2022 Gangwon Design Festa (Gdf)_B | **Client:** Gangwon State /
Gangwon Institute of Design Promotion (GIDP) | **Design Firm:** DAEKI and JUN

RES EICHENBERGER

Title: Jacques Audiard—Cinéaste | Client: Kino Xenix
Design Firm: Res Eichenberger Design

KISHAN MUTHUCUMARU

Title: Men Payoff Poster | Client: A24
Design Firm: MOCEAN

JOHN GODFREY

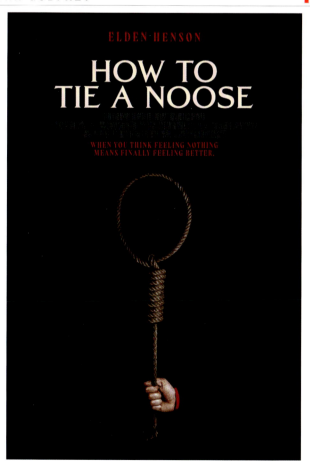

Title: How To Tie A Noose | Client: Joshua Barnett
Design Firm: Chargefield

CÉLIE CADIEUX

Title: Against the Current | Clients: Zeitgeist Films, Kino Lorber
Design Firm: Célie Cadieux

LEROY & ROSE 🇺🇸

Title: The Sky Is Everywhere | Client: Apple
Design Firm: Leroy & Rose

ANDRÉ BARNETTX 🇺🇸

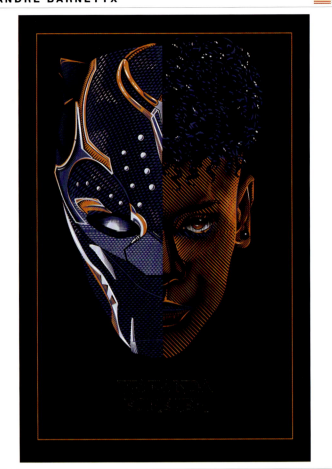

Title: Black Panther: Wakanda Forever | Client: Self-initiated
Design Firm: Only Child Art

ERIC SKILLMAN 🇺🇸

Title: The Rules of the Game | Client: Janus Films
Design Firm: Raphael Geroni Design

STEPHAN BUNDI 🇨🇭

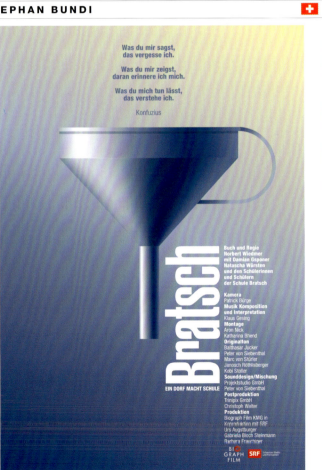

Title: Bratsch (Little Village) Documentary by Norbert Wiedmer
Client: Biograph Film | Design Firm: Atelier Bundi AG

SHAOYANG CHEN

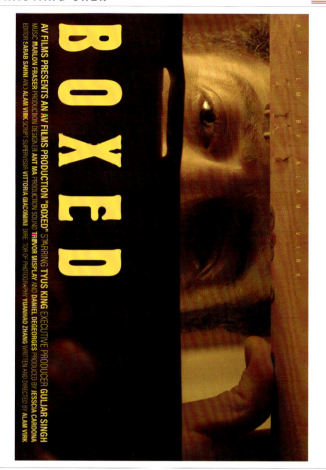

Title: Boxed | **Client:** Alam Singh Virk
Design Firm: Aydada.Inc.

AV PRINT

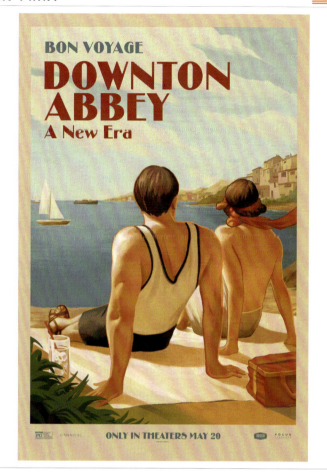

Title: Downton Abbey: A New Era - Beach Travel Poster
Client: Focus Features | **Design Firm:** AV Print

CÉLIE CADIEUX

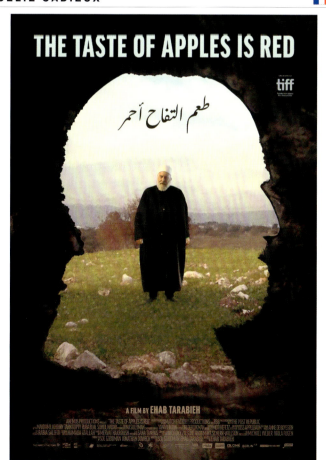

Title: The Taste of Apples Is Red | **Client:** The Match Factory
Design Firm: Célie Cadieux

KISHAN MUTHUCUMARU

Title: X Teaser Poster | **Client:** A24
Design Firm: MOCEAN

KISHAN MUTHUCUMARU 🇺🇸

Title: Catch The Fair One Payoff Poster
Client: IFC Films
Design Firm: MOCEAN

ARSONAL 🇺🇸

Title: Bones And All | **Clients:** Metro Goldwyn
Mayer Pictures, United Artists Releasing
Design Firm: ARSONAL

AV PRINT, JAMES JEAN 🇺🇸

Title: Everything Everywhere All At Once
- James Jean Illustration | **Client:** A24
Design Firm: AV Print

JOHN GODFREY 🇨🇦

Title: Rejoice In The Lamb | **Client:** Doormat
Pictures | **Design Firm:** Chargefield

YICHUN LIN 🇺🇸

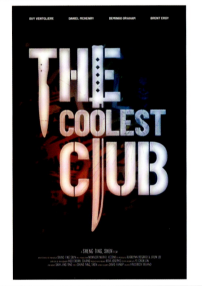

Title: The Coolest Club | **Client:** Sheng-Ting
(Sandy) Shen | **Design Firm:** Yichun Lin Design

R. DUNBAR, K. MUTHUCUMARU 🇺🇸

Title: Significant Other Teaser Poster
Client: Paramount+ | **Design Firm:** MOCEAN

RAVEN MO 🇺🇸

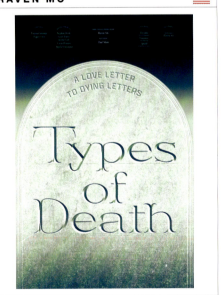

Title: Types of Death | **Client:** Self-initiated
Design Firm: Raven Mo Design

BÜLENT ERKMEN 🇹🇷

Title: Critical Distance | **Client:** Norgunk Film
Design Firm: BEK Design

WU QIXIN 🇨🇳

Title: SHE WILL | **Client:** SHE WILL
Design Firm: Cul-box

AV PRINT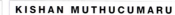

Title: Cocaine Bear - Payoff Poster | **Client:** Universal Pictures
Design Firm: AV Print

KISHAN MUTHUCUMARU

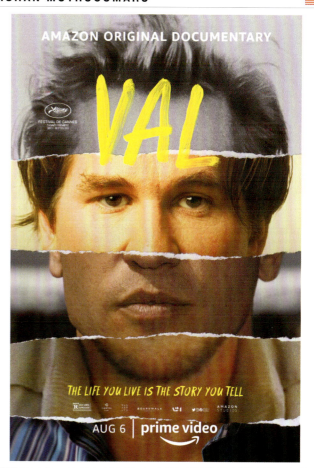

Title: Val Payoff Poster | **Client:** Amazon Studios
Design Firm: MOCEAN

STEPHEN CHILDRESS

Title: The World's Strongest Coffee - Coffee Bean Grenade,
Bomb & Match Stick | **Client:** Black Insomnia | **Design Firm:** Brandon

MOE MINKARA

Title: Château Ksara New Year 2023 | **Client:** Château Ksara
Design Firm: Mink

CURIOUS

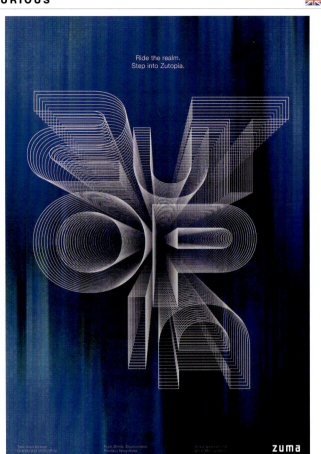

Title: **Zutopia** | Client: **Zuma**
Design Firm: **CURIOUS**

NAOTO ONO

Title: **To Go From Vietnam to Brooklyn** | Client: **Di An Di Restaurant**
Design Firm: **Naoto Ono Creative**

203

Title: **203_Food&Drink_Series** | Client: **Street H**
Design Firm: **203 Infographic Lab**

TED WRIGHT

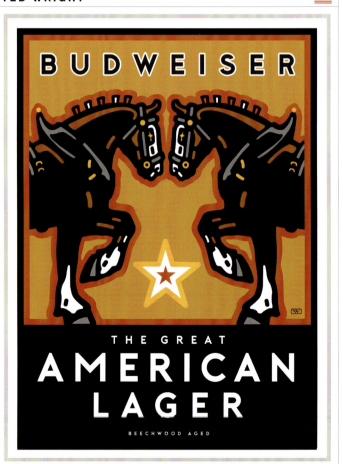

Title: **Budweiser The Great American Lager** | Client: **Anheuser Busch**
Design Firm: **Ted Wright Illustration & Design**

PETROL ADVERTISING

Title: Dead Island 2 - Game Informer Cover | **Clients:** Deep Silver, Dambuster | **Design Firm:** PETROL Advertising

PETROL ADVERTISING

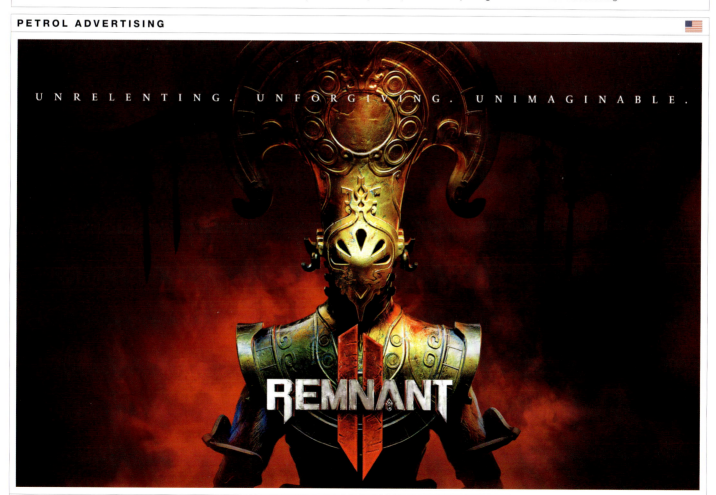

Title: Remnant 2 - Announce Monster Key Art Poster | **Client:** Gearbox Publishing San Francisco
Design Firm: PETROL Advertising

PETROL ADVERTISING 🇺🇸

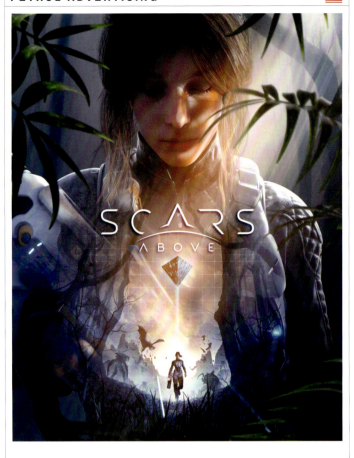

Title: Scars Above - Key Art Poster | **Client:** Koch Media
Design Firm: PETROL Advertising

KELLY SALCHOW MACARTHUR 🇺🇸

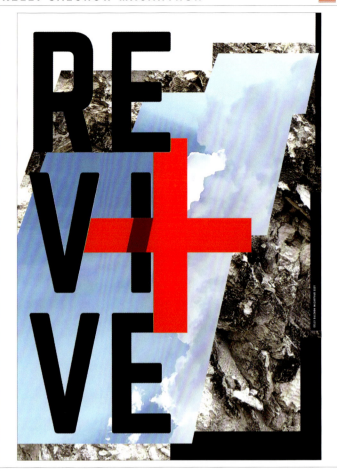

Title: Revive | **Client:** Message Journal
Design Firm: Elevate Design

DAEKI SHIM, HYO JUN SHIM 🇰🇷

Becoming a Digital Being
Meta: NFT 2022
Daeki Shim Solo Exhibition
www.b-d-b.xyz
4th June-31st July 2022
3F Sikmulgwan PH Gallery

PH's 27th 전시 — 심대기
초대개인전

PH CA BOOKS

DAEKI and JUN

Title: Becoming a Digital Being Meta: NFT 2022 | **Clients:** Sikmulgwan
PH Gallery, Design Magazine CA (Korea) | **Design Firm:** DAEKI and JUN

MELCHIOR IMBODEN 🇨🇭

VIGNELLI MASSIMO

Title: MASSIMO VIGNELLI 1931 – 2014 | **Client:** The Vignelli Center
for Design Studies | **Design Firm:** Imboden Graphic Studio

ANNA LEITHAUSER 🇺🇸

Title: Hamilton Leithauser Carlyle Cafe Residency
Client: Hamilton Leithauser | **Design Firm:** Anna Leithauser

CARLO FIORE 🇮🇹

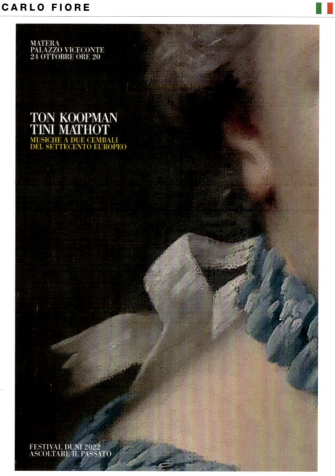

Title: Duni 2022 – Early Music Festival "Listening to the Past"
Client: Festival Duni (Matera, Italy) | **Design Firm:** Venti Caratteruzzi

MARTIN FRENCH 🇺🇸

Title: Mingus 100 | **Client:** Self-initiated
Design Firm: Martin French Studio

DUY DAO 🇻🇳

Title: GIEO ALBUM POSTER | **Clients:** NGOT, LP Music
Design Firm: STUDIO DUY

MIKEY LAVI

Title: The National — Live in Milwaukee | Client: The National | Design Firm: Mikey Lavi

GREGORY PAONE

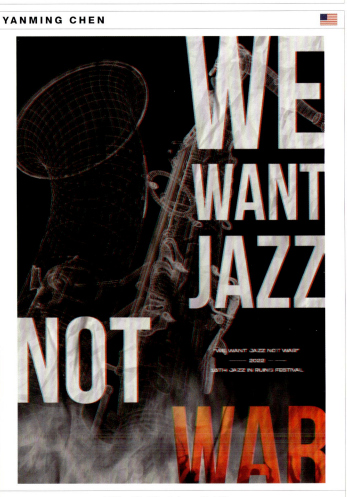

Title: Philadelphia Youth Orchestra Winter Concert Poster
Client: Philadelphia Youth Orchestra | Design Firm: Paone Design Associates

YANMING CHEN

Title: We Want Jazz, Not War
Client: Self-initiated | Design Firm: Yanming Chen

MIKEY LAVI

Title: **Noah Kahan — Live in Boston**
Client: **Noah Kahan** | Design Firm: **Mikey Lavi**

STEPHAN BUNDI

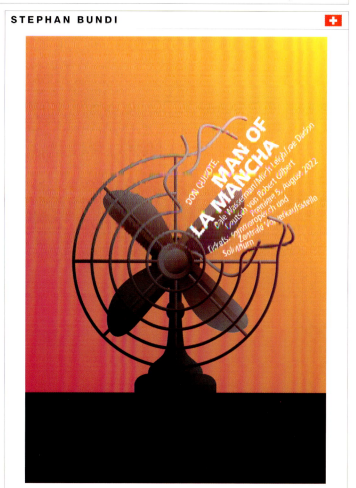

Title: **Man of La Mancha** | Client: **Sommeroper Selzach**
Design Firm: **Atelier Bundi AG**

GREGORY PAONE

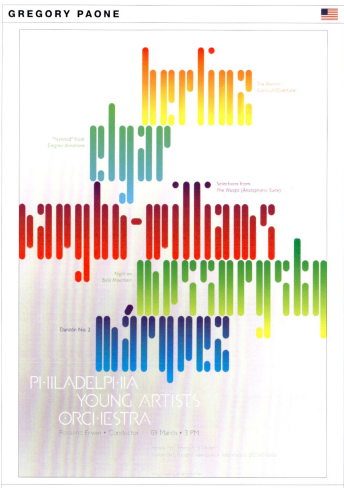

Title: **Philadelphia Young Artists Orchestra Winter Concert Poster**
Client: **Philadelphia Youth Orchestra** | Design Firm: **Paone Design Associates**

GUNTER RAMBOW

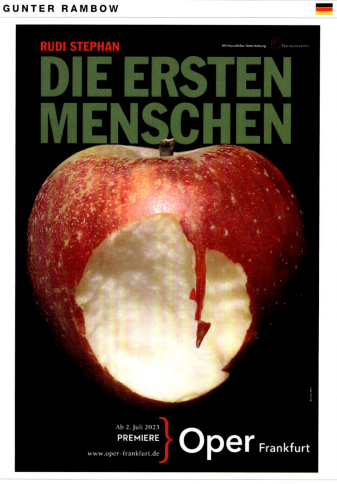

Title: **The First Humans** | Client: **Oper Frankfurt**
Design Firm: **Gunter Rambow**

EDUARD CEHOVIN

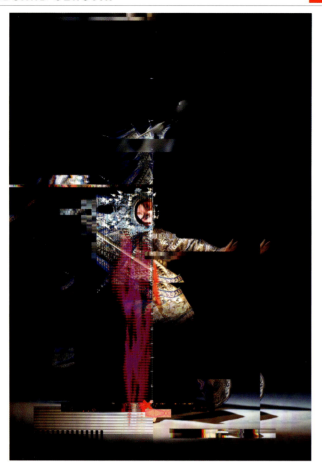

Title: Four=Four | **Client:** Beijing Opera Art International Poster Biennale
Design Firm: Studio Eduard Cehovin

FIDEL PEÑA, CLAIRE DAWSON

Title: Beijing Opera International Biennale Poster | **Client:** Beijing Opera
International Poster Biennale | **Design Firm:** Underline Studio

STEPHAN BUNDI

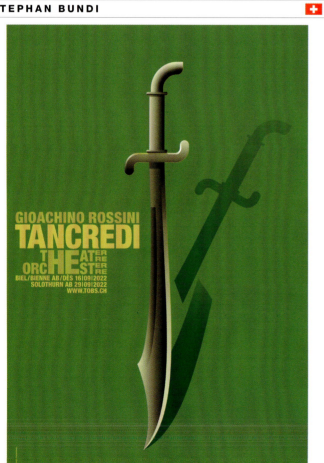

Title: Tancredi | **Client:** Theater Orchester Biel Solothurn
Design Firm: Atelier Bundi AG

XIAN LIYUN

Title: Sweeny Todd | **Client:** Dcuve Art Center
Design Firm: Sun Design Production

GUNTER RAMBOW

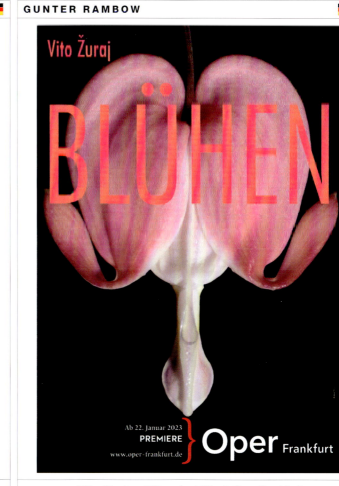

Title: **Hercules** | Client: Oper Frankfurt
Design Firm: Gunter Rambow

GUNTER RAMBOW

Title: **Bluehen / Blooming** | Client: Oper Frankfurt
Design Firm: Gunter Rambow

GUNTER RAMBOW

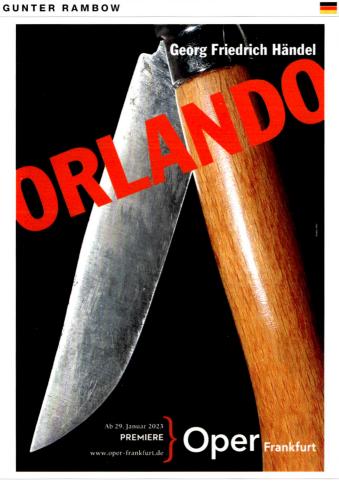

Title: **Orlando** | Client: Oper Frankfurt
Design Firm: Gunter Rambow

GUNTER RAMBOW

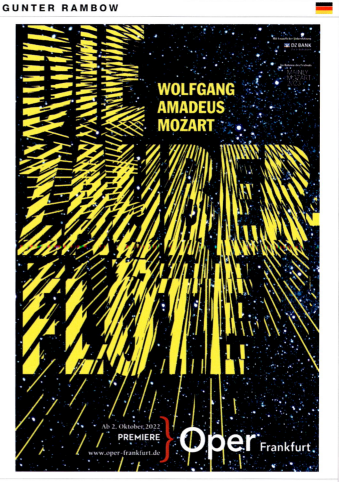

Title: **Die Zauberfloete / The Magic Flute** | Client: Oper Frankfurt
Design Firm: Gunter Rambow

SIMON ELLIOTT

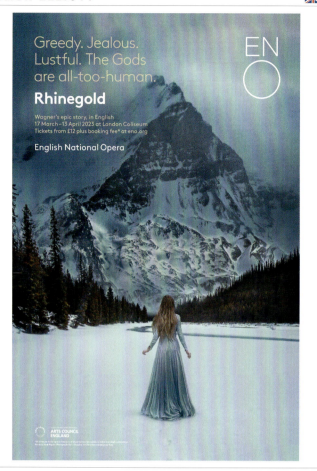

Title: The Rhinegold – ENO 2022/23
Client: English National Opera | **Design Firm:** Rose

SIMON ELLIOTT

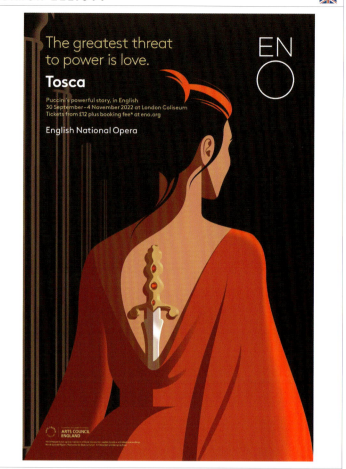

Title: Tosca – ENO 2022/23
Client: English National Opera | **Design Firm:** Rose

SIMON ELLIOTT

Title: Carmen – ENO 2022/23
Client: English National Opera | **Design Firm:** Rose

SIMON ELLIOTT

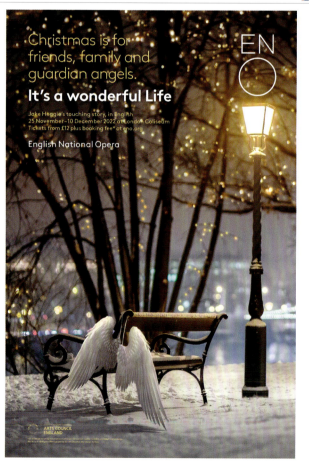

Title: It's a Wonderful Life – ENO 2022/23
Client: English National Opera | **Design Firm:** Rose

SIMON ELLIOTT

Heartbreak has
never been so funny.

**The Yeomen
of the Guard**

Gilbert and Sullivan's moving story, in English
3 November – 2 December 2022 at London Coliseum
Tickets from £12 plus booking fee* at eno.org

English National Opera

EN
O

Title: The Yeomen of the Guard – ENO 2022/23
Client: English National Opera | **Design Firm:** Rose

SIMON ELLIOTT

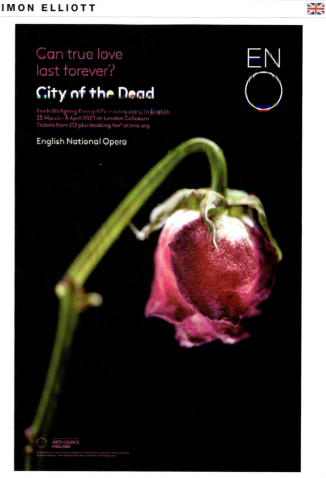

Can true love
last forever?

City of the Dead

Erich Wolfgang Korngold's moving story, in English
25 March – 8 April 2023 at London Coliseum
Tickets from £12 plus booking fee* at eno.org

English National Opera

EN
O

Title: The Dead City – ENO 2022/23
Client: English National Opera | **Design Firm:** Rose

SIMON ELLIOTT

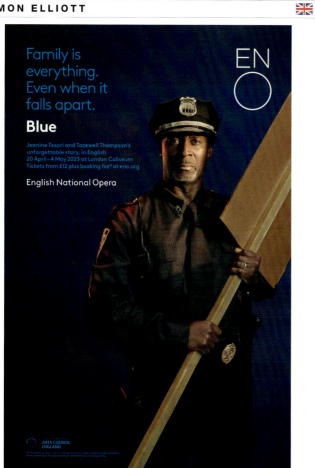

Family is
everything.
Even when it
falls apart.

Blue

Jeanine Tesori and Tazewell Thompson's
unforgettable story, in English
20 April – 4 May 2023 at London Coliseum
Tickets from £12 plus booking fee* at eno.org

English National Opera

EN
O

Title: Blue – ENO 2022/23
Client: English National Opera | **Design Firm:** Rose

SIMON ELLIOTT

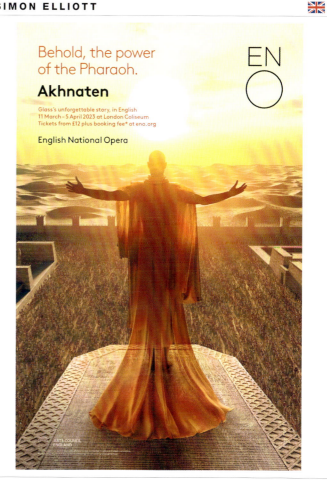

Behold, the power
of the Pharaoh.

Akhnaten

Glass's unforgettable story, in English
11 March – 5 April 2023 at London Coliseum
Tickets from £12 plus booking fee* at eno.org

English National Opera

EN
O

Title: Akhnaten – ENO 2022/23
Client: English National Opera | **Design Firm:** Rose

SCOTT LASEROW

Title: Bluebeard's Castle
Client: Self-initiated | **Design Firm:** Scott Laserow Posters

CARLO FIORE

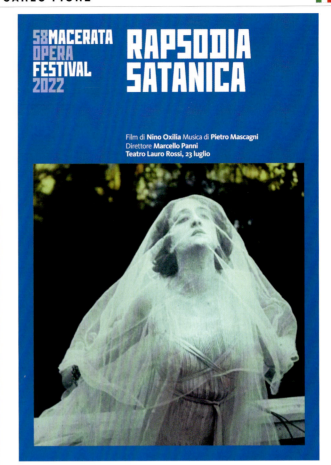

Title: Macerata Opera Festival 2022
Client: Associazione Arena Sferisterio | **Design Firm:** Venti Caratteruzzi

DAVID THORNHILL

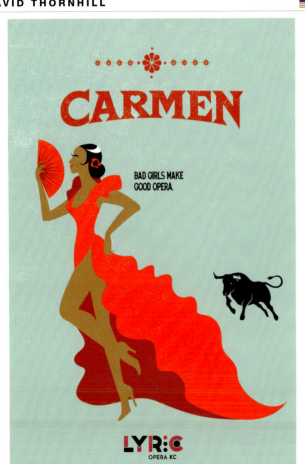

Title: Carmen | **Clients:** Lyric Opera Kansas City,
Greg Campbell, Deb Sandler | **Design Firm:** Bailey Lauerman

CHARLES HIVELY

Title: 3x3 Call for Entries 20 Poster | **Client:** 3x3, The Magazine
of Contemporary Illustration | **Design Firm:** Hively Designs

DAEKI SHIM, HYO JUN SHIM

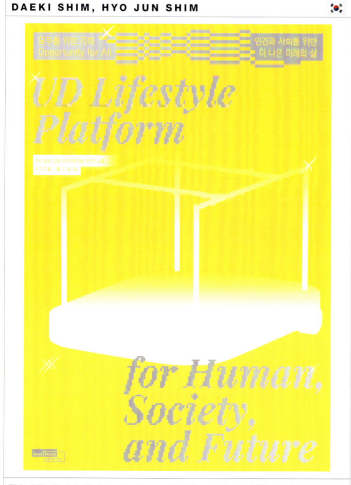

Title: UD Lifestyle Platform for Human, Society, and Future | **Clients:** Dongdaemun Design Plaza (DDP), Seoul Design Foundation | **Design Firm:** DAEKI and JUN

TOYOTSUGU ITOH

Title: Mount Tado | **Client:** Japan Graphic Design Association Inc.
Design Firm: Toyotsugu Itoh Design Office

CARMIT MAKLER HALLER

Title: Seasons | **Client:** Self-initiated | **Design Firm:** Carmit Design Studio

HAOTIAN DONG

Title: CASALEX | **Client:** Alex Beaufort | **Design Firm:** CASALEX

HOON-DONG CHUNG

Title: Schrodinger's Cat
Client: Self-initiated | **Design Firm:** Dankook University

PEP CARRIÓ

Title: Biblioteca Palermo Libro/Laberinto
Client: Artes Gráficas Palermo | **Design Firm:** Estudio Pep Carrió

DERWYN GOODALL

Title: Celebrate | **Client:** Self-initiated
Design Firm: Goodall Integrated Design

THOMAS BRAND

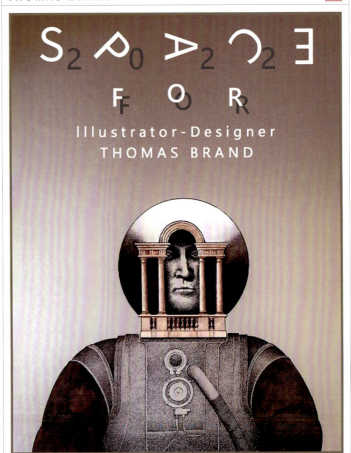

Title: Promotional Poster | **Client:** Self-initiated
Design Firm: IBEX Studio

DAEKI SHIM, HYO JUN SHIM

Title: DDP NFT Collecting Vol. 1 | Clients: Dongdaemun Design Plaza (DDP), Seoul Design Foundation | Design Firm: DAEKI and JUN

DAEKI SHIM, HYO JUN SHIM

Title: DDP NFT Exhibition | Clients: Dongdaemun Design Plaza (DDP), Seoul Design Foundation | Design Firm: DAEKI and JUN

KISHAN MUTHUCUMARU

Title: Pearl Specialty Poster | Client: A24
Design Firm: MOCEAN

MICHAEL VANDERBYL

Title: Teknion Product Introduction Posters | Client: Teknion
Design Firm: Vanderbyl Design

MAI KATO ●

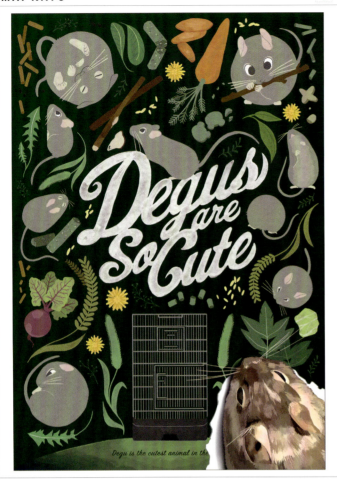

Title: Small Animal Shop Poster | **Client:** PC | **Design Firm:** PEACE Inc.

BORIS LJUBICIC

Title: No Name | **Client:** Self-initiated | **Design Firm:** STUDIO INTERNATIONAL

ARIEL FREANER 🇺🇸

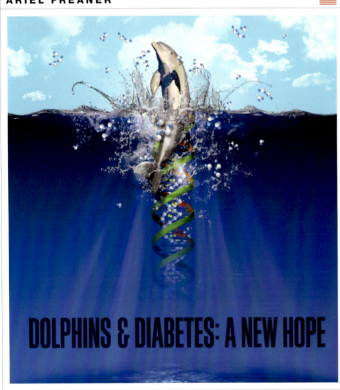

Title: NMMF Conference Poster Advertising Diabetes Dolphins
Clients: National Marine Mammal Foundation, Mike Marchesano,
Steve Walker, Cynthia Smith | **Design Firm:** Freaner Creative

ARIEL FREANER 🇺🇸

Title: ZETA Free As The Wind
Client: ZETA
Design Firm: Freaner Creative

EDITH SULLIVAN 🇺🇸

Title: Sunny | **Client:** Self-initiated
Design Firm: Love Letters

LISA WINSTANLEY 🇸🇬

Title: In The Making | **Client:** Self-initiated
Design Firm: Lisa Winstanley Design

ARIEL FREANER 🇺🇸

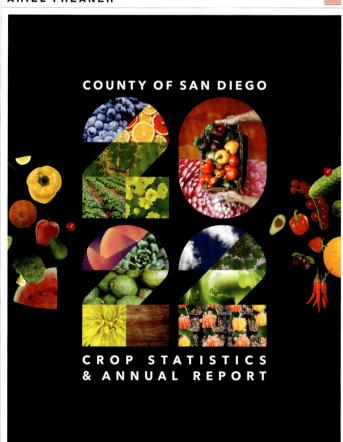

Title: County of San Diego Department of Agriculture, Weights and Measures 2022 Crop Annual | **Client:** County of San Diego Department of Agriculture, Weights and Measures | **Design Firm:** Freaner Creative

JACK HARRIS 🇺🇸

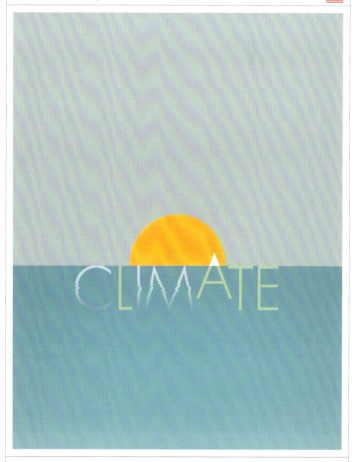

Title: Is It Too Late?
Client: Self-initiated
Design Firm: Harris Design

LU YE

Title: The Passcode of COVID-19 | **Client:** The Light of China
Design Firm: Lang Xuan

JAN ŠABACH

Title: Help Democracy Grow. Vote. | **Client:** AIGA Get Out the Vote
Design Firm: Code Switch

ARIEL FREANER

Title: San Diego District Attorney's Office Insurance Fraud Outdoor Campaign | **Client:** San Diego District Attorney's Office | **Design Firm:** Freaner Creative

KIRSTEN GRACIE

NICHOLE TRIONFI

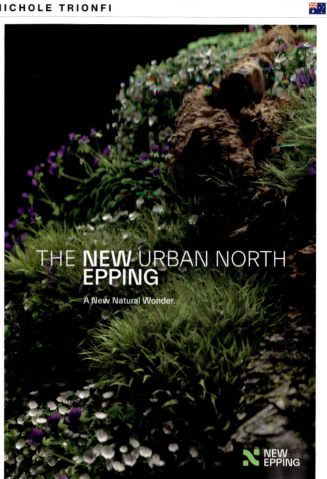

THE **NEW** URBAN NORTH EPPING

A New Natural Wonder.

NEW EPPING

Title: Ethos | **Client:** Central Element | **Design Firm:** Hoyne

Title: New Epping | **Client:** Riverlee | **Design Firm:** Hoyne

STEPHEN CHILDRESS

THE ART OF BIG GAME FISHING

There's an art to the pastimes of the oceans we love so much. And there's an art to crafting apparel designed to protect you from the elements and protect the beauty of the sea. From using recycled materials in our apparel to ensuring a portion of the proceeds support the Guy Harvey Ocean Foundation (GHOF), wearing Guy Harvey means you're a part of the movement to protect our sport and our oceans for generations to come. GuyHarvey.com

GUY HARVEY

TURN THE TIDES

Title: Guy Harvey - The Art of Big Game Fishing | **Client:** Guy Harvey | **Design Firm:** Brandon

GARY HILTON

Title: Drink, Drank, Drunk
Client: Field and Forest Pub | Design Firm: Anolith

MICHAEL VANDERBYL

Title: City Center Bishop Ranch Superb Taste Poster Campaign
Client: Sunset Development | Design Firm: Vanderbyl Design

MAYUMI KATO

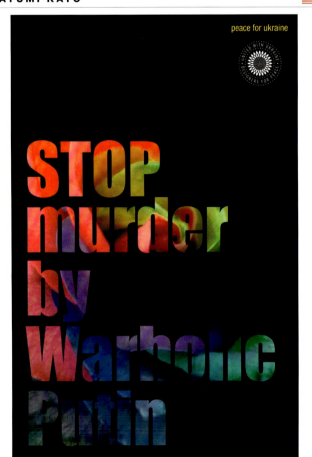

Title: Stop Murder | Client: Graphis Designers for Peace
Poster Competition | Design Firm: Legis Design

DAISUKE KASHIWA

Title: Russia-Ukraine War | Client: 4th Block Association
of Graphic Designers | Design Firm: Daisuke Kashiwa

JOÃO MACHADO

MICHAEL GRAZIOLO

Title: Woman. Life. Freedom. | **Client:** Woman, Life, Freedom
Design Firm: João Machado Design

Title: Peace in Ukraine | **Client:** Graphis Designers for Peace
Poster Competition | **Design Firm:** Drive Communications

JOHN GRAVDAHL

MARLENA BUCZEK SMITH

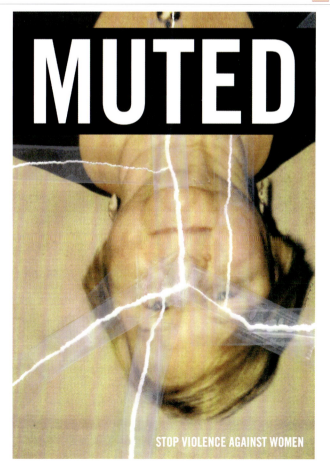

Title: United for Ukraine | **Client:** Graphis Designers for Peace
Poster Competition | **Design Firm:** Gravdahl Design

Title: Muted | **Client:** Self-initiated
Design Firm: Marlena Buczek Smith

LI ZHANG

STOP HUMAN TRAFFICKING

Title: Broken Wings | **Client:** National Palace of Culture, Sofia, Bulgaria
Design Firm: Purdue University

JACK HARRIS

TWITTER ON HISTORY

Title: Twitter On... | **Client:** Self-initiated
Design Firm: Harris Design

KIT HINRICHS

WOMAN LIFE FREEDOM

Article 638 of the 1996 Islamic Penal Code stipulates that it's compulsory for all women and girls over the age of nine to wear a head covering (hijab) in public at all times. This law is enforced by the "morality police" and is punishable by fines or imprisonment from 10 days to two months.

SUPPORT IRANIAN WOMEN

Title: Woman, Life, Freedom | **Client:** Morteza Majidi
Design Firm: Studio Hinrichs

TOYOTSUGU ITOH

BROKEN

GIVE PEACE A CHANCE

Title: Broken - Give Peace a Chance | **Client:** Peace-Loving Innovators of Nations | **Design Firm:** Toyotsugu Itoh Design Office

BEN GREENGRASS

Title: Posters to Support Ukraine | **Client:** Self-initiated
Design Firm: ThoughtMatter

RENE V. STEINER

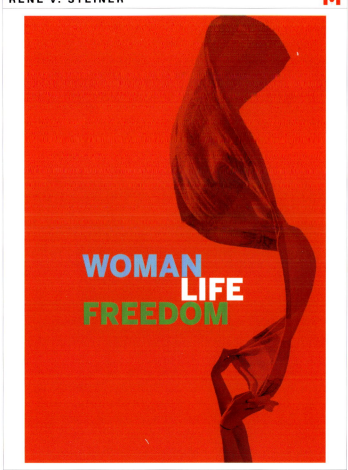

Title: Woman. Life. Freedom. | **Client:** Woman, Life, Freedom
Design Firm: Steiner Graphics

JOHN GRAVDAHL

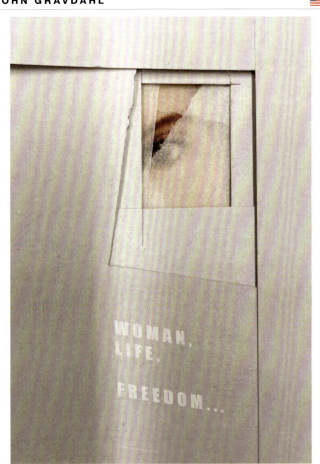

Title: Woman, Life, Freedom... | **Client:** Invitational Exhibition
Design Firm: Gravdahl Design

RENE V. STEINER

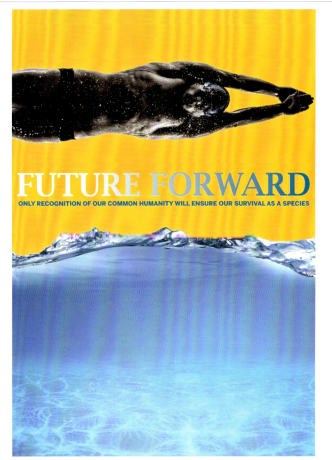

Title: Future Forward | **Client:** Self-initiated
Design Firm: Steiner Graphics

JOÃO MACHADO

Title: No War for Ukraine | **Client:** Ogaki Poster Museum, Japan
Design Firm: João Machado Design

DERWYN GOODALL

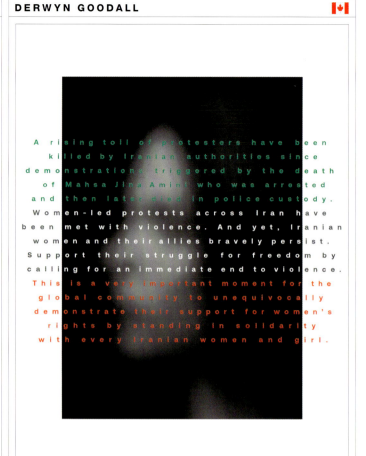

Title: Women. Life. Freedom. | **Client:** Self-initiated
Design Firm: Goodall Integrated Design

TOYOTSUGU ITOH

Title: Undying Anger | **Client:** Chubu Creators Club
Design Firm: Toyotsugu Itoh Design Office

DERWYN GOODALL

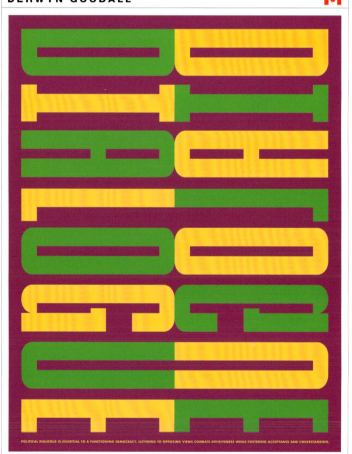

Title: Dialogue | **Client:** Self-initiated
Design Firm: Goodall Integrated Design

ARNAUD GHELFI 🇺🇸

MARLENA BUCZEK SMITH 🇺🇸

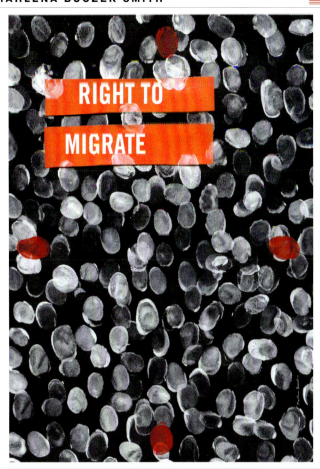

Title: Ukraine War: One Year | **Client:** Self-initiated
Design Firm: Atelier Starno

Title: Right to Migrate | **Clients:** Xavier Bermudez Banuelos, International
Poster Biennial in Mexico | **Design Firm:** Marlena Buczek Smith

IVAN KASHLAKOV 🇧🇬

YOSSI LEMEL 🇮🇱

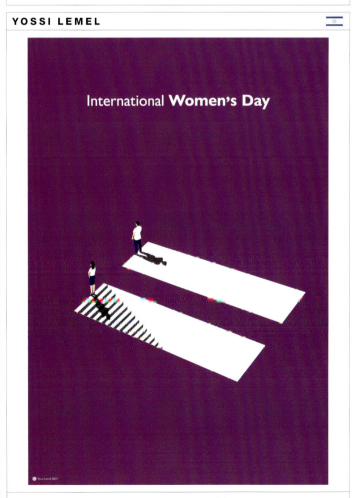

Title: The Woman in the Poster | **Clients:** University of Information
Technology and Management in Rzeszów, CEIDA | **Design Firm:** Kashlak

Title: International Women's Day 2023 | **Client:** Self-initiated
Design Firm: Yossi Lemel

SHUICHI NOGAMI ●

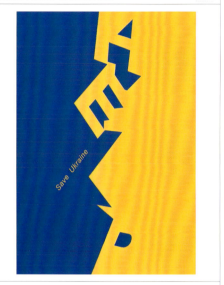

Title: Save Ukraine
Client: Self-initiated
Design Firm: Nogami Design Office

ARNAUD GHELFI 🇺🇸

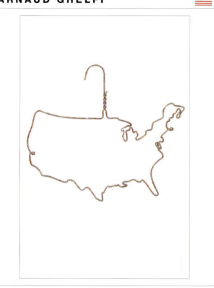

Title: R.I.P. Roe
Client: Self-initiated
Design Firm: Atelier Starno

ERIC BOELTS 🇺🇸

Title: Civilitas
Client: Posters Without Borders
Design Firm: Brain Bolts

MICHAEL VANDERBYL 🇺🇸

Title: Woman Life Freedom
Client: Woman, Life, Freedom
Design Firm: Vanderbyl Design

RADOVAN JENKO 🇸🇮

Title: Woman_Life_Freedom
Client: Morteza Mojidi
Design Firm: Atelier Radovan Jenko

ANNE M. GIANGIULIO 🇺🇸

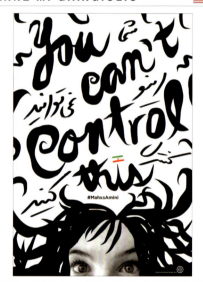

Title: You Can't Control This
Client: Design to Raise Awareness
Design Firm: Anne M. Giangiulio Design

ARIANE SPANIER 🇩🇪

Title: Woman Life Freedom
Client: Woman, Life, Freedom
Design Firm: Ariane Spanier Design

RIKKE HANSEN 🇩🇰

Title: Woman. Life. Freedom.
Client: Woman, Life, Freedom
Design Firm: Rikke Hansen

RYAN SLONE 🇺🇸

Title: Broken Girls
Client: Universidad Alianza Hispana
Design Firm: Ryan Slone Design

HOLGER MATTHIES 🇩🇪

Title: Woman, Life, Freedom
Client: Self-initiated
Design Firm: Holger Matthies

KARI PIIPPO ➕

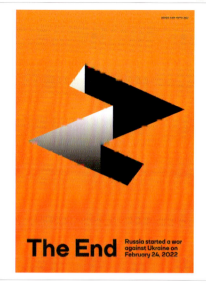

Title: The End
Client: Ogaki Poster Museum
Design Firm: Kari Piippo Ltd.

ERIC BOELTS 🇺🇸

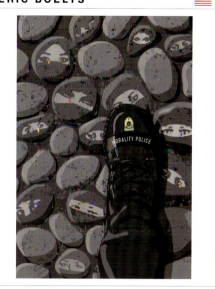

Title: Support the Women of Iran
Client: Iranian Protests
Design Firm: Brain Bolts

ALIREZA VAZIRI RAHIMI 🇺🇸

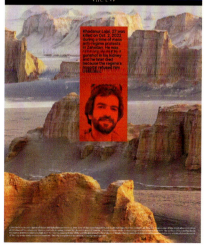

Title: Beautiful Iran! | **Client:** People of Iran | **Design Firm:** Vaziri Studio

MENG LAN

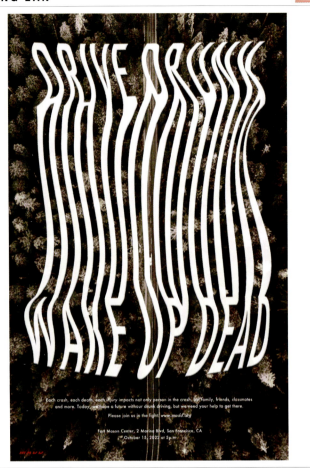

Title: Drive Drunk, Wake Up Dead | **Client:** Mothers Against Drunk Driving | **Design Firm:** Meng Lan

CARTER WEITZ

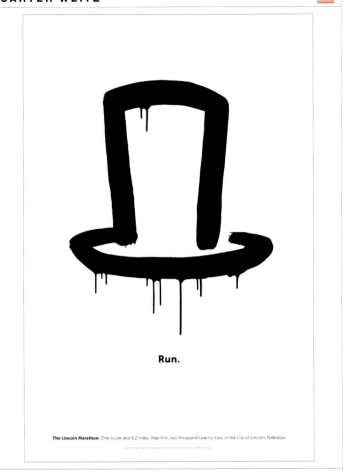

Title: Run | **Client:** Lincoln Track Club
Design Firm: Bailey Lauerman

ANDREW YANEZ

Title: Bowl for the Brave 20th Anniversary | **Clients:** ESPN Events, Lockheed Martin Armed Forces Bowl | **Design Firm:** PytchBlack

LEROY & ROSE

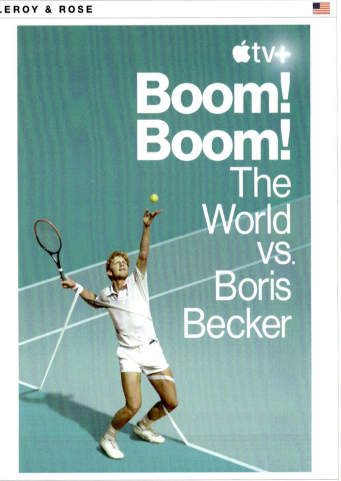

Title: Boom! Boom! The World vs. Boris Becker | **Client:** Apple
Design Firm: Leroy & Rose

FX NETWORKS, AV PRINT 🇺🇸

Title: Pistol - Queen Art Specialty Poster | Client: FX Networks
Design Firm: AV Print

LEROY & ROSE 🇺🇸

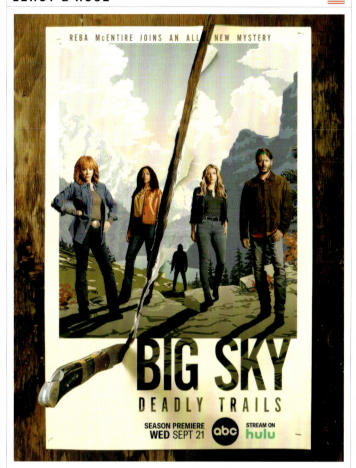

Title: Big Sky Season 3 | Client: ABC
Design Firm: Leroy & Rose

LEROY & ROSE 🇺🇸

Title: Atlanta Season 4 | Client: FX Networks
Design Firm: Leroy & Rose

ARSONAL, AMC, AMC+ 🇺🇸

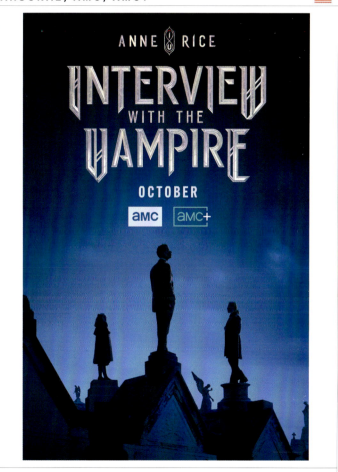

Title: Interview with the Vampire | Clients: AMC, AMC+
Design Firm: ARSONAL

KISHAN MUTHUCUMARU

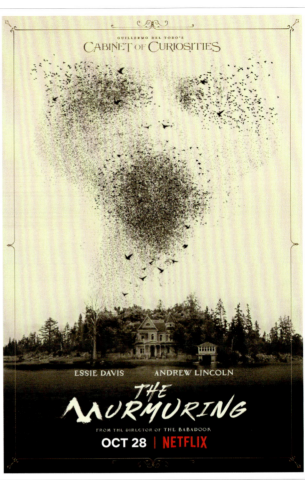

Title: Cabinet of Curiosities Episodic Posters | **Client:** Netflix | **Design Firm:** MOCEAN

TIFFANY PRATER

Title: NCIS - Ziva David
Client: Self-initiated | **Design Firm:** T&P Designs

STEPHAN BUNDI

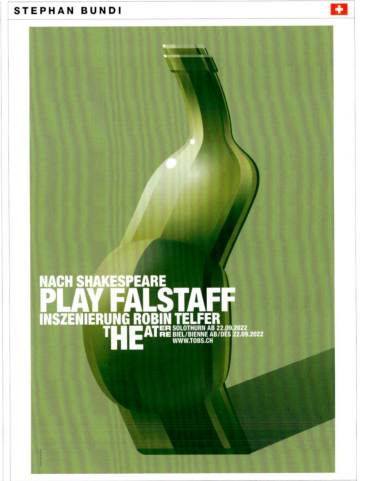

Title: Falstaff (After Shakespeare)
Client: Theater Orchester Biel Solothurn | **Design Firm:** Atelier Bundi AG

MIRKO ILIC

TIT ANDRONIK

Title: Titus Andronicus
Client: JDP-Yugoslav Drama Theater | **Design Firm:** Mirko Ilic Corp.

MIRKO ILIC

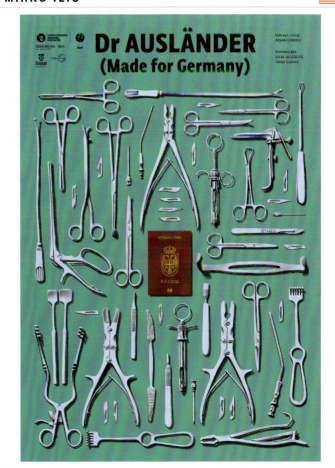

Dr AUSLÄNDER
(Made for Germany)

Title: Dr. Ausländer (Made for Germany)
Client: JDP-Yugoslav Drama Theater | **Design Firm:** Mirko Ilic Corp.

OLGA SEVERINA

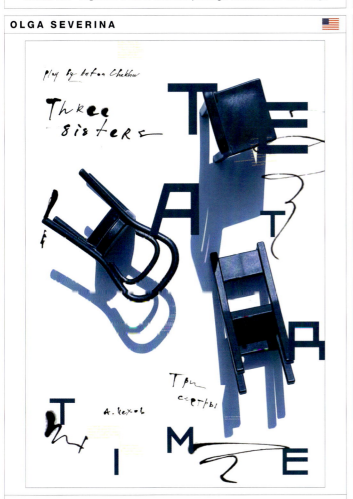

Title: The Three Sisters by Anton Chekhov | **Client:** Self-initiated
Design Firm: PosterTerritory

MARCOS MININI

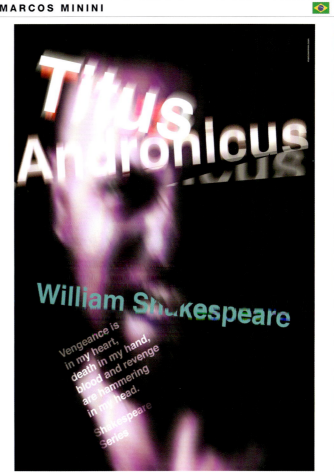

Title: Shakespeare Series II | **Client:** Self-initiated
Design Firm: Marcos Minini Design

STEPHAN BUNDI 🇨🇭

Title: Bellissima | **Client:** Theater Orchester Biel Solothurn
Design Firm: Atelier Bundi AG

NICKY LINDEMAN 🇺🇸

Title: The Skin of Our Teeth | **Client:** Lincoln Center Theater
Design Firm: SpotCo

STEPHAN BUNDI 🇨🇭

Title: Kafka in Farbe (Kafka in Color)
Client: Theater Orchester Biel Solothurn | **Design Firm:** Atelier Bundi AG

NGADHNJIM MEHMETI 🇲🇰

Title: The Balcony
Client: The Albanian Theatre Skopje | **Design Firm:** EGGRA

AYKUT GENÇ

ANDREW SOBOL

Title: Kırmızı Yorgunları | **Client:** Süleyman Arda Eminçe
- Varyete Kumpanya | **Design Firm:** Müessese

Title: Evening of One Acts | **Client:** Theatre at the Mill
Design Firm: Andrew Sobol

TED WRIGHT

Title: YELLOWSTONE - High Country Backwoods | **Client:** Yellowstone National Park | **Design Firm:** Ted Wright Illustration & Design

HANNAH HOWARD

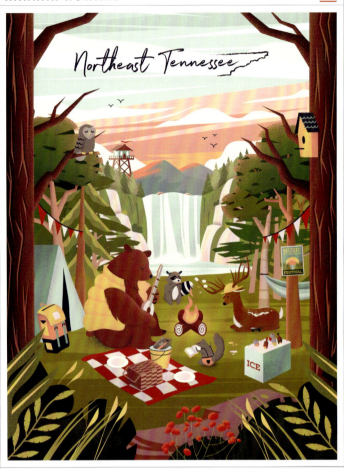

Title: Wonderfully Wild Northeast Tennessee | **Client:** Northeast Tennessee Tourism Association | **Design Firm:** Creative Energy

203

Title: 203_Tourism_Series | **Client:** Street H
Design Firm: 203 Infographic Lab

JILLIAN COOREY

FLOWERS GROW OUT OF DARK MOMENTS. —CORITA KENT

Title: Hope | **Client:** Typography Day
Design Firm: Jillian Coorey

MIKHAIL LYCHKOVSKIY

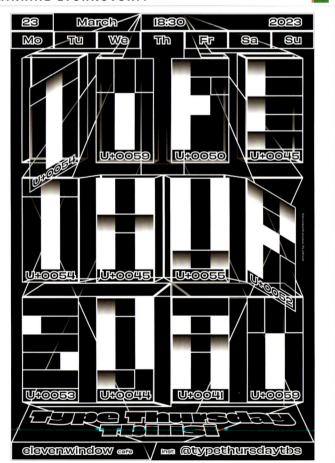

Title: Type Thursday Tbilisi | **Client:** Type Thursday Tbilisi
Design Firm: Mikhail Lychkovskiy

LEO LIN

THOMAS KÜHNEN

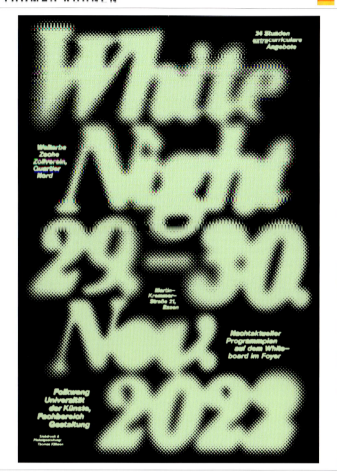

Title: TPDA 30 | **Client:** Taiwan Poster Design Association
Design Firm: Leo Lin Design

Title: White Night | **Client:** Folkwang University of the Arts
Design Firm: Thomas Kühnen

NANA FUKASAWA, MIKI TAGUCHI, HEITA IKEDA, RYOTA SUGAHARA, TAICHI TAMAKI

Title: A Mountain of History | **Client:** SEIBIDO Co., Ltd. | **Design Firm:** Taichi Tamaki

IVAN KASHLAKOV

Title: UNOVIS. XXI Century. #EL130 | **Client:** Vitebsk Center for Modern and Contemporary Art | **Design Firm:** Kashlak

BERNICE WONG

Title: Habits | **Client:** Self-initiated
Design Firm: Bernice Wong

FA-HSIANG HU

Title: New Rules | **Client:** ADLINK Education Foundation
Design Firm: Hufax Arts/FJCU

LEO LIN

Title: The Glory of Centennial: Exhibition of Centennial of Taiwanese Design History | **Client:** NTNU, Department of Design | **Design Firm:** Leo Lin Design

Vestígio Design

Studio Matthews

DLR Group

Dunn&Co.

Nikkeisha, Inc.

Hey Mendoza

Res Eichenberger Design

Jenn Stucker

Joshua Ege

Braley Design

Randy Clark

Joshua Ege

DLR Group

Freaner Creative

Broly Su

Braley Design

Design SubTerra 🇺🇸

Cold Open 🇺🇸

ARSONAL 🇺🇸

SJI Associates 🇺🇸

The Refinery 🇺🇸

SJI Associates 🇺🇸

The Refinery 🇺🇸

Savannah Coll. of Art & Design 🇺🇸

SJI Associates 🇺🇸

The Refinery 🇺🇸

The Refinery 🇺🇸

The Refinery 🇺🇸

The Refinery 🇺🇸

Cold Open 🇺🇸

The Refinery 🇺🇸

ARSONAL 🇺🇸

DOG & PONY 🇺🇸

Cold Open 🇺🇸

The Refinery 🇺🇸

The Refinery 🇺🇸

The Refinery 🇺🇸

SJI Associates 🇺🇸

Cold Open 🇺🇸

Cold Open 🇺🇸

Braley Design 🇺🇸

Paco Macías Velasco Studio 🇲🇽

Hiroyuki Matsuishi Design Office 🇯🇵

Freaner Creative 🇺🇸

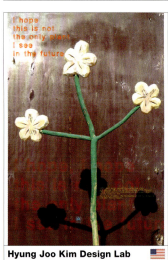

Hyung Joo Kim Design Lab 🇺🇸

Pukyong National University 🇰🇷

Kojima Design Office Inc. 🇯🇵

White & Case 🇺🇸

Neli Kumaeva

Coma, Comunicación Creativa

VANGUARD Visual Design Ltd.

Tsushima Design

Noriyuki Kasai

Ryan Slone Design

Choong Ho Lee

Anna Ganna

Choong Ho Lee

Dalian RYCX Design

Symbiotic Solutions

Ryan Slone Design

Ariane Spanier Design

Terashima Design Co.

Tetsuro Minorikawa

Purdue University

Responsiva 🇨🇭

Müessese 🇹🇷

Choong Ho Lee 🇰🇷

Randy Clark 🇨🇳

EGGRA 🇲🇰

Quesinberry and Associates 🇺🇸

Tetsuro Minorikawa 🔴

Devon Ward 🇺🇸

Atelier Radovan Jenko 🇸🇮

EGGRA 🇲🇰

DAEKI and JUN 🇰🇷

Studio Craig Byers 🇺🇸

Victor Lau Graphic Design 🇭🇰

BSSP 🇺🇸

Peterson Ray & Company 🇺🇸

MOCEAN 🇺🇸

PLASTIC PALMTREE

Aydada.Inc.

Aydada.Inc.

MOCEAN

Aydada.Inc.

Graphonic

AV Print

AV Print

Leroy & Rose

MOCEAN

ARSONAL

ARSONAL

AV Print

Terashima Design Co.

PEACE Inc.

PEACE Inc.

PETROL Advertising 🇺🇸

PETROL Advertising 🇺🇸

Randy Clark 🇨🇳

Hey Mendoza 🇺🇸

Amanda Lenig Design 🇺🇸

Traction Factory 🇺🇸

Traction Factory 🇺🇸

Noriyuki Kasai 🇯🇵

Attic Child Press, Inc. 🇺🇸

DLR Group 🇺🇸

Anagraphic 🇭🇺

Anagraphic 🇭🇺

Anagraphic 🇭🇺

Teikna Design 🇮🇹

Paone Design Associates 🇺🇸

Res Eichenberger Design 🇨🇭

Brian Danaher 🇺🇸

Brian Danaher 🇺🇸

Centre for Design Research 🇸🇮

Brian Danaher 🇺🇸

Gunter Rambow 🇩🇪

Gunter Rambow 🇩🇪

Bailey Lauerman 🇺🇸

Rose 🇬🇧

Sun Design Production 🇨🇳

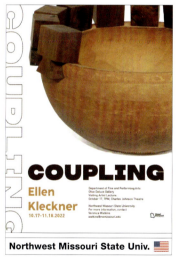

Northwest Missouri State Univ. 🇺🇸

Yichun Lin Design 🇺🇸

PEACE Inc. 🇯🇵

Hyung Joo Kim Design Lab 🇺🇸

Annette Chang 🇰🇷

Love Letters 🇺🇸

i,D 🇯🇵

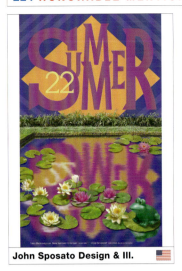

John Sposato Design & Ill. 🇺🇸

andKuo 🇺🇸

Goodall Integrated Design 🇨🇦

Freaner Creative 🇺🇸

Randy Clark 🇨🇳

Goodall Integrated Design 🇨🇦

Meng Lan 🇺🇸

Eduardo Davit 🇺🇾

Anagraphic 🇭🇺

Hoyne 🇦🇺

Hoyne 🇦🇺

TSDDesign Inc. 🇺🇸

Antonio Castro Design 🇺🇸

Meaghan A. Dee 🇺🇸

Urilic Studio 🇺🇸

Urilic Studio 🇺🇸

The Union Design Company 🇺🇸

Kari Piippo Ltd. 🇫🇮

Goodall Integrated Design 🇨🇦

Ivan Kashlakov 🇧🇬

Daisuke Kashiwa 🇯🇵

Code Switch 🇺🇸

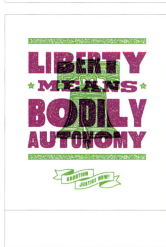

United States for Abortion 🇺🇸

Carina Länk 🇸🇪

Braley Design 🇺🇸

Gunter Rambow 🇩🇪

Brad Holland 🇺🇸

Russell & Russell, Co. 🇺🇸

Finn Nygaard 🇩🇰

Studio Craig Byers 🇺🇸

Atelier Starno 🇺🇸

Freaner Creative 🇺🇸

Dunn&Co.

Meaghan A. Dee

TSDDesign Inc.

Symbiotic Solutions

May & Co.

Filippos Fragkogiannis

L3&D

Filippos Fragkogiannis

Braley Design

Leroy & Rose

Leroy & Rose

Dennard, Lacey & Associates

Leroy & Rose

Studio Lonne Wennekendonk

Leroy & Rose

Leroy & Rose

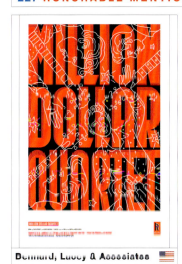

Dennard, Lacey & Associates 🇺🇸

AV Print 🇺🇸

Leroy & Rose 🇺🇸

Leroy & Rose 🇺🇸

Mirko Ilic Corp. 🇺🇸

Leroy & Rose 🇺🇸

Hey Mendoza 🇺🇸

Andrew Sobol 🇺🇸

HILLS 🇨🇳

SpotCo 🇺🇸

MOCEAN 🇺🇸

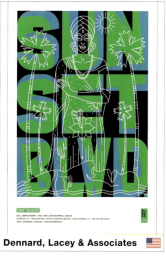

Dennard, Lacey & Associates 🇺🇸

BEK Design 🇹🇷

May & Co. 🇺🇸

Purdue University 🇺🇸

Rose 🇬🇧

Thomas Kühnen 🇩🇪

Thomas Kühnen 🇩🇪

Filippos Fragkogiannis 🇬🇷

T&P Designs 🇺🇸

As befits a traditional poster competition, there were many high-quality posters. Artists seem to have put a lot of thought into their presentation and message.

Mi-Jung Lee, *Designer & Assistant Professor, Namseoul University*

Successfully disrupting the industry balance can be done by smashing aesthetic conventions, but also by turning traditional mastery on its head. Both were amply represented in this competition.

Viktor Koen, *Artist, Designer, & Chair, BFA Comics, BFA Illustration, SVA*

The range of expression is wide, and by taking a multidimensional approach, not just a unified approach, I felt more possibilities for posters.

Noriyuki Kasai, *Graphic Designer & Associate Professor, Nihon University College of Art*

Alan Rellaford Design 🇺🇸

Freaner Creativa 🇺🇸

BULLET Inc. ⚫

PETROL Advertising 🇺🇸

Tangram Strategic Design 🇮🇹

Eight Sleep 🇺🇸

Freaner Creative 🇺🇸

Freaner Creative 🇺🇸

Brandon 🇺🇸

Brandon 🇺🇸

Freaner Creative 🇺🇸

Freaner Creative 🇺🇸

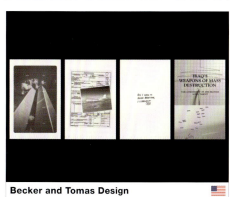

Becker and Tomas Design 🇺🇸

KMS TEAM GmbH 🇩🇪

Studio Usher 🇺🇸

Credits&Commentary

PLATINUM WINNERS:

34 ART THINKING & DESIGN THINKING
Design Firm: Kiyoung An Graphic Art Course Laboratory | Designer: Kiyoung An
Client: Kindal University, Department of Arts

35 THE MOSQUITO COAST, KEY ART | Design Firm: The Refinery
Designer: Michael Andrews | Client: Apple TV+
Assignment: Our project was to create a new poster for Season 2 of Apple TV+'s Mosquito Coast. The first season was a suspenseful, fast paced thriller, whereas Season 2 is more of a slow burn, more akin to a character study about a family falling apart. We needed to create a poster that echoed the change of pace, as well as the surreal quality of the show.
Approach: We dove into the deeper ideas of disillusionment and violence by juxtaposing the markings of a skull on a monarch butterfly. Normally, moths are associated with death and butterflies with rebirth, and in our poster we flipped that idea to create something new. However, in keeping with the sinister tone of a family on the run, the butterfly is trapped in a spider's web - symbolizing that no matter how far the family runs - they can't hide from their fate.
Results: The result was a gorgeous and engaging piece of artwork. Our client was over the moon and the feedback about the artwork was top notch.

36 MUSIC REACTIONS EVENT | Design Firm: Supremat
Designer: Roman Postovoy | Client: Music Reactions
Assignment: The assignment was to prepare a poster for a music event for the organizer of Music Reactions.
Approach: This poster was designed to promote a dark tech event and featured another unique blend of 2D and 3D graphics. The immersive atmosphere of the poster was achieved by combining different textures and gradients to create a sense of depth and movement in the design. The typography used in the poster was a mix of cyberpunk and sans-serif font styles, which added to the overall futuristic feel of the design. The balance between the two font styles created a visually appealing and modern look that perfectly matched the dark tech theme of the event.
Results: The result was a clean and attractive design that conveyed all the necessary information about the event without overwhelming the viewer with too much detail.

37 CJ BOLLAND MUSIC REACTIONS EVENT | Design Firm: Supremat
Designer: Roman Postovoy | Client: Music Reactions
Assignment: The task was to remake the existing poster of the event organizer for a fresher and more attractive design.
Approach: The poster combines abstract 3D models, unusual textures, and reflections to create a surrealistic atmosphere that speaks directly to the intended audience in such a way as to stimulate viewers' imaginations and pique their interest. By using minimalistic design, viewers are encouraged to focus on the shapes and colors instead of being distracted by too many details. The headline in red, which stands out in strong contrast against the background imagery, is eye-catching and energetic, mimicking the changing pace of electronic music beats. Various sans-serif fonts further add to the dynamic effect, creating a harmonious relationship between the design and the music. It's as if you closed your eyes for a second and imagined an association heard from the electronic music beats, where the surreal and strange imagery changes one by one as the track progresses.
Results: The poster gathered a lot of reactions from the designers, and the client was also pleased with the result.

38 RETOUR À LA NATURE; LE PETIT FESTIVAL DU THÉÂTRE, DUBROVNIK, 2022
Design Firm: Atelier Radovan Jenko | Designer: Radovan Jenko |
Client: Le Petit Festival du Theatre | Typography Design: Radovan Jenko
Photographer: Radovan Jenko | Illustrator: Radovan Jenko
Assignment: Le Petit Festival du Theatre is the festival of all arts with a focus on theatre, every year with a different theme of Festival. In 2022, the theme of the festival was ecology.
Approach: The night motif of pine trees as a typical Mediterranean scenery is covered by an inscription made of tiny pine twigs, which with its fragility speaks of the serious ecological situation in which we find ourselves.

39 AMIGOS | Design Firm: Antonio Castro Design
Designer: Antonio Castro | Clients: International Poster Biennial in Mexico, Taiwan International Student Design Competition
Assignment: To create a poster celebrating the friendship and collaboration between the International Poster Biennial in Mexico and the Taiwan International Student Design Competition.
Approach: In trying to come up with beautiful metaphors for both countries, I first ran into the image of a bird called the Taiwan Blue Magpie, its beautiful colors and the geometric pattern of its tail turned out to be the perfect symbol for Taiwanese design. I was now left with the task to find the perfect symbol for Mexico. Considering that the bird is blue, I immediately thought of the blue agave plant, this plant is not only endemic to Mexico, but it is also the plant from where Tequila comes from. Placing the Taiwan Blue Magpie resting on one of the Blue Agave leaves, was the perfect metaphor for the friendship shared by both design organizations.
Results: The exhibition of all posters was inaugurated as one of the main exhibitions during the International Poster Biennial in Mexico, the place and date of exhibition that will take place in Taipei is TBD.

40 PEARL JAM, PINKPOP '22 POSTER | Design Firm: Peter Diamond Illustration
Designer: Peter Diamond | Client: Pearl Jam / TSurt | Art Director: Chris Siglin
Assignment: For Pearl Jam's 2022 appearance at the PinkPop festival in the Netherlands, I was asked to make an image celebrating the band's long-awaited return to the festival. A strict colour budget of 6 colours, and the request to tie something in the image to the concert's locale, were the sum of the creative brief.
Approach: With the creative freedom provided, and the goal of making the most exuberant image I could, I focused on drawing mythical and folkloric imagery & symbols from my own passion projects. I researched the festival and its history for a connection between it and my visual language, and hit on a reference to the free apples given out at the first PinkPop. I imagined an ancestor of the tree bearing those apples and set my character next to it. Unexpectedly, the character (a soldier who traded weapons for instruments) took on new meaning as Russia invaded Ukraine on the day I began the final artwork. Besides the black and a shade, my 6 colour budget ended up consisting of Blue, Yellow, Red, and White.
Results: The design was well received by the band, and by the fans who bought up the whole edition very quickly. Additionally, the image was honoured with the Joseph Morgan Henninger Award for Best of Show in the Society Of Illustrators Los Angeles' annual show, Illustration West 61.

41 HAPPY INTERNATIONAL JAZZ DAY! | Design Firm: Kashlak
Designer: Ivan Kashlakov | Client: ITC
Assignment: "Jazz washes away the dust of everyday life." – Art Blakey. The assignment was to make a poster to celebrate international jazz day. Jazz is a constant flow, flow of music in the soul. A connection of the senses in an indescribable way, merging them into a unique feeling. It is a genre that continues to evolve and innovate, with artists constantly pushing the boundaries and experimenting with new styles and sounds to keep the music fresh and relevant.
Approach: My approach was to create a multidimensional bridge composition by connecting the letters of the word "JAZZ," using a vibrant and memorable color palette. The bridge symbolizes the strong foundation of jazz's rich heritage, while the audiovisual expression captures the energy and groovy mood of this music genre. This artwork represents music in motion, both figuratively and literally, and serves as a tribute to the dynamic character of jazz.
Results: The work was featured in many international exhibitions and got even in the top 20 poster design proposals for the Montreux Jazz Festival China 2022.

42 AMERICAN UNIVERSITY SYMPHONIC BAND | Design Firm: Chemi Montes
Designer: Chemi Montes | Client: American University, Department of Performing Arts

43 7TH SEAFARERS' UNION CONFERENCE | Design Firm: Šesnić&Turković
Designers: Marko Šesnić, Goran Turković | Client: Seafarers' Union of Croatia
Illustrator: Manuel Šumberac
Assignment: We need a poster design for our conference. Every 5 years, the Seafarers Union of Croatia hosts a Congress that brings together key players from Croatian and international maritime organizations. The Congress is the highest body of the Union and addresses vital topics for our seafarers: the challenges of local and international sailing, workers' rights and interests, and the promotion of the social status of workers related to maritime activities.
Approach: We combine two symbols, one for the union and one for the seafarers.
Results: Project was a big success. Goodies with the new symbol were a hit among the participants. The union is trying to find a way to change their visual identity and use the new symbol as their logo.

44 WORLD CUP 2022 POSTERS | Design Firm: Underline Studio
Designer: Fidel Peña | Client: George Brown College, School of Design
Creative Directors: Fidel Peña, Claire Dawson | Production Manager: Wali Mahmud
Printer: Flash Reproductions
Assignment: To create a series of posters for a series of viewing parties during the World Cup at the School of Design in support of the United Way.
Approach: Simple, graphic posters each in a different typeface to reflect the team represented in each of the posters.
Results: The exhibition was held in support of the work of United Way.

45 STOP WAR | Design Firm: Holger Matthies
Designer: Holger Matthies | Client: Self-initiated

46 CABINET OF CURIOSITIES TEASER POSTER | Design Firm: MOCEAN
Designer: Nathaniel Wheeler | Client: Netflix
Executive Creative Director: Kishan Muthucumaru | Associate Creative Director: Charlie Le

47 OEDIPUS | Design Firm: Mirko Ilic Corp. | Designer: Mirko Ilic
Client: JDP-Yugoslav Drama Theater | Illustrator: Mirko Ilic
Assignment: In the play Oedipus based on Greek mythology, the king of Thebes who unwittingly killed his father and married his mother. Later, when the truth became known, Oedipus, after blinding himself and went into exile.

GOLD WINNERS:

49 SLIP JOINT PLIERS PRODUCT LAUNCH | Design Firm: Traction Factory
Designers: Mike Basse, Paul Bartlett | Client: Snap-on Tools
Art Directors: Paul Bartlett, Mike Basse | Project Manager: Pam Sallis
Design Director: David Brown | Copywriters: Kirk Runke, Tom Dixon
Production Artist: Jenni Wierzba | Photographer: Ream Photography
Account Director: Shannon Egan
Assignment: Our challenge was to assist Snap-on® franchisees with bringing the new Long Nose Slip Joint Pliers to the technician market. Materials needed to emphasize the unique long, tapered nose design and three-position joint that make these pliers a must-have for any automotive technician.
Approach: In a mobile sales environment, where being the highlight of a customer's day is the key to success, we chose disruption as a way to break through and illustrate the unique features of this new product.
Results: In addition to the poster, franchisees were supported with point-of-sale and print advertising on this new product introduction. The fully evolved materials helped build sales momentum, which led to a successful product launch.

50 UNVEILED. UNBELIEVABLE. | Design Firm: Mythic | Designer: Alex-Marie Ablan
Client: Charlotte Ballet | Chief Creative Officer: Lee James

Associate Creative Director: Alexandra Frazier | Project Manager: Deanna Shuford
Photographer: Todd Rosenberg | Executive Creative Director: David Olsen
Account Manager: Emilie Boone | Account Executive: Riley McLeod

Assignment: Charlotte Ballet is known for its high caliber performances and versatile repertoire, ranging from classical ballets like the Nutcracker, to bold, contemporary works. After a pandemic-induced absence from the stage, they challenged Mythic to announce that they were back and better than ever in a bold 2022–2023 season campaign. The work needed to do two things: 1) tease the return of premier ballet in Charlotte and 2) promote the new hire of internationally acclaimed artistic director, Alejandro Cerrudo.
Approach: To unveil is to place something on public display for the first time. But how do you unveil an art form that tells a story with every subtle movement of the human body? The "Unveiled. Unbelievable." campaign captures and dramatizes the art of the reveal by cloaking the dancers in fabric. Glimpses of their bodies and the movement beyond help convey the newness to come, highlight the company's return to a full season of work, and create a series of visually striking out-of-home posters and digital ads to arrest local audiences' attention and drive ticket sales.
Results: After an almost two-year hiatus, the Charlotte Ballet saw audiences flock back to the theatre for storybook classics and modern new works. Attendance soared back to pre-pandemic levels and beyond, with audiences purchasing season tickets subscriptions in droves. Site traffic also increased, with the new photography and creative campaign driving digital views and social media engagement

51 UTAH STATE UNIVERSITY: LECTURE POSTER | Design Firm: Braley Design
Designer: Michael Braley | Client: Utah State University | Creative Director: Michael Braley
Assignment: Poster promoting Braley's lecture at Utah State University, Caine College of the Arts, for their Hashimoto Seminar design series.

52 ART SHOW AND TALK PROMOTIONAL POSTER | Design Firm: Michael Pantuso Design
Designer: Michael Pantuso | Client: Hinsdale Public Library
Assignment: Promotional Poster for Art Show and Talk in Hinsdale, Illinois.

53 PRATT INSTITUTE: LECTURE POSTER | Design Firm: Braley Design
Designer: Michael Braley | Clients: Self-initated, Pratt Institute | Creative Director: Michael Braley
Assignment: Poster promoting Braley's lecture at Pratt Institute: Spring 2022.

54 UTAH STATE TYPOGRAPHIC POSTER WORKSHOP | Design Firm: Braley Design
Designer: Michael Braley | Clients: Self-initated, Utah State University
Creative Director: Michael Braley
Assignment: Poster promoting Braley's Typographic Poster Workshop at Utah State University, Logan, Utah.

55 KINDAI GRAPHIC ART COURSE
Design Firm: Kiyoung An Graphic Art Course Laboratory | Designer: Kiyoung An
Client: Kindai University, Department of Arts

56 UMMA | Design Firm: Cold Open | Designer: Andrew Rubey
Clients: Sony, Matthew Hurwitz, VP Creative Advertising, Sony
Assignment: Umma, meaning 'mother' in Korean, is a powerful mother, daughter horror film starring Sandra Oh. Our aim was to create a piece of art that spoke to the main character's haunting past, which she must break free of in order to not follow in her mother's footsteps.
Approach: We wanted to highlight the struggle between the daughter and her controlling, evil mother by showing a darkness taking over her. Visually, her empty eyes and the masked shadow convey this darkness swallowing her identity.
Results: Client and viewers felt that creative delivered on the film's eerie nature.

57 FOR ALL MANKIND S3 | Design Firm: ARSONAL | Designer: ARSONAL
Client: Apple TV+ | Creative Director: ARSONAL | Art Director: ARSONAL
Assignment: Season 3 of For All Mankind has the exploration teams landing on Mars, so Apple wanted an iconic piece of art that highlighted where the season was going without giving away any spoilers as to which teams actually made it.
Approach: While competition and advancements in space technology open new possibilities of discovery, our heroes face a new world of unprecedented risk. We knew we needed to not just highlight Mars, but also hint at the danger that comes with it. We used a generic spacesuit to avoid any potential spoilers, and added the landscape in the reflection of the mask for a sense of place and scope. The suit then begins to break apart into dust, demonstrating the treachery of the new frontier.
Results: The art conveyed the major plot point of this season, intriguing and exciting fans and the client. It was also developed into a motion piece by our digital team that ran across digital and out-of-home paid media.

58 WATCHER, PRINT CAMPAIGN | Design Firm: The Refinery
Designer: The Refinery | Client: IFC Films
Assignment: When our clients asked us to work on this high-concept and almost atmospheric film, we were thrilled. It's not every day you get to work on a horror-thriller with groovy '70s vibes and we were here for it.
Approach: We ended up creating a series of three art pieces, one Key Art and three others as alt-posters for socials. A looming sense of dread, and the sinking feeling of being watched are the threads that connect them all.
Results: In our Key Art, a reflection of Maika Monroe is front and center, but her gaze is down. The reflection of another silhouette where her left eye should be leaves the viewer wondering just exactly who is watching who. For the "Eyes, Eyes, Eyes" social alternate, the layers of graphic eyes and Maika Monroe in the middle gives that particular piece a highly stylized '70s feel. It balances being a fun, even hip, piece with that ever looming sense of paranoia. Our final social piece almost takes on a romantic feel with the lovely cursive and soft lighting. If it weren't for Maika Monroe's harrowed look or the subtle reflection in her eye, you might know anything is amiss.

59 RENNERVATIONS | Design Firm: SJI Associates | Designer: SJI Associates
Clients: Disney Branded Television: EVP Creative Marketing – Chris Spencer,
VP Creative - Brian Everett, Director Marketing Design - Janice Wismar,
Director Marketing Production - Chris Holbrook | President: Suzy Jurist
Art Director: David O'Hanlon | Copywriter: David O'Hanlon | Main Contributor: SJI Associates
Assignment: Capture the optimistic tone, industrious protagonist, and global mission of this new series, in which actor Jeremy Renner channels his passion for building custom vehicles into improving communities around the world.
Approach: A confident and heroic portrait of Renner is set against a backdrop of auto parts and tools, communicating our host's ability to make order out of chaos and take ambitious builds, and the feeling that we're in good hands with him.
Results: The key art drove interest and awareness for the series, and was showcased in social, digital, OOH, and on-air graphics, driving tune-in and streaming views.

60 KINDERFANGER | Design Firm: Cold Open
Designer: Andrew Rubey | Clients: Crypt TV, Facebook/META
Assignment: For Kinderfänger, our goal was create compelling key art that promotes the thrilling content Crypt TV produced for Facebook/META.
Approach: Using smoke as a technique, we brought to life the eerie and hypnotizing skull-faced monster at the center of the story—one who lures children away with its evil pipe playing and steals them forever.
Results: The client was happy with the iconic key art solve and the subtle nuances of the story hidden within.

61 CARNIVAL ROW, FINAL SEASON, CHARACTER POSTERS | Design Firm: The Refinery
Designer: The Refinery | Client: Amazon Studios
Assignment: For the final season 2 of Amazon Studios' award-winning show, Carnival Row, our clients wanted to highlight the growth of our protagonists, and the destruction and chaos of their world. A challenge with any new season of a show is the need to ensure the return of existing audiences, while bringing in new audiences. This being the final season, put extra pressure to do justice to the world building of the series, and make sure the beloved characters were given a proper sendoff.
Approach: We opted for a stylized steampunk setting to give the hint of the setting, and used smoke in the background and embers in the foreground to hint at a world engulfed in flames. Philo and Vignette are in industrial settings - they're in danger and on the move. This contrasts with our ill-fated lovers, Imogen and Agreus, who are set at a port - will they finally run away together? Or is one leaving the other?
Results: Our art was well received by the client and was used all over Los Angeles as billboards and in other out-of-home settings. The level of finishing and detail on these pieces are incredible; we're super proud to have been part of this campaign.

62 ROCCO UP MOVIE POSTER Design Firm: Decker Design
Designer: Lynda Decker | Client: Ditch Plains Productions
Photographer: John Madere | Equipment: Drone camera
Assignment: Rocco Up, a documentary filmed & directed by John Madere, captures the heartfelt story of a severely autistic boy whose father taught him to surf as a non-verbal means of connecting with him. Along their journey the surf community of Montauk, NY, was instrumental in cheering him to stand "up" on the surfboard. The goal was to create a brand strategy and to promote the film to support the production's fundraising effort.
Approach: For the Rocco Up movie poster, John Madere concentrated on the technical and aesthetic aspects of the frame to capture the moment through a drone camera. Decker Design designed and curated the image to engage an audience in the emotional story while highlighting the natural beauty of Montauk—the backdrop to this tale. The film's brand identity was designed to provide visual consistency.
Results: As of October, Rocco Up was accepted into the Hamptons International Film Festival, Portland Film Festival, Toronto Film Festival, Korean International Short Film Festival and Surfalorous Film Festival. John Madere won the award for Best Documentary at the Korean International Short Film Festival and the editor and writer, Ruth Mamaril, won the award for Best Editing at the Surfalorus Film Festival. Social media has been meeting donor acquisition goals.

63 DON'T | Design Firm: Sun Design Production
Designers: Xian Liyun, Liang Gang | Client: Dcuve Art Center | Art Director: Xian Liyun
Assignment: This is a public welfare poster made to promote and protect the forest environment of the planet.
Approach: The paper cups in the poster are made of wood, which means that each paper cup used will reduce some trees. The ingenious combination of trees and paper cups reminds humans to cherish forest resources, protect the Earth's environment, and not use disposable paper cups.
Results: The final customer was very satisfied.

64 DECARBONIZE | Design Firm: João Machado Design
Designer: João Machado | Client: Unknowndesign

65 SCAD SAVANNAH FILM FESTIVAL POSTER SERIES
Design Firm: Savannah College of Art & Design | Designers: Andy Yanchunis, Jinna Lee
Client: Self-initiated | Creative Directors: Siobhan Bonnouvrier, Hadley Stambaugh
Art Director: Jennifer McCarn | Photographer: Colin Gray

66 MOVE MÓZG / U.R. TRAX | Design Firm: Ola Procak
Designer: Ola Procak | Clients: Ola Teks, Mateusz Cyryl
Assignment: One of the posters made for Move Mózg, a well known event series running from 2015, organised by Ola Teks and Cyryl and held at the club Jasna1, Warsaw. I was asked to refresh the existing key visual. My clients wanted the design to reflect cosmos and nature in up-to-date, abstract and slightly Y2K aesthetics style.
Approach: The series is based on one central object, different for each event. All objects depicted were made by me in 3D, then used on the final design. The font

used in Move Mózg logo is Arrogant by Przemysław Zięba, polish typographer.
Results: The poster was quickly implemented. It gained much attention on the local scene and made the event a promotional success. Also my clients were happy with the results. The project was featured in Digital Archive.

67 BOSTON 168 | Design Firm: Supremat
Designer: Roman Postovoy | Client: Music Reactions
Assignment: Create a poster for a musical event featuring the renowned Turin duo "Boston 168", who are known for their electrifying acid techno music.
Approach: Here, combined 3D and 2D graphics, using an acid-green color palette to create a sense of vibrancy and excitement. The poster featured abstract 3D objects that were arranged in a way that held the viewer's attention, like twisting spikes that seemed to come alive with the music. The names of the artists were also given special attention, with each one using a different font style to add a dynamic and unique feel to each artist's name. Combining all these elements created a visually stunning and impactful poster that perfectly captured the essence of the event.
Results: Combining all these elements created a visually stunning and impactful poster that perfectly captured the essence of the event.

68 GOOD WAVE | Design Firm: Tsushima Design | Designer: Hajime Tsushima
Client: "Digital Ocean" International Poster Invitation Exhibition Organizing Committee
Assignment: This is a poster for the "Digital Ocean" International Poster Invitation Exhibition. The theme of the exhibition is "Digital Ocean."
Approach: Development of marine industry better serve the comprehensive coordination and sustainable development of human society. I designed it with the meaning of riding the waves of this digital ocean.
Results: This exhibition was held in China.

69 FREE WIFI, FREE COFFEE, FREE WORK | Design Firm: Studio Lindhorst-Emme+Hinrichs
Designer: Sven Lindhorst-Emme | Client: Raum für drastische Maßnahmen
Assignment: Poster for an exhibition of an Artist-group for gallery weekend Berlin. The Design should be variable in use for other Gallery Weekend stuff like, Flyers, merch and Shuttle-Car design.
Approach: We used a patchwork of graphic shapes and many colors to meet all the requirements. Here, too, attention was paid to hierarchies of information.
Results: The design could be applied wonderfully to all other media and the poster. through color and the forms had a very strong external effect. Glued in a repeat, large areas could be advertised effectively with it.

70 AGI SPECIAL PROJECT 2022 «TOGETHER»
Design Firm: Imboden Graphic Studio | Designer: Melchior Imboden
Client: AGI Congress Trieste, Italy | Art Director: Melchior Imboden
Assignment: On the occasion of the AGI Congress Trieste, all AGI members were invited to design a poster on the theme "Together."
Approach: I was looking for a typographic solution. The individual letters are arranged in a circle and designed explicitly for this poster. The typography in the round areas is built up in a grid, coloured in different colours and connected to each other by lines. This symbolises the exchange between different cultures.
Results: It was a great pleasure to see the posters at the AGI Congress exhibition in Trieste. At the same time a wonderful exhibition catalogue was published.

71 SPIRIT OF THE SILK ROAD | Design Firm: Tsushima Design | Designer: Hajime Tsushima
Client: International Poster Design Exhibition of Silkworm Culture Organizing Committee
Assignment: This is a poster for the 1st International Poster Design Exhibition of Silkworm Culture. The creative theme is silk culture as the core, creating a lot of local cultural heritage, reflecting the values of the times, and being an excellent creative poster work that is closely related to people's lives.
Approach: I tried to express the flow of people crossing the road of the Silk Road. The Silk Road was necessary for the development of mankind. I tried to express the ties of people with silk lines.
Results: It was held from October 1st to October 15th, 2022 at Shen Ligao Agricultural Life Park Hundred Acres of mulberry garden.

72 D-SPACE | Design Firm: Dankook University
Designer: Hoon-Dong Chung | Client: Visual Information Design Association of Korea
Assignment: This poster is for the VIDAK International Winter Invitational Exhibition & Conference 2022 in Korea.
Approach: In 3D Typography, I try to convey 'D-Space', the event's main theme.
Results: The latest work.

73 DGWALTNEYART / CAROUSEL | Design Firm: dGwaltneyArt
Designer: David Gwaltney | Client: Self-initiated
Assignment: Self promotion for the The Artists Galley's January Show, "New". New work(s) that has not previously shown in the Gallery or to the general public. Carousel is a signed limited edition print on canvas created on the Apple iPad using the Procreate app.
Approach: As an exhibiting artist at the Artists Gallery in Virginia Beach, the poster was created to promote my series of signed limited edition prints of original digital paintings. All created on the Apple iPad Pro using the Procreate app.
Results: Carousel was one of 75 selected entries for the 2023 January Gallery Show "New" and it won an Honorable Mention award.

74 MUTOPIA | Design Firm: Studio XXY | Designer: Xinyi Shao | Client: Bizarrely Basic
Assignment: The boundaries between technology and humans are blurring. Technology becomes part of ourselves. There is no doubt that technology amplifies our abilities, but at the same time, we are also adapted to the logic and rules embedded in these tools and technologies. The Mutopia exhibition aims to explore the potential of human-machine collaboration and its impact on future creativity. This poster was designed to promote the exhibition's key ideas.

Approach: Drawing from the machine learning image data, the pattern was created by the code. By layering many different elements, this approach inspires viewers to consider possibilities beyond our traditional creative methods.
Results: Received positive feedback from the client.

75 COSMO | Design Firm: Tsushima Design
Designer: Hajime Tsushima | Client: Visual Information Design Association of Korea
Assignment: This poster is for the International Winter Invitational Exhibition & It's for Conference. This exhibition is about design, collaboration, exchange of designs with artists, countries and design associations.
Approach: I expressed the beauty of Cosmo and the infinite breadth.
Results: It was held from December 3rd to December 11th, 2022 at Dongdaemun Design Plaza (DDP) Museum - Desian Pathway.

76 FUTURE FORWARD | Design Firm: Elevate Design
Designer: Kelly Salchow MacArthur | Client: 4th Emirates International Poster Festival
Main Contributor: Kelly Salchow MacArthur
Assignment: The 4th Emirates International Poster Festival invited 100 designers to represent "a future-oriented and human-centric plan that calls for investments in the future and improving quality of life."
Approach: The concept of Future Forward was developed as a bold typographic statement, that embeds UAE in stylized letterforms that are unified with the progressive line intervals.
Results: The poster was chosen to be featured on the exhibition catalog cover.

77 HANGEUL BY GENIUS POET YI SANG | Design Firm: Gallery BI
Designer: Byoung il Sun | Client: Ministry of Culture
Assignment: This is a commemorative poster that interprets the world of genius poet Yi Sang in Korean. It is a concept that embodies the imagination of artists who worked as architects, painters, and poets while building a creative spiritual world. It is a poster design that focuses on the formativeness of Hangeul, which is unrivaled in many of his poetry worlds.
Approach: This is a poster that tried the Hangeul, space, and architectural image of Yi Sang, who achieved innovation in the world of Korean poetry.
Results: Hosted by Korea's Ministry of Culture, it commemorates his world of poetry and pays homage to the world of art.

78 DESIGNERS FOR PEACE | Design Firm: Hansung University, Design & Arts Institute
Designers: Hyo-Bin Park, Yeong-Hyun Gwan
Client: Graphis Designers for Peace Poster Competition
Assignment: Graphis Designers for Peace Poster: united with Ukraine Asia Traveling Show in Seoul.
Approach: The cries of designers wishing for peace in Ukraine.

79 THAT PHOTO SCHOOL AWAKEN SHOW | Design Firm: MARK
Designer: Mark Baker-Sanchez | Client: That Photo School | Art Director: Mark Baker-Sanchez
Director: Justin Clemons | Typefaces: FreightDisplay Pro, designed by Joshua Darden from Darden Studio, Nautica, designed by Giuseppe Salerno from Resistenza, Helvetica, designed by Max Miedinger and Eduard Hoffmann | Printer: Coupralux | Photographers: Paola Monreal, Lauren Levi, Korena Bolding Sinnett, Justin Clemons, Victoria Gomez, Molly Poluc
Photography Studio: FLOCC | Logo Designer: Mark Baker-Sanchez
Assignment: That Photo School — TPS — was re-launching their annual advanced member showcase, which had come to a halt due to the pandemic. They wanted to come back with a bang and did not want the event to be seen as a "student photography" show, but instead as a professional and high-level exhibit.
Approach: TPS needed visuals that would elevate the work and captivate the community, with the goal of driving foot traffic primarily within the professional visual communications scene. The concept for the show was "Awaken" and the members created work centered around this idea. The final design presents the member's work as nothing short of exquisite. A custom mark was hand drawn and then customized in Illustrator. A bespoke poster system was crafted to accommodate and shift around selected photography that would be in the show.
Results: The poster designs caught the attention of various professionals in the creative field and the broader visual arts scene in the Dallas/Fort Worth area. It also caught the attention of professional creative organizations including Where Are the Black Designers? and the Dallas Society of Visual Communications. There was high foot traffic of 500+ attendees to the event space at FLOCC on the night of the event. This led to exhibiting photographers to sell high volumes of work to patrons with some members selling out completely. Most importantly, this led to increased acquisition for the TPS Fall/Winter sign up period.

80 TOLERANCE | Design Firm: Tsushima Design
Designer: Hajime Tsushima | Client: Tolerance Poster Show
Assignment: This is a poster for the Tolerance Poster Show, which travels around the world. Each poster had to include the word "tolerance" in the artist's native language. The typography in the middle depicts the meaning of tolerance using Japanese kana. I also expressed tolerance in the image of the whole poster.
Approach: The country where I live, Japan, has three types of characters: hiragana, katakana, and kanji. I used hiragana in the middle of this poster, and kanji on the left and right sides of the poster. In this way, it is characteristic that there are three types of characters, and different images can be expressed.
Results: The Tolerance Poster Show has been held in many countries and regions so far, and many people have seen it. I think it's a very worthwhile show to be able to see the unique design power of designers from various countries.

81 FACE TO FACE | Design Firm: Tsushima Design
Designer: Hajime Tsushima | Client: International Osaka Poster Fest
Assignment: This is a poster exhibited at OSAKA POSTER FEST2022 Virtual Poster Exhibition. The theme is FACE.

Approach: Due to Covid19, people had to cover their faces with masks. I think that communication can be measured only when we face each other face to face. I represented this graphically.

Results: From November 18, 2022, the virtual exhibition was held. The exhibition was a success with 64 designers from all over the world participating. It's virtual, so anyone can go see it anytime, anywhere.

82 VIGNELLI 90 POSTER | Design Firm: Underline Studio
Designer: Fidel Peña | Client: Vignelli 90 Poster Exhibition
Creative Directors: Fidel Peña, Claire Dawson | Printer: Flash Reproductions

Assignment: To create a poster to celebrate the work and legacy of Massimo Vignelli for an exhibition organized by Vignelli 90.

Approach: Más Massimo, which translates as More Massimo celebrates the desire to always have more, and never enough of Vignelli's work in our lives.

Results: The exhibition was held in Montevideo, Uruguay.

83 BLONDE - VENICE FILM FESTIVAL ART | Design Firm: Leroy & Rose
Designer: Leroy & Rose | Client: Netflix

Approach: For the Venice Film Festival, we created a poster that resembles a vintage Italian magazine cover, with Ana de Armas as Marilyn Monroe holding a sign with the festival premiere date.

84 TÁR - PAYOFF POSTER | Design Firm: AV Print | Designer: AV Print
Clients: Focus Features, Blair Green, SVP Creative Advertising and Head of Brand Design,
Marcus Kaye, VP Creative Advertising & Marketing

Assignment: This film was truly an experience, one we were not fully prepared to take on until we were able to screen the film in a full theater setting.

Approach: In the absence of any unit photography, Todd Field and Focus Features provided us with a limited selection of stunning frame grabs from the film itself. We knew that type design would help us out a lot, so we settled on a big and bold lockup of the credits. By placing it on black and pushing her fingertips to the absolute edge of the frame, we were able to give the image all the space it needed to show the power of this moment.

Results: Despite not seeing Cate Blanchett's face, the intensity of her character still bursts off the page. What better way to showcase such an unexpected film than from an equally unexpected angle?

85 BLONDE | Design Firm: Leroy & Rose | Designer: Leroy & Rose | Client: Netflix

Approach: A close up headshot of our Marilyn Monroe highlights her beauty, while a wisp of blonde hair subtly references the film's title. The copy line "Watched by all, seen by none" further suggests elements of vulnerability and pervasiveness.

86 SILENT TWINS | Design Firm: ARSONAL | Designers: ARSONAL, FOCUS FEATURES
Clients: FOCUS FEATURES, Blair Green, SVP Creative Advertising and Head of Brand Design
Marcus Kaye, VP Creative Advertising & Marketing Deanna Shiverick, Coordinator Creative
Advertising Evie Kennedy, Assistant Creative Advertising | Copywriter: ARSONAL
Main Contributors: ARSONAL, FOCUS FEATURES

Assignment: Representing the true story of the Silent Twins respectfully and beautifully was the main goal of this campaign. In order to do so, it was our job to balance realism with whimsy, dark thematic undertones with symbols of light and positivity, all while conveying the severity of the story without turning audiences away.

Approach: Palette, treatment, photography and selection of expressions were our major tools in creating this piece of key art. While many of the color hues are darker, we softened the art overall. It was through balancing techniques such as this we were able to explore the light and darkness of their story. The central device offers a unique approach in uniting and separating the twin's faces simultaneously while the symbols inside integrated with the type hinted at the sometimes chaotic and confusing nature between them.

Results: The client was so pleased with our presentation, it was difficult for them to select just one approach. However, they felt this piece of art was the best overall interpretation of balance across the board to drive viewership.

87 THE OUTFIT - PAYOFF POSTER | Design Firm: AV Print | Designer: AV Print
Clients: Focus Features, Blair Green, SVP Creative Advertising and Head of Brand Design,
Marcus Kaye, VP Creative Advertising & Marketing

Assignment: This was an incredibly fun project to jump into with Focus Features.

Approach: The challenge with the payoff became creating a dynamic piece with tension and intrigue without tipping audiences off to the film's climactic twist. By employing the shears as an integral piece of the art – we were able to deliver on the title as well as divide our cast in a very interesting way.

Results: The groupings invite audiences to consider where the lines will be drawn, and who will be on the same side at the film's conclusion.

88 DEMONIC PAYOFF POSTER | Design Firm: MOCEAN | Designer: Jason Low
Client: IFC Films | Executive Creative Director: Kishan Muthucumaru
Associate Creative Director: Robert Dunbar

**89 TASTY BACON BITS WITH CREAMY CHUNKS OF CHEDDAR CHEESE FOR
SAUSAGE LOVING DUDES AND DUDETTES** | Design Firm: Michael Pantuso Design
Designer: Michael Pantuso | Client: BOBAK Sausage Company | Writer: Mike Meyers

Assignment: The BOBAK Sausage Company has been a favorite brand of Chicago for over 50 years. In 2023, BOBAK'S is adding a line of Craft Chicken Sausages to their traditional line of pork and beef products. This new line is called "Stan's Secret Stash" and represent a new brand and new approach. To mark their distinction and express the brands disruptive personality, Stan Bobak asked Michael Pantuso Design to create packaging and marketing that is intensely enthusiastic. Each flavor has it's own personality and original artwork. Shown here are the poster expressions for this flavor profile.

Approach: Digital Illustration.

**90 SEND YOUR TASTE BUDS SOUTH & WEST, THEN BITE INTO THE GUMBO OF
CHICKEN SAUSAGE** | Design Firm: Michael Pantuso Design
Designer: Michael Pantuso | Client: BOBAK Sausage Company

Assignment: The BOBAK Sausage Company has been a favorite brand of Chicago for over 50 years. In 2023, BOBAK'S is adding a line of Craft Chicken Sausages to their traditional line of pork and beef products. This new line is called "Stan's Secret Stash" and represent a new brand and new approach. To mark their distinction and express the brands disruptive personality, Stan Bobak asked Michael Pantuso Design to create packaging and marketing that is intensely enthusiastic. Each flavor has it's own personality and original artwork. Shown here are the poster expressions for this flavor profile.

Approach: Digital Illustration.

**91 THERE'S ALWAYS ROOM TO DO MORE SHROOMS! ESPECIALLY WHEN THEY'RE
BIG, MEATY, FLAVORFUL PORTOBELLO MUSHROOMS—AT THE TOP OF THE
MUSHROOM FOOD CHAIN** | Design Firm: Michael Pantuso Design
Designer: Michael Pantuso | Client: BOBAK Sausage Company | Writer: Mike Meyers

Assignment: The BOBAK Sausage Company has been a favorite brand of Chicago for over 50 years. In 2023, BOBAK'S is adding a line of Craft Chicken Sausages to their traditional line of pork and beef products. This new line is called "Stan's Secret Stash" and represent a new brand and new approach. To mark their distinction and express the brands disruptive personality, Stan Bobak asked Michael Pantuso Design to create packaging and marketing that is intensely enthusiastic. Each flavor has it's own personality and original artwork. Shown here are the poster expressions for this flavor profile.

Approach: Digital Illustration.

92 MEXICAN-INSPIRED SAUSAGE THAT WILL MAKE YOUR TASTE BUDS SING
Design Firm: Michael Pantuso Design | Designer: Michael Pantuso
Client: BOBAK Sausage Company

Assignment: The BOBAK Sausage Company, makers of Polish Sausage and Deli Meats has been a favorite brand of Chicago for over 50 years. In 2023, for the first time in their history, BOBAK'S is adding a line of Craft Chicken Sausages to their traditional line of pork and beef products. This new line is called "Stan's Secret Stash" and represent a new brand and new approach. Created from Stan Bobak's personal favorites, made for decades and kept only to himself, family and friends are becoming available to the public. Inspired by bold, unique flavors, craft made in small batches, and all natural (clean label). These are the highest quality offering in the category. To mark their distinction and express the brands disruptive personality, Stan Bobak asked Michael Pantuso Design to create packaging and marketing that is intensely enthusiastic. Each flavor has it's own personality and original artwork. Shown here are the poster expressions for this flavor profile.

Approach: Digital Illustration

93 ARTIFICIAL PLANTS: A BOTANIC GARDEN | Design Firm: DAEKI and JUN
Designer: Daeki Shim | Clients: Sikmulgwan PH Gallery, Design Magazine CA (Korea)
Creative Director: Daeki Shim | Art Director: Daeki Shim

Assignment: Artificial Plants: A Botanic Garden

Approach: Artificial Plants: A Botanic Garden

Results: Artificial Plants: A Botanic Garden

94 LANGUAGE ERUPTIONS | Design Firm: Ariane Spanier Design
Designer: Ariane Spanier | Client: Klassikstiftung Weimar

Assignment: The poster series is part of a bigger typographic project including sculptures, installations and exhibitions about language by the Klassikstiftung Weimar. The 3 posters show quotes of German poets Johann Wolfgang von Goethe ("We all sleep on volcanos"), Friedrich Schiller ("The forever yesterday") and Christoph Martin Wieland ("Where is the truth?") on societal and political issues. The posters were offered for free pick up for visitors of the exhibition.

Approach: The quotes were typographically designed with distorted and tilted typography for the "Year of Language 2022", designed by Ariane Spanier.

Results: The posters were taken by the visitors quickly, assuming they were enjoyed.

95 DESIGN | Design Firm: João Machado Design
Designer: João Machado | Client: Unknowndesign

96 WHETŪRANGITIA/MADE AS STARS | Design Firm: Extended Whānau
Designers: Toaki Okano, Charles Dolbel, Max Quinn-Tapara, Tyrone Ohia
Client: Dowse Art Museum | Photographer: Eva Charlton

Assignment: Whetūrangitia/Made As Stars is an exhibition of contemporary Indigenous artists from around the world at The Dowse Art Museum in New Zealand. The show explores the real-time lived relationships first cultures have with their gods.

Approach: A striking poster was needed to reflect the exhibition's Indigenous futurism themes. Working with crafts people, we created a balloon sculpture that reflected a system of galaxies, indigenous patterning, and humankind simultaneously.

Results: The final poster collides traditional motifs with new material applications to create a striking take on Indigenous futurism.

97 RESTART - MONTREUX JAZZ FESTIVAL 2021 | Design Firm: Primoz Zorko
Designer: Primoz Zorko | Client: Montreux Jazz Festival

Assignment: The iconic Montreux Jazz Festival has returned after a year of hiatus due to the covid pandemic, issuing an open call for posters that would announce and celebrate the 'Restart' which was the theme of the 2021 edition.

Approach: The poster sought to offer a message of hope. Showing the first bloom in the spring singing the song of a new beginning. It represents a vision of a world as it starts back up.

Results: The poster was not chosen as the official image of the 2021 edition of the festival but it was part of the showcased and published selection as well as part of some poster exhibitions.

98 FALL FOR JAZZ | Design Firm: Chemi Montes
Designer: Chemi Montes | Client: American University, Department of Performing Arts

99 PHILADELPHIA YOUTH ORCHESTRA ANNUAL FESTIVAL CONCERT POSTER
Design Firm: Paone Design Associates | Designers: Gregory Paone, Joshua Bankes
Client: Philadelphia Youth Orchestra | Creative Director: Gregory Paone
Typographer: Gregory Paone | Typeface Designer: Gregory Paone
Photographers: Gregory Paone, Joshua Bankes
Assignment: The Philadelphia Youth Orchestra commissioned Paone Design Associates to produce its Annual Festival Concert Poster Series. This year, the PYO repertoire included Bela Bartok's "Concerto for Orchestra." This concerto, presenting its various "solo voices," provided inspiration for the poster's primary artwork. As each of five virtuosic instrumentals are featured throughout the musical composition, so too are woven the corresponding visual references in the poster; held in unity with a bold overarching typographic base. In addition to the photography, PDA created the orchestra's proprietary typeface which is utilized as a display font in the posters and program books.
Results: This communication was well received in both print and digital media applications, resulting in increased ticket sales and performance attendance.

100 WYNTON MARSALIS SUMMER TOUR | Design Firm: Paul Rogers Studio
Designer: Paul Rogers | Client: Wynton Marsalis Enterprises
Assignment: Wynton called and asked for a poster to promote a series of summer concerts in New England.
Approach: I drew Wynton in a modernist summery landscape, I know he loves being on the road and I made sure to include one in the scene. The little chapel is there because music from the church can be heard in Wynton's music and sometimes his concerts have the joyful feeling of folks gathering for a service.
Results: Posters sold out at the gigs and online.

101 STAY STRONG, STAND UP, HAVE A VOICE | Design Firm: Studio Eduard Cehovin
Designer: Eduard Cehovin | Client: The International Reggae Poster Contest
Assignment: The guideline in the design was to visually describe the meaning of reggae using design elements of colour, line, dot, shape, texture, space and form. The latter are directly related to the structure of reggae. Their rhythmic relationships are detected from the counterpoint between the bass and offbeat rhythmic sections and drum downbeat.
Approach: Women, as the theme of the design, are visually expressed in a stylised image and enhanced by the use of a distinctive colour composition. The motto STAY STRONG, STAND UP and HAVE A VOICE is devoted to all reggae music women singers and women authors wherever they are.
Results: Project was very successful from my point of view.

102 GAZE | Design Firm: Scott Laserow Posters
Designer: Scott Laserow | Client: Beijing Oprea Art International Poster Biennale 2022
Assignment: Make a poster for the Beijing Oprea Art International Poster Biennale.
Approach: This hand-cut paper illustration pays homage to the traditional Chinese cut papper. Captivated by the stark white faces highlighted by the rich reds surrounding the eyes and lips of the performers was my motivation for the image. Continuing with this esthetic, I felt it was essential to handle the typography similarly. In this case, I chose to use traditional Chinese rice paper to enhance the narrative.
Results: This poster was chosen as part of the exhibition and won a special award.

103 BEIJING OPERA | Design Firm: Rikke Hansen
Designer: Rikke Hansen | Client: Beijing Opera Art International Poster Biennale
Assignment: Make a poster for the Beijing Oprea Art International Poster Biennale.
Approach: This poster is inspired by the costumes from the Beijing Opera. By photos of 3D objects and Graphic elements finaly build in adobe illustrator and photoshop. It is a tribute to the colors, the geometry, the masks, the energy and the movements. The poster is made up of all these elements in order to form a tribute figure for the viewer.
Results: Huge poster exhibition and a book published about Beijing Opera and selected posters, which this poster is a part of. The book will be published and sold all over China in 2023.

104 DIE ZAUBERIN / THE CHARMING | Design Firm: Gunter Rambow
Designer: Gunter Rambow | Client: Oper Frankfurt
Assignment: Opera by Peter I. Tschaikowski
Approach: The son of a rich family falls in love with a natural beauty.
Results: Poster for advertisement and poster pillars.

105 VOWELS | Design Firm: Wesam Mazhar Haddad
Designer: Wesam Mazhar Haddad | Client: Beijing Opera Art International Poster Biennale
Assignment: Make a poster for the Beijing Oprea Art International Poster Biennale.
Approach: Concept: Opera is a play in which the words are sung rather than spoken. The title of the poster is called "Vowels". Vowels are proper in vocal technique to help with tuning, increase airflow, decrease airflow, and drive the voice towards a "headier" resonance. Vowels are vital elements in opera signing to carry the emotion and the music." Explanation: The poster focuses on the mouth as the focal part in the operatic scheme, linking it with a famous traditional Tang Chinese lip makeup pattern called the "flower petal".The typographic font was chosen to reflect the tone of the words and to represent them as melodies rather than spoken words which is one of the core essences of the operatic play.
Results: The poster has been selected for many exhibitions around the globe.

106 ART_UNLIMITED (SERIES) | Design Firm: Hufax Arts/FJCU
Designers: Fa-Hsiang Hu, Fei Hu, Di Hu | Client: The ADLINK Education Foundation
Creative Director: Fa-Hsiang Hu | Art Director: Fa-Hsiang Hu
Assignment: The featured program of this Taiwan Traditional Opera Academy

performance festival is to travel through time, encounter the past and present, and blend East and West through a dialogue of modern style and cultural inheritance. This extends the audience's sense of time and space, not only by integrating the physical aesthetics, cultural ideas, and skills of the East and West, but also by creating a rare encounter between the two in a seemingly conflicting form.
Approach: The visual design concept is to deconstruct and reconstruct the Chinese characters for "unlimited drama" as a curtain for young people on the new stage. Using contemporary internationalist design techniques, layers of Chinese character strokes are deconstructed to create a 3-D space and relationship between performers and the stage, presenting the artistic trend and momentum of the new generation of Taiwanese performers. The symbolic roles also roam among the stage curtains, showcasing the physical movements of performance art with the aesthetic beauty of calligraphy strokes.

107 THE WORLD OF FUN IS CREATED BY THOSE WHO ENJOY IT
Design Firm: PEACE Inc. | Designer: Abe Kanta | Client: Taiyo Holdings
Assignment: A company whose main business is the manufacture and sale of chemical products mainly for the Japanese electronics industry.
It is a poster that visualizes "The world of fun is created by those who enjoy it", which is the company's catch phrase.
Approach: TAIYO Holdings was founded as a printing ink manufacturing company, later developed solder resist, entered the electronics business, and is currently involved in pharmaceuticals. We incorporated this historical flow into the design based on the slogan "The world of fun is created by those who enjoy it."
Results: The client is happy and it is a great success.

108, 109 TIJUANA INDUSTRIAL PROMOTION POSTER | Design Firm: Freaner Creative
Designer: Ariel Freaner | Clients: Ayuntamiento de Tijuana, Jorge Astiazaran
Illustrator: Ariel Freaner | Digital Artist: Ariel Freaner
Assignment: Tijuana needed a presence in San Diego and other parts of the US to promote their industrial parks capabilities and services with a limited budget.
Approach: We created the word TIJUANA formed of all the services the industrial parks can provide in Tijuana. The posters were placed in bus stops, airports, trade shows, and business centers throughout critical cities in the United States.
Results: Increase awareness and consideration of Tijuana to foreign investors.

110 BOLTBOLT NFT POSTER SERIES | Design Firm: BoltBolt
Designers: Joohyun Park, Hongming Li | Client: Self-initiated | Creative Director: Ken Chen
Assignment: Posters were made to promote BOLTBOLT and NEBULA, which is BOLTBOLT's first product. BOLTBOLT Uses the latest technology in digital art, blockchain authentication, augmented reality, precise engineering and advanced manufacturing to create products co-existing in the real life and in the meta-verse.
Approach: Our team focused on determining the themes we wanted to incorporate into our NEBULA physical and digital creations. Given that our company is a startup, we strategically utilized a 3D tool to captivate viewers and generate interest. We firmly believed that the production of 3D would offer a delightful and engaging experience for consumers. To further solidify our brand identity system, we developed a series of posters. Additionally, we integrated motion into these posters to effectively engage viewers and provide them with a visually pleasing experience.
Results: This internal project brought us immense satisfaction. The posters played a crucial role in capturing the attention of potential investors. They thoroughly enjoyed the animated posters, and even in their static form, they possessed enough allure to captivate and generate an affinity towards BOLTBOLT.

111 TRES Y CONTANDO POSTER | Design Firm: Freaner Creative
Designer: Ariel Freaner | Client: Jorge D'Garay | Art Director: Ariel Freaner
Assignment: "Tres y Contando" promotional poster.
Approach: "Tres y Contando" is a group of three women literature writers who promote their books via conferences, book readings, and book presentations. The exciting part here is the meaning of the group. The English translation is Three and counting; however, In Mexico, "Contando" translates to both "counting numbers" as well as "to tell a story." The poster represents the number three, diverse colors, and a speech bubble for storytelling.
Results: Increase in brand recognition, event attendance, and book sales.

112 SHE STOOD FIRM | Design Firm: Studio Garbett
Designer: Paul Garbett | Client: Woman, Life, Freedom
Assignment: I was invited to contribute to the protest movement for women in Iran. 'Woman, Life, Freedom' is a slogan used to promote gender equality and women's rights. The resulting posters will be compiled into an exhibition.
Approach: This work is dedicated to Mahsa Amini who was beaten to death by the morality police for violating a law about wearing head scarves.

113 BALLOONS ARE TRASHY | Design Firm: Arcana Academy
Designer: Brad Palm | Client: Balloon Brigade | Photographer: Shawn Michienzi
Chief Creative Directors: Shane Hutton, Lee Walters
Assignment: What goes up, must come down. That's why our oceans are awash with balloons. Their strings, often fishing line, make them the number one killer of seabirds worldwide. They kill dolphin, that mistake them for jellyfish, and whales, that scoop them up unknowingly. It's a bad situation, but entirely preventable.
Approach: People love balloons. The emotional connection people have with balloons prevents them from seeing balloons as what they become when they land in the ocean, litter. For this campaign we needed a strong, simple concept executed impactfully enough to shake people from their emotional connections to balloons and see them as what they become once released, garbage. To do this we shot beautiful of balloons depicted as other types of litter that people could not imagine throwing in the ocean. We then placed them in front of original photography of ocean vistas shot by renowned photographer, Shawn Michienzi. We paired the

resulting imagery with a simple, memorable line designed to change perceptions around behavior. "Releasing balloons is trashy."

Results: The campaign goes a long way to make Balloon Brigade look professional, polished, and established. This is critical in a market like the United States where there is widespread skepticism regarding non-profit start-ups. The cultural impact is being felt. Awareness is up. Balloon Brigade has received letters of appreciation and requests for new chapters from several coastal areas around the country. One-time donations are at an all-time high. And corporate partners have started conversations about longer-term partnerships. Several thousand balloons have been removed from the ocean and one can only imagine how many seabirds and other wildlife has been spared horrible deaths.

114 ISLE | Design Firm: Hoyne | Designers: Jillian Clinch, Elliott Pearson
Client: Mirvac | Creative Director: Nichole Trionfi | Copywriter: Matt Ellis
Account Directors: Katrina Legge, Michelle Thai

115 THE CAPITOL RESIDENCES TORONTO | Design Firm: IF Studio
Designer: Hisa Ide | Client: Madison Group | Design Director: Hisa Ide
Creative Strategist: Sarah Tan | Creative Director: Toshiaki Ide
Photographer: Athena Azevedo | Managing Partner: Amy Frankel
Digital Artist: Magnus Gjoen | Account Director: Anya LaLonde

116 HELP UKRAINE | Design Firm: Carmit Design Studio | Designer: Carmit Makler Haller
Client: Graphis Designers for Peace Poster Competition | Photographer: Adobe Stock
Assignment: The first thing that came to my mind when invited to take part in the "designers for peace" competition, was the Ukraine people calling desperately for help, yet the world has done nothing since.
Approach: The perfect image to convey this message of help are two hands—one reaching out for help and the other pulling it upwards for salvage. The hands carry the colors of the Ukraine flag.
Results: A simple yet impactful poster with great reivews so far.

117 DESIGNERS FOR PEACE CALL FOR ENTRIES: RUSSIA, STOP THE KILLING!
Design Firm: Studio Hinrichs | Designers: Kit Hinrichs, Carrie Cheung
Client: Graphis Designers for Peace Poster Competition | Creative Director: Kit Hinrichs
Assignment: Raise awareness for the people of Ukraine and support relief efforts.
Approach: In collaboration with Graphis' B. Martin Pedersen, Studio Hinrichs organized this call for poster entries and created this poster not only to express our outrage at the war in Ukraine, but also to spark creative action from designers around the globe. We superimposed the Matryoshka doll onto a grenade to highlight the contrast between the Russian toys and the destructive actions of the Russian government. The proceeds from the sale of this poster, entries into the competition, and subsequent exhibition went to non-profits supporting the Ukrainian people.
Results: Entries came from over 300 designers from more than 30 countries. Multiple exhibitions have been organized in the United States and abroad.

118 NO WAR | Design Firm: Tsushima Design
Designer: Hajime Tsushima | Client: Peace-Loving Innovators of Nations
Assignment: It's been four months since the war between Ukraine and Russia began. I watch it on TV every day. I really hurt my heart. Why should we fight? Why do we have to wage a war that involves the general public? I want you to finish it as soon as possible. I think most people in the world are screaming.
Approach: I expressed the cry of people all over the world. No War. No Bomb. Cry For Peace. So far, various places in Ukraine have been blown up. Every time I want to scream. I want these posters to resonate with me.
Results: I hope the war will end soon. Stop destroying everyone's happiness.

119 MORE PEACE PLEASE | Design Firm: Namseoul University
Designer: Mi-Jung Lee | Client: Ministry of Unification | Professor: Mi-Jung Lee
Assignment: A large number of birds symbolizing peace and wishing for peace gather together to form partly a person, and the shape is a poster composed and expressed as another large person. The message is that if people work for peace, they will also find peace.
Approach: The poster embodies the expectation effect that peace is life and life.
Results: It has fully conveyed its function as a poster that informs many people of the value and importance of peace and induces interest.

120 PUTIN: FALSE | Design Firm: Roger@Wong.Digital | Designer: Roger Wong
Client: Graphis Designers for Peace Poster Competition | Illustrator: Roberto Vescovi
Assignment: When President Vladimir Putin of Russia invaded Ukraine in February 2022, along with the rest of the world, I was appalled. Sparked by Graphis' call for entries in the Designers for Peace competition, plus a strong desire to do something, I was reminded of a segment on Putin from "Last Week Tonight with John Oliver," where they show clips of everyday Russians falling prey to propaganda and worshipping Putin like a mega-celebrity. This project aimed to point out to the Russian people that they are revering a fraud, a false god.
Approach: The biblical story of the Golden Calf was the perfect allegory for what I wanted to convey. I found 3D artist Roberto Vescovi online and collaborated with him to sculpt the bust of Putin. We made him look angry and menacing, the opposite of what the press reveals to the Russian public. The image was released online on social media and submitted to the Graphis competition. In addition, I reached out to a printer in Kyiv and had them print copies and post them in the city. I had a small run screen-printed using blue, red, black, and metallic gold inks.
Results: The poster did not win anything in the Graphis competition. But I was happy that it was well-received in Ukraine. Photos of the digital image, the screen print, and the versions posted in Kyiv are included in this entry.

121 WOMAN, LIFE, FREEDOM | Design Firm: BEK Design | Designer: Bülent Erkmen
Clients: Morteza Majidi, Movement for Women of Iran

122 TOLERANCE | Design Firm: Bruketa&Zinic&Grey | Designer: Davor Bruketa
Client: The Tolerance Project Inc. | Drawing: Domagoj Sokcevic
Assignment: The Tolerance Project Inc. invites designers like Davor Bruketa from all over the world to create a poster illustrating their take on tolerance.
Approach: Tolerance requires empathy, intelligence, bravery and strength.
Results: The Tolerance Project has organized poster exhibitions across the world and to date has put on 139 exhibitions in more than 40 countries worldwide and has brought a message of inclusion and acceptance to over 40.000 people. The "Tolerance" Poster Show was thus held at Times Square in NYC, in Dubai, Los Angeles, at the Design Museum in London, in Reykjavík, Helsinki, Toronto, Beijing, during the Berlin Design Week and at the Library of Art History (Kunstbibliothek Berlin), in Madrid and many other cities.

123 HOPE | Design Firm: Yossi Lemel
Designer: Yossi Lemel | Client: 4th Bloch Ukraine

124 CEASEFIRE IN UKRAINE | Design Firm: Harris Design | Designer: Jack Harris
Client: Graphis Designers for Peace Poster Competition
Assignment: Designed for the Graphis Designers for Peace poster invitational, it was completed too late for submission. I am concerned for the innocent people of Ukraine. The circumstances compel me to create different messages to express my deep concern for people, particularly children. This idea was expressed in two different solutions. The second version of this idea was submitted to the competition (included in the exhibit and recognized with a merit award). This version had been my first idea, and as I explored various options, I settled on another solution, which I decided later was not the best.
Approach: I completed multiple versions of the poster. I was concerned that Ukraine's country's shape would not be recognizable in the original version of this poster. It was smaller, and the type was more prominent in relation to the "burn graphic." I later realized I could improve the design by making the country's shape much larger. As with most designers, my process is one of iteration. Sometimes the best ideas are the first ones.
Results: Too late in submitting for the Graphis competition; there has been no formal reaction to the work.

125 UKRAINE ROSE | Design Firm: Randy Clark | Designer: Randy Clark | Client: Self-initiated
Assignment: Probably like yourself, it is appalling the savagery of the Russian/Ukrainian conflict that continues to go unabated. I have done a number of posters decrying this senseless war. This is but another one.
Approach: I have a number of concepts in my head. This one just felt right.
Results: As this is self-initiated, I hope along with the other posters begging for peace, my visual voice collectively will be heard and heeded.

126 PRAY FOR PEACE | Design Firm: Dalian RYCX Design
Designer: Zhongjun Yin | Client: Mankind | Creative Director: Zhongjun Yin
Assignment: "War and Peace" is an eternal issue faced by mankind.
Approach: At present, the conflict between Russia and Ukraine continues to intensify, and the potential "nuclear crisis" under the arms race among major powers is touching Pandora's box, and the alarm bell has already sounded.
Results: "Peace" requires the common wisdom of mankind...

127 THE COST | Design Firm: Purdue University | Designer: Li Zhang
Client: Communication and Convergence of the Non-Contact Era International Conference
Assignment: Post Corvid Pandemic thinking and related issues.
Approach: The Cost: • Is to reveal multiple issues and thinking about Corvid Pandemic with layers of messages through a chained mask as a metaphor. • Heavy chains, with broken part, connected with light weighted mask • The cost of chain up a mask or the cost of broken chains with millions of deaths?
Results: The finished poster was exhibited at the 2nd International Invitation Kapidağ Visual Arts Exhibition in Turkey.

128 POSTERS FOR FREEDOM | Design Firm: Anet Melo
Designer: Anet Melo (AKA Amegla) | Client: Self-initated
Assignment: Context: November 27, 2021 marks a turning point in over six decades of political oppression in Cuba. 300+ intellectuals, artists and journalists convened that day at the Ministry of Culture in Havana to demand the recognition of their rights and freedoms as citizens'; and to reject State violence, which has been carried out for years. The Cuban government institutions promised a dialogue that never happened but instead resulted in more retaliation. Cuba's much needed change depends on a more participatory citizenry with greater degree of awareness that the political and economic future of this country depends on everyone. Cuba is avid for visual stimuli that contribute to the awakening of consciousness and critical thinking at a social level. Unfortunately, producing a graphic work focused on communicating alternative ways of understanding, assuming, and rebuilding the country with the current system of government is an almost utopian task, especially from within the island. However, the growing openness to the virtual universe and specifically the impact of social networks on a growing number of Cubans on the Island opens the door to an alternative way for that civic awareness to germinate without which no political change is possible. Inspired by my home-country situation, I decided to create a series of posters with the theme of "freedom" that could initially be socialized digitally on social media, and at some point printed out and posted on the walls of all major cities in Cuba, as a fair counterpoint to more than six decades of political propaganda and demagogy to provide a visual "voice" to the frustration of the Cuban people.
Approach: These posters are inspired by and dedicated to all those who risk their freedom and their lives every day in Cuba, demanding that their voices are heard and their human rights respected. I stylistically chose to reinterpret the quintessential symbols of peace and freedom the cuban government has used for over six

decades to cynically portray an image of justice and equality to the world that's far from real. Resembling the simple and impactful nature of the silk-screen political poster art heritage of the Cuba I grew up in, this series of posters aims to expose the current events and the crude reality my people is facing under the most flagrant dictatorship in Latin America.
Results: The posters were digitally posted on various social media platforms.

129 WAR CRIMINAL | Design Firm: Code Switch
Designer: Jan Šabach | Client: Graphis Designers for Peace Poster Competition
Assignment: Poster supporting Ukraine and its fight against the Russian invasion.

130 WOMAN LIFE FREEDOM | Design Firm: Studio Garbett
Designer: Paul Garbett | Client: Woman, Life, Freedom
Assignment: I was invited to contribute to the protest movement for women in Iran. 'Woman, Life, Freedom' is a slogan used to promote gender equality and women's rights. The resulting posters will be compiled into an exhibition.
Approach: This work is dedicated to Mahsa Amini who was beaten to death by the morality police for violating a law about wearing head scarves.

131 BLOOD WILL HAVE BLOOD | Design Firm: Harris Design
Designer: Jack Harris | Client: Graphis Designers for Peace Poster Competition
Assignment: Designed for the Graphis Designers for Peace poster invitational, it needed to be completed earlier to be submitted. I am concerned for the innocent people of Ukraine. The circumstances compel me to create different messages to express my deep concern for the people, particularly the children.
Approach: The process of arriving at this solution was to thumbnail different ideas that used blood as the symbol for the conflict. The critical part of the solution was to communicate the idea that the conflict leads to the spilling of the blood of innocents on both sides. "Blood will have blood," a quote from Macbeth, reinforces the idea that war is a zero-sum game.
Results: Too late to submit for the Graphis competition; there has been no formal reaction to the work.

132 LET'S MAKE 2023 EXTRAORDINARY! | Design Firm: Goodall Integrated Design
Designer: Derwyn Goodall | Client: Self-initiated
Assignment: Create a poster that communicates "Let's Make 2023 Extraordinary!"
Approach: Let's make 2023 extraordinary by celebrating... empathy, mutual respect, friendship, courage, passion, tolerance, generosity, inclusiveness, compassion and positivity. Using bold colour, graphics and typography I wanted to communicate what is possible in 2023!
Results: Wonderful responses and replies from clients and colleagues alike.

133 LIFE. ESSENTIAL FREEDOM. | Design Firm: Marlena Buczek Smith
Designer: Marlena Buczek Smith | Client: Women, Life, Freedom
Assignment: Make a poster for Woman of Iran—Women Life Freedom movement.
Results: Fighting for Freedom.

134, 135 FLATTERY | Design Firm: Ron Taft Brand Innovation & Media Arts
Designer: Ron Taft | Client: Planet365 | Art Director: Ron Taft
Copywriter: Dylan Gerber | Typography Design: Greco/Taft
Assignment: Martin Luther King, Jr. said in one of his impassioned speeches: "We may have all come on different ships, but we're in the same boat now." Our assignment was to celebrate the idea of immigration in a fresh and artistic way.
Approach: We decided to use letterforms to represent the breadth and origin of cultures (Middle East, Eastern Europe, Asia, Africa, South America, Mexico)— from where most immigration currently emanates; thus, allowing the viewer to discover the word immigration through artistic expressions of indigenous letterforms. The pastiche of letterforms represent a general swath of the connectedness ever-present in the plight of immigrants.
Results: The poster is currently being distributed to companies and organizations that support positive immigration policies that enhance their local communities.

136 REPERESSED | Design Firm: Noriyuki Kasai
Designer: Noriyuki Kasai | Client: Osaka University of Arts
Assignment: The Osaka University of Arts Design Department stared a project named Hyper Project in 2021 to provide students opportunity to take initiatives and expand the range of their designing area. The 2nd poster festival was held online with invited artists, with the theme "Face", participants could express their brilliant ideas through their artworks regarding face covering in masks amid the pandemic.
Approach: To indicate the repression caused by the pandemic as well as inflation and climate change which we have been experiencing, my first attempt was a human face covered with hands. Then I made the eyes and mouth be sewn up to depict the deprivation of freedom to see and talk.
Results: Our actions were limited due to anti-coronavirus measures amid the pandemic, in addition to economic and environmental issues we had to face. People have to fight against repression, but learn to live in the presence at the same time.

137 UNITED WITH UKRAINE / DESIGNERS FOR PEACE
Design Firm: João Machado Design | Designer: João Machado
Client: Graphis Designers for Peace Poster Competition

138 UFC - 284 | Design Firm: PETROL Advertising
Designer: PETROL Advertising | Client: UFC
Assignment: Create a PPV Poster that features the Event / Fighter Matchups and creates a unique branded look for all Promotional Materials.
Approach: Explore layouts that highlight the Event matchups and attitude of the fighters, while use a unique/bold color to help the poster standout.
Results: The Poster drove the color/branding for the UFC 284 Event and is one of the most anticipated Fighter of the Year.

139 UFC - 275 | Design Firm: PETROL Advertising
Designer: PETROL Advertising | Client: UFC
Assignment: Create a PPV Poster that features the Event / Fighter Matchups and creates a unique branded look for all promotional materials.
Approach: Use both Fighter imagery and graphic design to highlight individual fighters as well as the Event matchups in a readable way that allows for featuring 3-fights / 6 total fighters.
Results: The Poster was a success, resonating with Fans and established the branded look/feel for the Event promotional materials.

140 PRETTY LITTLE LIARS: ORIGINAL SIN TEASER CAMPAIGN
Design Firm: MOCEAN | Designer: Elizabeth English | Client: HBO Max
Executive Creative Director: Kishan Muthucumaru | Creative Director: Nathaniel Wheeler
Associate Creative Director: Robert Dunbar

141 1923 | Design Firm: Leroy & Rose | Designer: Leroy & Rose | Client: Paramount
Approach: For the art for this prequel to Paramount Network's Yellowstone and sequel to its 1883, we aimed to showcase talent while suggesting the uncertainty of the time the characters live in.

142 OUTER RANGE KEY ART CAMPAIGN | Design Firm: MOCEAN
Designers: Robert Dunbar, Kishan Muthucumaru | Client: Amazon Studios

143 RESERVATION DOGS SEASON 2 - PAYOFF POSTER
Design Firm: AV Print | Designers: FX Networks, AV Print | Client: FX Networks
President: Stephanie Gibbons, FX Networks, Creative Director/President, Creative, Strategy & Digital, Multi- Platform Marketing | Vice President: Rob Wilson, FX Networks, VP Print Design
General Manager: Sarin Markarian, FX Networks, Senior Manager Print Design
Creative Director: Michael Brittain, FX Networks, Creative Director/SVP Print Design
Director: Lisa Lejeune, FX Networks, Production Director, Print Design
Project Director: Laura Handy, FX Networks, Project Director, Print Design
Assignment: For the second season, we were tasked to deliver on all of the attitude audiences have come to expect from these kids but at the same time remind viewers that the town that they come from really makes them who they are.
Approach: We included the large, bold wall and telephone wires one might expect from their reservation town as well as a nod to the kids hideout with the spray-painted title. Our talent sits together through the turmoil, backed by a blue sky reminding us that there is beauty wherever they may end up.
Results: Especially when seen in outdoor and extension billboard postings, when the kids pop off into the blue Los Angeles sky, this artwork gives the impression of youth and an openness to the journey ahead.

144 OUTER BANKS SEASON 3 - TEASER KEY ART | Design Firm: MOCEAN
Designer: Louis Percival | Client: Netflix | Executive Creative Director: Kishan Muthucumaru
Creative Director: Jason Low | Associate Creative Director: Charlie Le

145 LIEBE JELENA SERGEJEWNA (DEAR ELENA SERGEYEVNA)
Design Firm: Atelier Bundi AG | Designer: Stephan Bundi
Client: Theater Orchester Biel Solothurn
Assignment: Dear Elena Sergeyevna, Play by Lyudmila Razumsovskaya
Approach: In order to exchange their math work and thus ensure a good final grade, the youngsters want to extort the key to the safe from their teacher.
Results: Visual for poster, program and advertisements.

146 BEAUTIFUL QUZHOU | Design Firm: Chikako Oguma Design
Designer: Chikako Oguma | Client: Zhejiang China | Art Director: Chikako Oguma
Assignment: Poster for Tourism Promotion Poster Exhibition in QUZHOU.
Approach: I used the city's symbolic gate and typography to express imagery.
Results: I think the exhibition was a success.

147 THE YEAR OF ALABAMA BIRDING | Design Firm: Dan Cosgrove Design LLC
Designer: Dan Cosgrove | Client: Alabama Tourism | Illustrator: Dan Cosgrove
Art Director: Dwayne O'Riley | Account Director: Lee Sentell
Assignment: I was commissioned to design and illustrate a poster featuring the Alabama State bird, the Northern Flicker also known as the Yellowhammer.
Approach: We were trying to create a graphic image that celebrates the the beauty of the Yellowhammer in flight to promote birding and tourism in the state of Alabama.
Results: The poster was printed in various sizes and was well received.

148 THE OTHER SIDE OF TIJUANA | Design Firm: Freaner Creative
Designer: Ariel Freaner | Clients: City of Tijuana, Jorge Astiazaran
Digital Artist: Ariel Freaner | Art Director: Ariel Freaner
Assignment: The City of Tijuana needed to improve its image domestically and across the border with San Diego, California.
Approach: We created a series of posters promoting the image, and social acceptance of Tijuana to show the good, bright, and better side of Tijuana, such as arts, folklore, culinary arts, etc.
Results: The City of Tijuana improved tourism traffic and image.

149 TAO TE CHING | Design Firm: TOTHEE Design
Designer: Hong Tao Yuan | Client: Shenzhen Exhibition
Assignment: Recently, I was just learning "Tao Te Ching," which stirred up my vague yearning for "Tao". This invisible, inaudible, imperceptible and untouchable "Tao", in my cognition, moves from the coarse grains of extremely low resolution to the fine grains of clear pixels at a very slow speed. So I try to express this ambiguity with the design language sense of a graphic designer, and to understand the infinite power behind "nameless", "inaction", "unaggressive", etc.
Approach: Water is the closest medium in the world to the "Tao". When we cannot understand "Tao", we can imagine and perceive water as much as possible, perceiving its shapes and ever-changing forms. I chose the Chinese character and English character of "water" as the design elements.

Results: It was an interesting attempt, but also an open proposition, with unlimited possibilities for creation.

150 HARMONY | Design Firm: Lisa Winstanley Design | Designer: Lisa Winstanley
Client: KICD Winter International Invitational Exhibition
Assignment: Represent K-Design Culture.
Approach: This poster is a multicultural experimental exploration of typography between the Hangul and the Latin alphabet. I collided and designed with both languages to show how each graphic system can be beautifully integrated. The chosen colours are to represent the bright and vibrant culture of Korea. This is a representation of two cultures harmonized in design and typography.
Results: The exhibition was held at Dongdaemun Design Plaza (DDP) in South Korea. Catalogue published and disseminated internationally.

SILVER WINNERS:
152 2023 LYCEUM FELLOWSHIP COMPETITION CALL FOR ENTRIES POSTER
Design Firm: Skolos-Wedell | Designers: Thomas Wedell, Nancy Skolos
Client: Lyceum Fellowship Committee | Photographer: Thomas Wedell
Model Maker: Thomas Wedell

152 19TH ANNUAL ARCHITECTURE + THE CITY FESTIVAL
Design Firm: Studio Hinrichs | Designers: Kit Hinrichs, Carrie Cheung
Clients: Center for Architecture + Design, AIA San Francisco
Creative Director: Kit Hinrichs

152 ZIRKULÄRES BAUEN (CIRCULAR BUILDING) | Design Firm: Atelier Bundi AG
Designer: Stephan Bundi | Client: Architekturforum Bern

152 THE FLATIRON BUILDING – 120TH ANNIVERSARY | Design Firm: May & Co.
Designer: Douglas May | Client: Self-initiated

153 SAW BASS | Design Firm: Scott Laserow Posters | Designer: Scott Laserow
Client: International Invitational Poster Exhibition: National Design Legends

153 PAULSON FONTAINE PRESS—PRINTING ART ON PAPER SINCE 1996
Design Firm: Craig Frazier Studio | Designer: Craig Frazier | Client: Paulson Fontaine Press

153 VIGNELLI LEGACY MAP | Design Firm: Christopher Scott Designer
Designer: Christopher Scott | Clients: The Vignelli Center for Design Studies, The Vignelli Archive

153 ANTON STANKOWSKI HOMAGE | Design Firm: Braley Design
Designer: Michael Braley | Client: Golden Bee Biennale | Creative Director: Michael Braley

154 DIARIO PÚBLICO. 15 ANIVERSARIO.
Design Firm: Estudio Pep Carrió | Designer: Pep Carrió | Client: Diario Público
Photographer: Antonio Fernández | Agency: Lizarraga Palau

154 GRAFFITI / CONSTRUCTIVISM 100 | Design Firm: Simon Peter Bence
Designer: Peter Bence Simon | Client: Golden Bee Biennale

154 YEAR OF THE RABBIT 2023 | Design Firm: Gravdahl Design
Designer: John Gravdahl | Client: Self-initiated

154 HARLEM URBAN DANCE FESTIVAL | Design Firm: Martin French Studio
Designer: Martin French | Client: Harlem Swing Dance Society

155 WINTER DANCE WORKS 2022 | Design Firm: Hyungjoo Kim Design Lab
Designer: Hyungjoo A. Kim | Client: Purdue Contemporary Dance Company
Photographer: Madeleine Tingting Yang

155 PUT IN PULL OUT | Design Firm: Design SubTerra
Designer: R.P. Bissland | Client: Self-initiated

155 ARTCENTER: ASK ME ANYTHING LECTURE POSTER
Design Firm: Braley Design | Designer: Michael Braley
Client: ArtCenter School of Design | Creative Director: Michael Braley

155 THE MUSEUM OF EXTRAORDINARY THINGS EXHIBITION POSTER
Design Firm: Attic Child Press, Inc. | Designer: Viktor Koen | Client: School of Visual Arts

156 DON'T BANG MY KYTCHEN. DON'T BANG DNIPRO KYTCHEN'S.
Design Firm: CCC + JC. Jacinta & Carlos | Designers: Carlos Casimiro Costa, Jacinta Costa
Client: Polytechnic Institute of Bragança

156 1 TAG 1 THEMA (1 DAY 1 TOPIC) | Design Firm: Res Eichenberger Design
Designer: Res Eichenberger | Client: Kantonsschule Baden

156 CCA DESIGN LECTURE SERIES FALL 2022 | Design Firm: Aufuldish & Warinner
Designer: Bob Aufuldish | Client: California College of the Arts, Design Division
Photographer: Bob Aufuldish

156 RUNAWAY FROM THE CITY | Design Firm: Yanming Chen
Designer: Yanming Chen | Client: Self-initiated

157 BACHELOR IN PARADISE | Design Firm: Cold Open
Designer: Courtney Camperell | Clients: ABC, Gennifer Leong, Grace Ewy, Michelle Yu

157 A SMALL LIGHT | Design Firm: SJI Associates | Designer: David O'Hanlon
Clients: National Geographic, EVP Creative - Chris Spencer, VP Design - Brian Everett,
Design Director. - Mariano Barreiro, Project Manager - Leah Wojda
President: Suzy Jurist | Art Director: David O'Hanlon | Main Contributor: SJI Associates

157 MAYFAIR WITCHES S1 | Design Firm: ARSONAL
Designer: ARSONAL | Clients: AMC, Ed Sherman, VP Brand & Design, Mark Williams SVP
Creative & Campaign Marketing, Nancy Hennings, VP Production Brand & Design
Creative Director: ARSONAL | Copywriter: ARSONAL
Main Contributors: ARSONAL, AMC

157 SOMEBODY I USED TO KNOW KEY ART | Design Firm: The Refinery
Designer: The Refinery | Client: Amazon Studios

158 LOVE, LIZZO KEY ART | Design Firm: The Refinery
Designer: The Refinery | Client: HBO Max

158 BRIAN AND CHARLES | Design Firm: Cold Open | Designer: Craig Hennie
Clients: Focus Features, Marcus Kaye, VP Creative Advertising & Marketing, Focus Features,
Evie Kennedy, Creative Advertising Assistant, Focus Features, Deanna Shiverick,
Creative Advertising Coordinator, Focus Features, Blair Green, SVP Creative Advertising and
Head of Brand Design, Focus Features

158 JERRY AND MARGE GO LARGE CHARACTER POSTERS
Design Firm: The Refinery | Designer: The Refinery | Client: Paramount+

158 WAKEFIELD | Design Firm: ABC Made
Designer: Clare D'Arcy | Client: Jungle Entertainment | Creative Director: Diana Constantini
Senior Art Director: Clare D'Arcy | Photographer: Toby Burrows | Retoucher: Nicholas Mueller
Agency: ABC Made | Agency Producer: Marina Younger | Main Contributor: Clare D'Arcy

158 TOTAL CONTROL | Design Firm: ABC Made
Designer: Clare D'Arcy | Client: Blackfella Films | Creative Director: Diana Constantini
Senior Art Director: Clare D'Arcy | Photographer: Lisa Tomasetti | Retoucher: Nicholas Mueller
Agency: ABC Made | Agency Producer: Marina Younger | Main Contributor: Clare D'Arcy

158 TRAFFICKED WITH MARIANA VAN ZELLER SEASON 3 KEY ART
Design Firm: The Refinery | Designer: The Refinery | Client: National Geographic

158 FLOOD IN THE DESERT | Design Firm: SJI Associates
Designer: David O'Hanlon | Clients: Chika Offurum, American Experience Films
President: Suzy Jurist | Art Director: David O'Hanlon | Main Contributor: SJI Associates

158 A SMALL LIGHT – CHARACTER POSTER SERIES | Design Firm: SJI Associates
Designer: David O'Hanlon | Clients: National Geographic, EVP Creative - Chris Spencer,
VP Design - Brian Everett, Design Director - Mariano Barreiro, Project Manager - Leah Wojda
President: Suzy Jurist | Art Director: David O'Hanlon | Main Contributor: SJI Associates

159 CHRIS ROCK: SELECTIVE OUTRAGE (TEASER) | Design Firm: Cold Open
Designer: Val Lopez | Clients: Netflix, Emily Jordan, Director, Creative Marketing, Netflix,
Dionne Buxton, Manager, Creative Marketing, Netflix

159 TOKYO VICE | Design Firm: Cold Open
Designer: Gardner DeFranceaux | Client: HBO

159 HOCUS POCUS 2; CHARACTER POSTERS | Design Firm: The Refinery
Designer: The Refinery | Client: The Walt Disney Studios

159 THE DROPOUT | Design Firm: Cold Open | Designer: Courtney Camperell
Clients: Hulu, Barrie Gruner, EVP, Hulu Originals Marketing & Publicity, Aaron Goldman,
EVP, Creative Marketing, ABC, Hulu & General Entertainment, Elizabeth Blalock,
Creative Marketing Lead, Hulu, Carey Billings, Associate Creative Marketing Lead, Hulu,
Trisha Choate, VP, Content Creative Marketing, Hulu, Shannon Ryan, President,
Content Marketing | Hulu & Disney General Entertainment

160 SECRETS OF THE ELEPHANTS
Design Firm: SJI Associates | Designers: Jon Lyness, Mike Stampone
Clients: National Geographic, EVP Creative - Chris Spencer, VP Design - Brian Everett,
Design Director - Mariano Barreiro, Project Manager - Maricruz Merlo
President: Suzy Jurist | Art Director: David O'Hanlon | Main Contributor: SJI Associates

160 MRS. HARRIS GOES TO PARIS (INT'L) | Design Firm: Cold Open
Designer: Anne Kelly | Clients: Focus Features, Marcus Kaye, VP Creative Advertising &
Marketing, Focus Features, Evie Kennedy, Creative Advertising Assistant, Focus Features,
Deanna Shiverick, Creative Advertising Coordinator, Focus Features, Blair Green,
SVP Creative Advertising and Head of Brand Design, Focus Features

160 LIZZO LIVE IN CONCERT KEY ART | Design Firm: The Refinery
Designer: The Refinery | Client: HBO Max | Main Contributor: The Refinery

160 CARNIVAL ROW FINAL SEASON PRINT CAMPAIGN
Design Firm: The Refinery | Designer: The Refinery | Client: Amazon Studios

161 SCHMIGADOON S2 | Design Firm: ARSONAL | Designer: ARSONAL
Client: Apple TV+ | Copywriter: Apple TV+ | Photographer: Brendan Meadows
Creative Director: ARSONAL | Art Director: ARSONAL

161 BLUMHOUSE'S COMPENDIUM OF HORROR | Design Firm: Cold Open
Designer: Kevin Wiener | Clients: MGM+, BJ Smith, SVP Creative, MGM+, Crystal Hall,
VP Brand Design, MGM+, Ryan Pitula, Art Director, MGM+, Jessica Wolf, VP Production
Management, MGM+ | Illustrator: Sam Hadley

161 THE HANDMAID'S TALE | Design Firm: Cold Open
Designer: Alex Villa | Clients: Hulu, Barrie Gruner, EVP, Hulu Originals Marketing & Publicity,
Aaron Goldman, EVP, Creative Marketing, ABC, Hulu & General Entertainment, Elizabeth Blalock,
Creative Marketing Lead, Hulu, Carey Billings, Associate Creative Marketing Lead, Hulu,
Trisha Choate, VP, Content Creative Marketing, Hulu, Shannon Ryan, President,
Content Marketing | Hulu & Disney General Entertainment

161 DYING FOR SOUP | Design Firm: PPK USA | Designer: Alan Schneller
Client: Animal Welfare Institute | Photographer: Garrett Garcia
Executive Creative Director: Paul Prato | Creative Directors: Michael Schillig, Javier Quintana
Art Director: Alan Schneller | Illustrator: Alan Schneller
Copywriter: Michael Schillig | Other: Tom Kenny, CEO

162 OPEN CITIES: WHERE ANYTHING IS POSSIBLE | Design Firm: Braley Design
Designer: Michael Braley | Clients: Self-initated, Madrid Grafica 2022
Creative Director: Michael Braley

162 REFRAME CLIMATE AWARENESS | Design Firm: Goodall Integrated Design
Designer: Derwyn Goodall | Client: Self-initiated

162 CORAL REEF PROTECTION POSTER SERIES
Design Firm: Xindi Lyu | Designer: Xindi Lyu | Client: Self-initiated

162 PROTECT MOTHERLAND | Design Firm: Purdue University
Designer: Li Zhang | Client: Florida A&M University

163 (SOS) EARTHQUAKE IN TÜRKIYE AND SYRIA | Design Firm: Studio Pekka Loiri
Designer: Pekka Loiri | Client: Giresun University Görele, Faculty of Fine Arts, Turkey
Artist: Pekka Loiri

163 NATURE CONNECTS US | Design Firm: Braley Design
Designer: Michael Braley | Client: Antachen Awards VI | Creative Director: Michael Braley

163 BOM – SPRING IS COMING | Design Firm: Rikke Hansen
Designer: Rikke Hansen | Client: Visual Information Design Association of Korea

163 GRAPHIC DESIGN EXHIBITION OF TOYOTSUGU ITOH "TO YOU"
Design Firm: Toyotsugu Itoh Design Office | Designer: Toyotsugu Itoh
Client: Nagoya Zokei University

164 YEAR OF LANGUAGE 2022 | Design Firm: Ariane Spanier Design
Designer: Ariane Spanier | Client: Klassikstiftung Weimar

164 DROP.CRACK.PUNGENT. | Design Firm: 246 Graphics.
Designer: Takashi Matsuda | Client: Shizuoka Institute of Science & Technology
Creative Director: Takashi Matsuda | Producer: Ben Nanzai
Copywriter: Takashi Matsuda | Photographer: Keita Otsuka

164 2021 TCA NATIONAL MEETING | Design Firm: Alan Rellaford Design
Designer: Alan Rellaford | Client: Train Collectors Association

164 STOP THE WAR | Design Firm: Legis Design
Designer: Mayumi Kato | Client: NM Designers Club

165 HAMAMNAME ETRAFINDA | Design Firm: Müessese
Designer: Aykut Genç | Client: M. Melih Güneş - Murathan Mungan

165 BEN SIMS MUSIC REACTIONS EVENT | Design Firm: Supremat
Designer: Roman Postovoy | Client: Music Reactions

165 INKLINGROOM | Design Firm: Ola Procak | Designer: Ola Procak | Client: Wash Electra

165 POSTER FOR ANIMAL FARM'S 18TH BIRTHDAY | Design Firm: Supremat
Designer: Roman Postovoy | Client: Animal Farm

166 YOOPER DISCOVERY STORIES: URHO CELEBRATION | Design Firm: Nordyke Design
Designer: John Nordyke | Client: Town of Crystal Falls | Illustrator: John Nordyke

166 UNDER THE SURFACE | Design Firm: Bailey Lauerman
Designer: Caitlin Viar | Client: Special Olympics Nebraska
Chief Creative Officer: Carter Weitz | Photo Retouching: Joe McDermott
Production Manager: Gayle Adams | Printer: Firespring
Copywriter: Sophia Messineo | Account Director: Jessica Jarosh

166 THE DSVC PRESENTS THE 54TH DALLAS SHOW
Design Firm: Dennard, Lacey & Associates | Designer: James Lacey
Client: Dallas Society of Visual Communication - The Dallas Show | Illustrator: James Lacey

166 25TH ANNUAL WIENERSCHNITZEL WIENER NATIONALS
Design Firm: INNOCEAN USA | Designers: Allison Inouye, Ryan Owens | Client: Wienerschnitzel

166 KIRAATHANE* BOOK FAIR | Design Firm: BEK Design
Designer: Bülent Erkmen | Client: Kıraathane Istanbul Literature House

166 WYNSIDEOUT | Design Firms: Hoyne, Premium Media
Designer: Walter Ochoa | Client: NSW Government | Creative Director: Cam Dunnet
Strategy Director: Tom Payne | Copywriter: Rachel Walton

166 WOMEN IN MOTION AT WEST BUND
Design Firm: Jihe Culture & Art Planning Co., Ltd. | Designers: Hanyue Song, Yingxuan Chen
Clients: West Bund Museum, Centre Pompidou; Kerning | Design Director: Hanyue Song

166 GARDENER'S MARKET 2022 | Design Firm: Design SubTerra
Designer: R.P. Bissland | Client: Cache Valley Gardener's Market Association
Font Designer: Rian Hughes/Sparrowhawk

167 WOHNEN 2020 (LIVING 2023) - EXPERIMENTS, EXHIBITIONS, DEBATES
Design Firm: Ariane Spanier Design | Designer: Ariane Spanier | Client: Klassikstiftung Weimar

167 STOCKADE FAIRE '22 | Design Firm: IF Studio | Designer: Hisa Ide
Client: Stockade Faire | Project Director: Christine Beattie | Design Director: Hisa Ide
Creative Director: Toshiaki Ide | Managing Partner: Amy Frankel

167 NEBRASKA STORYTELLING FESTIVAL | Design Firm: Bailey Lauerman
Designer: David Thornhill | Clients: Nebraska Storytelling Festival, Rich Claussen
Creative Director: David Thornhill | Chief Creative Officer: Carter Weitz
Retoucher: Gayle Adams

168 DUSK LL DAWN - A FUNDRAISING EVENT FOR ABORTION ACCESS
Design Firm: Claudia Chung | Designer: Hao Wen (Claudia) Chung | Client: HaiLife

168 TYPO LANTERNS / BEAUTIFUL SEOUL
Design Firm: Simon Peter Bence | Designer: Peter Bence Simon
Client: KECD (Korea Ensemble of Contemporary Design Association)

168 WARM FLOWER | Design Firm: Terashima Design Co.
Designer: Momoe Sato | Client: Self-initiated

168 DAN FAN DANCE | Design Firm: Lisa Winstanley Design
Designer: Lisa Winstanley | Client: Beijing Opera Art International Poster Biennale

169 WO[MAN] | Design Firm: Lisa Winstanley Design
Designer: Lisa Winstanley | Client: International Poster Biennial in Mexico

169 F FOR FACE | Design Firm: Dankook University
Designer: Hoon-Dong Chung | Client: International Osaka Poster Fest

169 BEAUTIFUL | Design Firm: Tsushima Design | Designer: Hajime Tsushima
Client: 2022 "Beautiful QUZHOU" Poster Design International Invitation Exhibition

169 FRAMENELLI | Design Firm: BEK Design
Designer: Bülent Erkmen | Client: Vignelli 90 Poster Exhibition

170 2122 - THE EXHIBITION OF CROATIAN DESIGN
Design Firm: Šesnić&Turković | Designers: Marko Šesnić, Goran Turković
Client: Croatian Designers Association | Illustrator: Manuel Šumberac

170 23RD GRAPHIC DESIGN BIENNALE | Design Firm: Andrea Szabó
Designer: Andrea Szabó | Client: Association of Hungarian Fine and Applied Artists

170 TRANSCENDANCE | Design Firm: MARK | Designer: Mark Baker-Sanchez
Client: Kent Barker | Creative Director: Mark Baker-Sanchez | Producer: Mark Baker-Sanchez
Printer: AlphaGraphics | Photographer: Kent Barker | Copywriter: Mark Baker-Sanchez
Typefaces: FreightBig Pro, designed by Joshua Darden from Darden Studio, Bebas Neue Pro,
designed by Ryoichi Tsunekawa from Dharma Type

170 MAPPA 150 | Design Firm: Andrea Szabó
Designer: Andrea Szabó | Client: Hungarian University of Fine Arts

171 BLACK & WHITE | Design Firm: Tsushima Design
Designer: Hajime Tsushima | Client: Design Education Committee of CIDA

171 ELUSIVE GROUNDS | Design Firm: Studio Lindhorst-Emme+Hinrichs
Designer: Sven Lindhorst-Emme | Client: Raum für drastische Maßnahmen

171 BEGINNING OF THE SPRING EXHIBITION POSTER DESIGN
Design Firm: Danyang Ma | Designer: Danyang Ma
Client: 2022 Typeface Design Exhibition and Typography Workshop

171 GOOD BOY - FAITHFUL AND TRUE | Design Firm: Ted Wright Illustration & Design
Designer: Ted Wright | Client: Furminator | Illustrator: Ted Wright

172 NO GUN NO TRIGGER | Design Firm: Hiroyuki Matsuishi Design Office
Designer: Hiroyuki Matsuishi | Client: Self-initiated

172 I'M NOT HERE TO MAKE FRIENDS | Design Firm: Studio Lindhorst-Emme+Hinrichs
Designer: Sven Lindhorst-Emme | Client: Raum für drastische Maßnahmen

172 MAKE FUTURE - UAE CENTENNIAL 2071 | Design Firm: Noriyuki Kasai
Designer: Noriyuki Kasai | Client: The Culture and Science Association

172 HORIZONTE | Design Firm: Gottschalk+Ash Int'l | Designer: Sascha Loetscher
Client: University of Zurich Archaelogical Collection

172 THE ART OF DESIRE | Design Firm: Ron Taft Brand Innovation & Media Arts
Designer: Ron Taft | Client: VOX CUPIO | Photographer: Eugene Partyzan
Logo Designer: Ron Taft | Copywriter: Ron Taft

172 BYE BYE CHINA | Design Firm: Randy Clark
Designer: Randy Clark | Client: Chen Tianlong Art Museum

172 DARKNESS AND LIGHT: A DEEP-COILED TENSION | Design Firm: Diotop
Designer: Chihiro Otsuki | Clients: National Institute of Japanese Literature, NIJL Arts Initiative
Artists: Natsuko Tanihara, Satoshi Someya | Printing: Syubisya

172 RICHTFEST – LENA SCHRAMM | Design Firm: Studio Lindhorst-Emme+Hinrichs
Designer: Sven Lindhorst-Emme | Client: Raum für drastische Maßnahmen

172 REBELLION | Design Firm: Monokromatic | Designer: Luis Antonio Rivera Rodriguez
Client: Red Interuniversitaria de Cartel | Artist: Luis Antonio Rivera Rodriguez

173 WOMAN, LIFE, FREEDOM | Design Firm: Estudio Pep Carrió
Designer: Pep Carrió | Client: Woman, Life, Freedom

173 BAW-WOW | Design Firm: Terashima Design Co.
Designer: Saki Kogenji | Client: Self-initiated

173 YOUNG VOICES | Design Firm: Andrea Szabó
Designer: Andrea Szabó | Client: Hungarian University of Fine Arts

173 DEADWOOD | Design Firm: Ryan Slone Design | Designer: Ryan Slone
Client: International Poster Biennial in Mexico

174 TIRANA INTERNATIONAL FILM FESTIVAL 2021 | Design Firm: EGGRA
Designer: Igor Nastevski | Client: Tirana International Film Festival
Design Director: Ngadhnjim Mehmeti

174 CINANIMA 2023 | Design Firm: João Machado Design
Designer: João Machado | Client: Cooperativa Nascente

174 2022 GANGWON DESIGN FESTA (GDF)_C | Design Firm: DAEKI and JUN
Designers: Daeki Shim, Hyo Jun Shim | Clients: Gangwon State / Gangwon Institute of Design
Promotion (GIDP): President Insuk Choi / Team Managers: Kyoungcheol Shin, Yongsun Choi /

Managers: Mikyung Lee, Aeri Jang, Yeongshin Seong / Assistant Manager: Kyuseong Shim
Creative Directors: Daeki Shim, Hyo Jun Shim | Art Directors: Daeki Shim, Hyo Jun Shim
Assistant Designers: Hyunjin Cho (Intern), Hangyeol Park (Intern)

174 2022 GANGWON DESIGN FESTA (GDF)_B | Design Firm: DAEKI and JUN
Designers: Daeki Shim, Hyo Jun Shim | Clients: Gangwon State / Gangwon Institute of Design
Promotion (GIDP): President Insuk Choi / Team Managers: Kyoungcheol Shin, Yongsun Choi /
Managers: Mikyung Lee, Aeri Jang, Yeongshin Seong / Assistant Manager: Kyuseong Shim
Creative Directors: Daeki Shim, Hyo Jun Shim | Art Directors: Daeki Shim, Hyo Jun Shim
Assistant Designers: Hyunjin Cho (Intern), Hangyeol Park (Intern)

175 JACQUES AUDIARD—CINÉASTE | Design Firm: Res Eichenberger Design
Designer: Res Eichenberger | Client: Kino Xenix

175 MEN PAYOFF POSTER | Design Firm: MOCEAN | Designer: Robert Dunbar | Client: A24
Executive Creative Director: Kishan Muthucumaru | Creative Director: Nathaniel Wheeler

175 HOW TO TIE A NOOSE | Design Firm: Chargefield
Designer: John Godfrey | Client: Joshua Barnett

175 AGAINST THE CURRENT | Design Firm: Célie Cadieux
Designer: Célie Cadieux | Clients: Zeitgeist Films, Kino Lorber

176 THE SKY IS EVERYWHERE | Design Firm: Leroy & Rose
Designer: Leroy & Rose | Client: Apple

176 BLACK PANTHER: WAKANDA FOREVER | Design Firm: Only Child Art
Designer: André Barnett | Client: Self-initiated

176 THE RULES OF THE GAME | Design Firm: Raphael Geroni Design
Designer: Raphael Geroni | Client: Janus Films | Art Director: Eric Skillman

176 BRATSCH (LITTLE VILLAGE) DOCUMENTARY BY NORBERT WIEDMER
Design Firm: Atelier Bundi AG | Designer: Stephan Bundi | Client: Biograph Film

177 BOXED | Design Firm: Aydada.Inc.
Designer: Shaoyang Chen | Client: Alam Singh Virk

177 DOWNTON ABBEY: A NEW ERA - BEACH TRAVEL POSTER
Design Firm: AV Print | Designer: AV Print | Clients: Focus Features, Blair Green, SVP Creative
Advertising and Head of Brand Design, Marcus Kaye, VP Creative Advertising & Marketing

177 THE TASTE OF APPLES IS RED | Design Firm: Célie Cadieux
Designer: Célie Cadieux | Client: The Match Factory

177 X TEASER POSTER | Design Firm: MOCEAN
Designer: Elizabeth English | Client: A24 | Executive Creative Director: Kishan Muthucumaru
Creative Director: Nathaniel Wheeler | Associate Creative Director: Robert Dunbar

178 CATCH THE FAIR ONE PAYOFF POSTER | Design Firm: MOCEAN
Designer: Ignacio Perez | Client: IFC Films | Executive Creative Director: Kishan Muthucumaru
Creative Director: Jason Low | Associate Creative Director: Charlie Le

178 BONES AND ALL | Design Firm: ARSONAL | Designer: ARSONAL
Clients: Metro Goldwyn Mayer Pictures, United Artists Releasing, Amy Mastriona, EVP Creative
Advertising | Art Director: ARSONAL | Creative Director: ARSONAL
Photographer: Yannis Drakoulidis

178 EVERYTHING EVERYWHERE ALL AT ONCE - JAMES JEAN ILLUSTRATION
Design Firm: AV Print | Designers: AV Print, James Jean | Client: A24

178 REJOICE IN THE LAMB | Design Firm: Chargefield
Designer: John Godfrey | Client: Doormat Pictures | Illustrator: Colin Murdoch

178 THE COOLEST CLUB | Design Firm: Yichun Lin Design
Designer: Yichun Lin | Client: Sheng-Ting (Sandy) Shen

178 SIGNIFICANT OTHER TEASER POSTER | Design Firm: MOCEAN
Designers: Robert Dunbar, Kishan Muthucumaru | Client: Paramount+

178 TYPES OF DEATH | Design Firm: Raven Mo Design
Designer: Raven Mo | Client: Self-initiated

178 CRITICAL DISTANCE | Design Firm: BEK Design
Designer: Bülent Erkmen | Client: Norgunk Film

178 SHE WILL | Design Firm: Cul-box
Designer: Wu Qixin | Client: SHE WILL

179 COCAINE BEAR - PAYOFF POSTER | Design Firm: AV Print
Designer: AV Print | Clients: Universal Pictures, Patrick Starr, EVP Creative Advertising,
Claire-Marie Murphy, VP Creative Advertising

179 VAL PAYOFF POSTER | Design Firm: MOCEAN | Designer: Jeffrey Wadley
Client: Amazon Studios | Executive Creative Director: Kishan Muthucumaru
Creative Director: Nathaniel Wheeler | Associate Creative Director: Robert Dunbar

**179 THE WORLD'S STRONGEST COFFEE - COFFEE BEAN GRENADE, BOMB & MATCH
STICK** | Design Firm: Brandon | Designer: The Brandon Creative Team
Client: Black Insomnia | Chief Creative Officer: Stephen Childress
Associate Creative Director: Jonathan Williams

179 CHÂTEAU KSARA NEW YEAR 2023 | Design Firm: Mink
Designer: Ru'a Tohme | Client: Château Ksara | Executive Creative Director: Moe Minkara
Associate Creative Director: Jessy Ghostine

180 ZUTOPIA | Design Firm: CURIOUS
Designer: CURIOUS | Client: Zuma

180 TO GO FROM VIETNAM TO BROOKLYN | Design Firm: Naoto Ono Creative
Designer: Naoto Ono | Client: Di An Di Restaurant | Illustrator: Naoto Ono
Typeface Designer: Naoto Ono

180 203_FOOD&DRINK_SERIES | Design Firm: 203 Infographic Lab
Designer: 203 | Client: Street H

180 BUDWEISER THE GREAT AMERICAN LAGER
Design Firm: Ted Wright Illustration & Design | Designer: Ted Wright
Client: Anheuser Busch | Illustrator: Ted Wright

181 DEAD ISLAND 2 - GAME INFORMER COVER | Design Firm: PETROL Advertising
Designer: PETROL Advertising | Clients: Deep Silver, Dambuster

181 REMNANT 2 - ANNOUNCE MONSTER KEY ART POSTER
Design Firm: PETROL Advertising | Designer: PETROL Advertising
Client: Gearbox Publishing San Francisco

182 SCARS ABOVE - KEY ART POSTER | Design Firm: PETROL Advertising
Designer: PETROL Advertising | Client: Koch Media

182 REVIVE | Design Firm: Elevate Design | Designer: Kelly Salchow MacArthur
Client: Message Journal | Photographer: Kelly Salchow MacArthur
Main Contributor: Kelly Salchow MacArthur

182 BECOMING A DIGITAL BEING META: NFT 2022
Design Firm: DAEKI and JUN | Designers: Daeki Shim, Hyo Jun Shim
Clients: Sikmulgwan PH Gallery, Design Magazine CA (Korea)
Creative Directors: Daeki Shim, Hyo Jun Shim | Art Directors: Daeki Shim, Hyo Jun Shim
Assistant Designer: Hyuntae Kim (Intern)

182 MASSIMO VIGNELLI 1931 – 2014 | Design Firm: Imboden Graphic Studio
Designer: Melchior Imboden | Client: The Vignelli Center for Design Studies
Art Director: Melchior Imboden

183 HAMILTON LEITHAUSER CARLYLE CAFE RESIDENCY | Design Firm: Anna Leithauser
Designer: Anna Leithauser | Client: Hamilton Leithauser

183 DUNI 2022 – EARLY MUSIC FESTIVAL "LISTENING TO THE PAST"
Design Firm: Venti Caratteruzzi | Designer: Carlo Fiore
Client: Festival Duni (Matera, Italy)

183 MINGUS 100 | Design Firm: Martin French Studio
Designer: Martin French | Client: Self-initiated

183 GIEO ALBUM POSTER | Design Firm: STUDIO DUY
Designers: Duy Dao, Hiep Hoang | Clients: NGOT, LP Music
Client Support: MINH Q.HA | Publisher: LP Music | Production Manager: Colin Tran
Photographers: Duc Viet, VIDUA Studio | Illustrator: Khim Dang
Art Director: Duy Dao | Account Director: Anh Nguyen | Assistants: Tom Huy, Thuy Nguyen

184 THE NATIONAL — LIVE IN MILWAUKEE | Design Firm: Mikey Lavi
Designer: Mikey Lavi | Client: The National | Print Producer: The Cardboard Box Project

184 PHILADELPHIA YOUTH ORCHESTRA WINTER CONCERT POSTER
Design Firm: Paone Design Associates | Designer: Gregory Paone
Client: Philadelphia Youth Orchestra | Creative Director: Gregory Paone
Typographer: Gregory Paone | Typeface Designer: Gregory Paone

184 WE WANT JAZZ, NOT WAR | Design Firm: Yanming Chen
Designer: Yanming Chen | Client: Self-initiated

185 NOAH KAHAN — LIVE IN BOSTON | Design Firm: Mikey Lavi
Designer: Mikey Lavi | Client: Noah Kahan | Client Support: Drew Simmons

185 MAN OF LA MANCHA | Design Firm: Atelier Bundi AG
Designer: Stephan Bundi | Client: Sommeroper Selzach

185 PHILADELPHIA YOUNG ARTISTS ORCHESTRA WINTER CONCERT POSTER
Design Firm: Paone Design Associates | Designers: Gregory Paone, Joshua Bankes
Client: Philadelphia Youth Orchestra | Creative Director: Gregory Paone
Typographer: Gregory Paone | Typeface Designer: Gregory Paone

185 THE FIRST HUMANS | Design Firm: Gunter Rambow
Designer: Gunter Rambow | Client: Oper Frankfurt

186 FOUR=FOUR | Design Firm: Studio Eduard Cehovin
Designer: Eduard Cehovin | Client: Beijing Opera Art International Poster Biennale

186 BEIJING OPERA INTERNATIONAL BIENNALE POSTER
Design Firm: Underline Studio | Designer: Fidel Peña
Client: Beijing Opera International Poster Biennale 2022
Creative Directors: Fidel Peña, Claire Dawson | Printer: Flash Reproductions

186 TANCREDI | Design Firm: Atelier Bundi AG
Designer: Stephan Bundi | Client: Theater Orchester Biel Solothurn

186 SWEENY TODD | Design Firm: Sun Design Production
Designer: Xian Liyun | Client: Dcuve Art Center

187 HERCULES | Design Firm: Gunter Rambow
Designer: Gunter Rambow | Client: Oper Frankfurt

187 BLUEHEN / BLOOMING | Design Firm: Gunter Rambow
Designer: Gunter Rambow | Client: Oper Frankfurt

187 ORLANDO | Design Firm: Gunter Rambow
Designer: Gunter Rambow | Client: Oper Frankfurt

187 DIE ZAUBERFLOETE / THE MAGIC FLUTE | Design Firm: Gunter Rambow
Designer: Gunter Rambow | Client: Oper Frankfurt

188 THE RHINEGOLD – ENO 2022/23 | Design Firm: Rose
Designers: Rose, Yafet Bisrat | Client: English National Opera
Copywriter: Andy Rigden | Creative Director: Simon Elliott
Photographer: TJ Drysdale | Project Manager: Joanna Waclawski

188 TOSCA – ENO 2022/23 | Design Firm: Rose
Designers: Rose, Paloma Kaluzinska | Client: English National Opera
Creative Director: Simon Elliott | Copywriter: Andy Rigden
Production Manager: Joanna Waclawski | Illustrator: Deanna Halsall

188 CARMEN – ENO 2022/23 | Design Firm: Rose
Designers: Rose, Yafet Bisrat | Client: English National Opera
Project Manager: Joanna Waclawski | Creative Director: Simon Elliott
Copywriter: Andy Rigden | Photographer: David Pineda Ovenske

188 IT'S A WONDERFUL LIFE – ENO 2022/23 | Design Firm: Rose
Designers: Rose, Yafet Bisrat | Client: English National Opera
Project Manager: Joanna Waclawski | Creative Director: Simon Elliott
Copywriter: Andy Rigden | Photographer: ZG

189 THE YEOMEN OF THE GUARD – ENO 2022/23 | Design Firm: Rose
Designers: Rose, Yafet Bisrat | Client: English National Opera
Creative Director: Simon Elliott | Copywriter: Andy Rigden
Project Manager: Joanna Waclawski | Photographer: Katinka Herbert

189 THE DEAD CITY – ENO 2022/23 | Design Firm: Rose
Designers: Rose, Yafet Bisrat | Client: English National Opera
Creative Director: Simon Elliott | Copywriter: Andy Rigden
Project Manager: Joanna Waclawski | Photographer: Iain Crockart

189 BLUE – ENO 2022/23 | Design Firm: Rose
Designers: Rose, Yafet Bisrat | Client: English National Opera
Project Manager: Joanna Waclawski | Creative Director: Simon Elliott
Copywriter: Andy Rigden | Photographer: Greg Funnell

189 AKHNATEN – ENO 2022/23 | Design Firm: Rose
Designers: Rose, Yafet Bisrat | Client: English National Opera
Creative Director: Simon Elliott | Copywriter: Andy Rigden
Project Manager: Joanna Waclawski | Photographer: Eduardo Armbrust

190 BLUEBEARD'S CASTLE | Design Firm: Scott Laserow Posters
Designer: Scott Laserow | Client: Self-initiated

190 MACERATA OPERA FESTIVAL 2022 | Design Firm: Venti Caratteruzzi
Designer: Carlo Fiore | Client: Associazione Arena Sferisterio

190 CARMEN | Design Firm: Bailey Lauerman | Designer: David Thornhill
Clients: Lyric Opera Kansas City, Greg Campbell, Deb Sandler
Creative Director: David Thornhill | Copywriter: Aaron Weidner

190 3X3 CALL FOR ENTRIES 20 POSTER | Design Firm: Hively Designs
Designer: Charles Hively | Client: 3x3, The Magazine of Contemporary Illustration

191 UD LIFESTYLE PLATFORM FOR HUMAN, SOCIETY, AND FUTURE
Design Firm: DAEKI and JUN | Designers: Daeki Shim, Hyo Jun Shim, Shin Kwak
Clients: Dongdaemun Design Plaza (DDP), Seoul Design Foundation /
President: Kyung-don Rhee / Division Director: Sangmook Rhee / Team Manager: Nari Kim /
Senior Associate: Hyewon Lee / Project Coordinators: Minji Park, Hyejin Kim, Aran Cho,
Jieun Jeong | Creative Directors: Daeki Shim, Hyo Jun Shim
Art Directors: Daeki Shim, Hyo Jun Shim

191 MOUNT TADO | Design Firm: Toyotsugu Itoh Design Office
Designer: Toyotsugu Itoh | Client: Japan Graphic Design Association Inc.

191 SEASONS | Design Firm: Carmit Design Studio
Designer: Carmit Makler Haller | Client: Self-initiated
Photographer: Adobe Stock | Digital Artists: Jorge Gamboa, Mal de Ojo

191 CASALEX | Design Firm: CASALEX
Designer: Haotian Dong | Client: Alex Beaufort

192 SCHRODINGER'S CAT | Design Firm: Dankook University
Designer: Hoon-Dong Chung | Client: Self-initiated

192 BIBLIOTECA PALERMO LIBRO/LABERINTO
Design Firm: Estudio Pep Carrió | Designer: Pep Carrió
Client: Artes Gráficas Palermo | Photographer: Antonio Fernández

192 CELEBRATE | Design Firm: Goodall Integrated Design
Designer: Derwyn Goodall | Client: Self-initiated

192 PROMOTIONAL POSTER | Design Firm: IBEX Studio
Designer: Thomas Brand | Client: Self-initiated

193 DDP NFT COLLECTING VOL. 1 | Design Firm: DAEKI and JUN
Designers: Daeki Shim, Hyo Jun Shim, Shin Kwak | Clients: Dongdaemun Design Plaza (DDP),
Seoul Design Foundation / President: Kyung-don Rhee / Division Director: Sangmook Rhee /
Team Manager: Nari Kim / Senior Associate: Hyewon Lee / Project Coordinators: Minji Park,
Hyejin Kim, Aran Cho, Jieun Jeong | Creative Directors: Daeki Shim, Hyo Jun Shim
Art Directors: Daeki Shim, Hyo Jun Shim

193 DDP NFT EXHIBITION | Design Firm: DAEKI and JUN
Designers: Daeki Shim, Hyo Jun Shim, Shin Kwak | Clients: Dongdaemun Design Plaza (DDP),
Seoul Design Foundation / President: Kyung-don Rhee / Division Director: Sangmook Rhee /
Team Manager: Nari Kim / Senior Associate: Hyewon Lee / Project Coordinators: Minji Park,
Hyejin Kim, Aran Cho, Jieun Jeong | Creative Directors: Daeki Shim, Hyo Jun Shim
Art Directors: Daeki Shim, Hyo Jun Shim

193 PEARL SPECIALTY POSTER | Design Firm: MOCEAN
Designers: Greg Soto, Robert Dunbar | Client: A24
Executive Creative Director: Kishan Muthucumaru | Creative Director: Nathaniel Wheeler

193 TEKNION PRODUCT INTRODUCTION POSTERS | Design Firm: Vanderbyl Design
Designers: Michael Vanderbyl, Tori Koch | Client: Teknion | Creative Director: Michael Vanderbyl

194 SMALL ANIMAL SHOP POSTER | Design Firm: PEACE Inc.
Designer: Mai Kato | Client: PC

194 NO NAME | Design Firm: STUDIO INTERNATIONAL
Designer: Boris Ljubicic | Client: Self-initiated

194 NMMF CONFERENCE POSTER ADVERTISING DIABETES DOLPHINS
Design Firm: Freaner Creative | Designer: Ariel Freaner
Clients: National Marine Mammal Foundation, Mike Marchesano, Steve Walker, Cynthia Smith
Digital Artist: Ariel Freaner | Art Director: Ariel Freaner

194 ZETA FREE AS THE WIND | Design Firm: Freaner Creative
Designer: Ariel Freaner | Client: ZETA | Digital Artist: Ariel Freaner

195 SUNNY | Design Firm: Love Letters
Designer: Edith Sullivan | Client: Self-initiated

195 IN THE MAKING | Design Firm: Lisa Winstanley Design
Designer: Lisa Winstanley | Client: Self-initiated

**195 COUNTY OF SAN DIEGO DEPARTMENT OF AGRICULTURE, WEIGHTS AND
MEASURES 2022 CROP ANNUAL REPORT PROMOTIONAL POSTER**
Design Firm: Freaner Creative | Designer: Ariel Freaner
Client: County of San Diego Department of Agriculture, Weights and Measures
Art Director: Ariel Freaner | Digital Artist: Ariel Freaner

195 IS IT TOO LATE? | Design Firm: Harris Design
Designer: Jack Harris | Client: Self-initiated

196 THE PASSCODE OF COVID-19 | Design Firm: Lang Xuan
Designer: Lu Ye | Client: The Light of China

196 HELP DEMOCRACY GROW. VOTE. | Design Firm: Code Switch
Designer: Jan Šabach | Client: AIGA Get Out the Vote

**196 SAN DIEGO DISTRICT ATTORNEY'S OFFICE INSURANCE FRAUD OUTDOOR
CAMPAIGN** | Design Firm: Freaner Creative | Designer: Ariel Freaner
Client: San Diego District Attorney's Office | Digital Artist: Ariel Freaner

197 ETHOS | Design Firm: Hoyne | Designers: Linda Te, Oliver Robson
Client: Central Element | Creative Director: Kirsten Gracie
Copywriter: Cam Dunnet | Photographer: Hugh Joyner

197 NEW EPPING | Design Firm: Hoyne | Designer: Elliott Pearson
Client: Riverlee | Creative Director: Nichole Trionfi | Copywriter: Matt Ellis
Artist: Mark Nesperos | Account Director: Katrina Legge

197 GUY HARVEY - THE ART OF BIG GAME FISHING | Design Firm: Brandon
Designer: The Brandon Creative Team | Client: Guy Harvey
Senior Art Directors: Colin Mulqueen, Todd Reed | Chief Creative Officer: Stephen Childress
Associate Creative Director: Dane Ogilvie | Copywriter: Aaron Carter
Account Executives: Todd Fuller, Mary Gamelin

198 DRINK, DRANK, DRUNK | Design Firm: Anolith
Designer: Gary Hilton | Client: Field and Forest Pub
Copywriter: Kaleb Hilton | Photographers: Egor Mayer, Dean Drobot

198 CITY CENTER BISHOP RANCH SUPERB TASTE POSTER CAMPAIGN
Design Firm: Vanderbyl Design | Designers: Michael Vanderbyl, Tori Koch
Client: Sunset Development | Creative Director: Michael Vanderbyl

198 STOP MURDER | Design Firm: Legis Design
Designer: Mayumi Kato | Client: Graphis Designers for Peace Poster Competition

198 RUSSIA-UKRAINE WAR | Design Firm: Daisuke Kashiwa
Designer: Daisuke Kashiwa | Client: 4th Block Association of Graphic Designers

199 WOMAN. LIFE. FREEDOM. | Design Firm: João Machado Design
Designer: João Machado | Client: Woman, Life, Freedom

199 PEACE IN UKRAINE | Design Firm: Drive Communications
Designer: Michael Graziolo | Client: Graphis Designers for Peace Poster Competition

199 UNITED FOR UKRAINE | Design Firm: Gravdahl Design
Designer: John Gravdahl | Client: Graphis Designers for Peace Poster Competition

199 MUTED | Design Firm: Marlena Buczek Smith
Designer: Marlena Buczek Smith | Client: Self-initiated

200 BROKEN WINGS | Design Firm: Purdue University
Designer: Li Zhang | Client: National Palace of Culture, Sofia, Bulgaria

200 TWITTER ON | Design Firm: Harris Design
Designer: Jack Harris | Client: Self-initiated | Photographer: Adobe Stock

200 WOMAN, LIFE, FREEDOM | Design Firm: Studio Hinrichs
Designers: Kit Hinrichs, Taylor Wega | Client: Morteza Majidi | Creative Director: Kit Hinrichs

200 BROKEN - GIVE PEACE A CHANCE | Design Firm: Toyotsugu Itoh Design Office
Designer: Toyotsugu Itoh | Client: Peace-Loving Innovators of Nations

201 POSTERS TO SUPPORT UKRAINE | Design Firm: ThoughtMatter
Designers: Masha Foya, Katalina Maievska, Yurko Gutsulyak, Mykola Kovalenko
Client: Self-initiated | Creative Director: Ben Greengrass

201 WOMAN. LIFE. FREEDOM. | Design Firm: Steiner Graphics
Designer: Rene V. Steiner | Client: Woman, Life, Freedom

201 WOMAN, LIFE, FREEDOM... | Design Firm: Gravdahl Design
Designer: John Gravdahl | Client: Invitational Exhibition

201 FUTURE FORWARD | Design Firm: Steiner Graphics
Designer: Rene V. Steiner | Client: Self-initiated

202 NO WAR FOR UKRAINE | Design Firm: João Machado Design
Designer: João Machado | Client: Ogaki Poster Museum, Japan

202 WOMEN. LIFE. FREEDOM. | Design Firm: Goodall Integrated Design
Designer: Derwyn Goodall | Client: Self-initiated

202 UNDYING ANGER | Design Firm: Toyotsugu Itoh Design Office
Designer: Toyotsugu Itoh | Client: Chubu Creators Club

202 DIALOGUE | Design Firm: Goodall Integrated Design
Designer: Derwyn Goodall | Client: Self-initiated

203 UKRAINE WAR: ONE YEAR | Design Firm: Atelier Starno
Designer: Arnaud Ghelfi | Client: Self-initiated

203 RIGHT TO MIGRATE
Design Firm: Marlena Buczek Smith | Designer: Marlena Buczek Smith
Clients: Xavier Bermudez Banuelos, International Poster Biennial in Mexico

203 THE WOMAN IN THE POSTER | Design Firm: Kashlak | Designer: Ivan Kashlakov
Clients: University of Information Technology and Management in Rzeszów, CEIDA

203 INTERNATIONAL WOMEN'S DAY 2023 | Design Firm: Yossi Lemel
Designer: Yossi Lemel | Client: Self-initiated

204 SAVE UKRAINE Design Firm: Nogami Design Office
Designer: Shuichi Nogami | Client: Self-initiated

204 R.I.P. ROE | Design Firm: Atelier Starno | Designer: Arnaud Ghelfi | Client: Self-initiated
Illustrators: Kenn Brown, Chris Wren, Mondolithic Studios

204 CIVILITAS | Design Firm: Brain Bolts
Designer: Eric Boelts | Client: Posters Without Borders

204 WOMAN LIFE FREEDOM | Design Firm: Vanderbyl Design
Designers: Michael Vanderbyl, Tori Koch | Client: Woman, Life, Freedom
Creative Director: Michael Vanderbyl

204 WOMAN_LIFE_FREEDOM | Design Firm: Atelier Radovan Jenko
Designer: Radovan Jenko | Client: Morteza Mojidi

204 YOU CAN'T CONTROL THIS | Design Firm: Anne M. Giangiulio Design
Designer: Anne M. Giangiulio | Client: Design to Raise Awareness

204 WOMAN LIFE FREEDOM | Design Firm: Ariane Spanier Design
Designer: Ariane Spanier | Client: Woman, Life, Freedom

204 WOMAN. LIFE. FREEDOM. | Design Firm: Rikke Hansen
Designer: Rikke Hansen | Client: Woman, Life, Freedom

204 BROKEN GIRLS | Design Firm: Ryan Slone Design
Designer: Ryan Slone | Client: Universidad Alianza Hispana

205 WOMAN, LIFE, FREEDOM | Design Firm: Holger Matthies
Designer: Holger Matthies | Client: Self-initiated

205 THE END | Design Firm: Kari Piippo Ltd.
Designer: Kari Piippo | Client: Ogaki Poster Museum

205 SUPPORT THE WOMEN OF IRAN | Design Firm: Brain Bolts
Designer: Eric Boelts | Client: Iranian Protests

205 BEAUTIFUL IRAN! | Design Firm: Vaziri Studio
Designer: Alireza Vaziri Rahimi | Client: People of Iran

206 DRIVE DRUNK, WAKE UP DEAD | Design Firm: Meng Lan
Designer: Meng Lan | Client: Mothers Against Drunk Driving

206 RUN | Design Firm: Bailey Lauerman | Designer: Jim Ma | Client: Lincoln Track Club
Chief Creative Officer: Carter Weitz | Production Manager: Gayle Adams
Creative Director: Casey Stokes | Account Supervisor: Natalie Hudson

206 BOWL FOR THE BRAVE 20TH ANNIVERSARY | Design Firm: PytchBlack
Designer: Andrew Yanez | Clients: ESPN Events, Lockheed Martin Armed Forces Bowl
Graphic Designers: Christine Farnsworth, Tommy Torres
Photographer Studio: Imaginary Lines

206 BOOM! BOOM! THE WORLD VS. BORIS BECKER
Design Firm: Leroy & Rose | Designer: Leroy & Rose | Client: Apple

207 PISTOL - QUEEN ART SPECIALTY POSTER | Design Firm: AV Print
Designers: FX Networks, AV Print | Client: FX Networks

President: Stephanie Gibbons, FX Networks, Creative Director/President, Creative, Strategy &
Digital, Multi-Platform Marketing | Senior Vice Presidents: Michael Brittain, FX Networks,
Creative Director/SVP Print Design, Todd Heughens, FX Networks, Creative Director/SVP Print
Design | Project Director: Laura Handy, FX Networks, Project Director, Print Design
Director: Lisa Lejeune, FX Networks, Production Director, Print Design

207 BIG SKY SEASON 3 | Design Firm: Leroy & Rose | Designer: Leroy & Rose | Client: ABC

207 ATLANTA SEASON 4 | Design Firm: Leroy & Rose
Designer: Leroy & Rose | Client: FX Networks

207 INTERVIEW WITH THE VAMPIRE | Design Firm: ARSONAL
Designer: ARSONAL | Clients: AMC, AMC+, Ed Sherman, VP Brand & Design Kevin Vitale,
SVP Creative Nancy Hennings, VP Production Brand & Design | Creative Director: ARSONAL
Copywriter: ARSONAL | Main Contributors: ARSONAL, AMC, AMC+

208 CABINET OF CURIOSITIES EPISODIC POSTERS | Design Firm: MOCEAN
Designers: Scotti Everhart, Ravi Rochanayon, Ignacio Perez, Jon Cua, Kyle Stanclift, Charlie Le,
Nathaniel Wheeler | Client: Netflix | Executive Creative Director: Kishan Muthucumaru

208 NCIS - ZIVA DAVID | Design Firm: T&P Designs
Designer: Tiffany Prater | Client: Self-initiated

208 FALSTAFF (AFTER SHAKESPEARE) | Design Firm: Atelier Bundi AG
Designer: Stephan Bundi | Client: Theater Orchester Biel Solothurn

209 TITUS ANDRONICUS | Design Firm: Mirko Ilic Corp. | Designer: Mirko Ilic
Client: JDP-Yugoslav Drama Theater | Illustrator: Mirko Ilic

209 DR. AUSLÄNDER (MADE FOR GERMANY) | Design Firm: Mirko Ilic Corp.
Designer: Mirko Ilic | Client: JDP-Yugoslav Drama Theater | Illustrator: Mirko Ilic

209 THE THREE SISTERS BY ANTON CHEKHOV | Design Firm: PosterTerritory
Designer: Olga Severina | Client: Self-initiated

209 SHAKESPEARE SERIES II | Design Firm: Marcos Minini Design
Designer: Marcos Minini | Client: Self-initiated

210 BELLISSIMA | Design Firm: Atelier Bundi AG
Designer: Stephan Bundi | Client: Theater Orchester Biel Solothurn

210 THE SKIN OF OUR TEETH | Design Firm: SpotCo | Designer: Nicky Lindeman
Client: Lincoln Center Theater | Illustrator: Mirko Ilic

210 KAFKA IN FARBE (KAFKA IN COLOR) | Design Firm: Atelier Bundi AG
Designer: Stephan Bundi | Client: Theater Orchester Biel Solothurn

210 THE BALCONY | Design Firm: EGGRA
Designer: Ngadhnjim Mehmeti | Client: The Albanian Theatre Skopje

211 KIRMIZI YORGUNLARI | Design Firm: Müessese | Designer: Aykut Genç
Client: Süleyman Arda Eminçe - Varyete Kumpanya | Author: Özen Yula

211 EVENING OF ONE ACTS | Design Firm: Andrew Sobol
Designer: Andrew Sobol | Client: Theatre at the Mill

211 YELLOWSTONE - HIGH COUNTRY BACKWOODS
Design Firm: Ted Wright Illustration & Design | Designer: Ted Wright
Client: Yellowstone National Park | Illustrator: Ted Wright

212 WONDERFULLY WILD NORTHEAST TENNESSEE | Design Firm: Creative Energy
Designer: Isaiah Harwood | Client: Northeast Tennessee Tourism Association
Creative Director: Hannah Howard | Art Director: Stacey Suarez
Account Executive: Teresa Treadway

212 203_TOURISM_SERIES | Design Firm: 203 Infographic Lab
Designer: 203 | Client: Street H

212 HOPE | Design Firm: Jillian Coorey
Designer: Jillian Coorey | Client: Typography Day

212 TYPE THURSDAY TBILISI | Design Firm: Mikhail Lychkovskiy
Designer: Mikhail Lychkovskiy | Client: Type Thursday Tbilisi
Website: https://lychkovskiy.com/

213 TPDA 30 | Design Firm: Leo Lin Design
Designer: Leo Lin | Client: Taiwan Poster Design Association

213 WHITE NIGHT | Design Firm: Thomas Kühnen
Designer: Thomas Kühnen | Client: Folkwang University of the Arts

213 A MOUNTAIN OF HISTORY | Design Firm: Taichi Tamaki
Designers: Nana Fukasawa, Miki Taguchi, Heita Ikeda, Ryota Sugahara, Taichi Tamaki
Client: SEIBIDO Co., Ltd. | Producer: Takashi Okamoto

214 UNOVIS. XXI CENTURY. #EL130 | Design Firm: Kashlak
Designer: Ivan Kashlakov | Client: Vitebsk Center for Modern and Contemporary Art

214 HABITS | Design Firm: Bernice Wong
Designer: Bernice Wong | Client: Self-initiated

214 NEW RULES | Design Firm: Hufax Arts/FJCU
Designer: Fa-Hsiang Hu | Client: ADLINK Education Foundation
Creative Director: Fa-Hsiang Hu | Professor: Fa-Hsiang Hu

**214 THE GLORY OF CENTENNIAL: EXHIBITION OF CENTENNIAL OF TAIWANESE
DESIGN HISTORY** | Design Firm: Leo Lin Design
Designer: Leo Lin | Client: NTNU, Department of Design

DESIGN FIRMS

CLIENTS/CLIENT SUPPORT

GRAPHIC, SENIOR, JUNIOR, TYPE., SET, ASSISTANT, LOGO DESIGNERS/CREATIVE TEAMS/DESIGN ASSO./DESIGN DIRECTOR

EXECUTIVE ART DIRECTORS/SENIOR ART DIRECTORS/ART DIRECTORS

DESIGN DIRECTORS/VP DESIGN/EXECUTIVE DIRECTORS/DIRECTORS

CREATIVE DIR./EX., ASSO., CHIEF, GROUP CREATIVE DIR./CHIEF CREATIVE OFFICERS/EVP CREATIVES/CREATIVE STRAT.

GROUP ACCOUNT DIR./ACCOUNT DIR./ACCOUNT MANAGEMENT/ACCOUNT MANAGERS/MARKETING MANAGERS

I am always inspired by the unique creative forum of experimentation, innovation, artistry, and surprise that poster designers provide internationally.

Viktor Koen, *Artist, Designer, & Chair, BFA Comics, BFA Illustration, SVA*

I applaud the Graphis Annual for being a messenger of empathy and communication.

Mi-Jung Lee, *Designer & Assistant Professor, Namseoul University*

PLATINUM

Antonio Castro Design
www.acastrodesign.net
6148 Loma de Cristo Drive
El Paso, TX 79912
United States
Tel +1 915 356 0775
antcastro@utep.edu

Atelier Radovan Jenko
Slovenia
design@radovanjenko.si

Chemi Montes
www.american.edu
4400 Massachusetts Ave. NW.
Washington DC, 20016
United States
Tel +1 703 864 8767
cmontes@american.edu

Holger Matthies
www.holgermatthies.com
Wrangelstraße 13
20253 Hamburg
Germany
Tel +49 40 420 2641
info@matthiesholger.com

Kashlak
www.instagram.com/ivankashlak
Kv. Razsadnika-Koniovica, Bl.
26A, Ap. 26
Sofia Sofia 1330
Bulgaria
Tel +36 0807 027 800
kashlak.art@gmail.com

**Kiyoung An Graphic Art Course
Laboratory**
www.facebook.com/ANkiyoung
KINDAI University
(E-campus, A-2F)
Sinkamikosaka 228-3,
Higashi-osaka Osaka 577-081
Japan
Tel +81 90 9319 9396
aky6815@hotmail.com

Mirko Ilic Corp.
www.mirkoilic.com
41 Union Square W.,
Room 824
New York, NY 10003
United States
Tel +1 917 957 6040
studio@mirkoilic.com

MOCEAN
www.moceanla.com
2440 S. Sepulveda Blvd.
Los Angeles, CA 90064
United States
Tel +1 310 401 0000
candi.vong@moceanla.com

Peter Diamond Illustration
www.peterdiamond.ca
Seidlgasse 15/1
(Gassenlokal)
Vienna 1030
Austria
peter@peterdiamond.ca

Šesnić&Turković
www.sesnicturkovic.com
Krajiška 11
Zagreb 10000
Croatia
Tel +385 01 5587 880
sesnic.turkovic@gmail.com

Supremat
Microdistrict Jal-23, 5/1a
26 Bishkek 720038
Kyrgyzstan
Tel +996 221 129 489
dr.postovoi@gmail.com

The Refinery
www.therefinerycreative.com
Sherman Oaks Galleria
15301 Ventura Blvd., Bldg. D,
Suite 300
Sherman Oaks, CA 91403
United States
Tel +1 818 843 0004
claire.delouraille@therefinerycre
ative.com

Underline Studio
www.underlinestudio.com
247 Wallace Ave., 2nd Floor
Toronto, ON M6H 1V5
Canada
Tel +1 416 341 0475
studiomanager@underlinestudio.
com

GOLD

Anet Melo
www.anetmelo.com
690 Academy St., Apt 4G
New York, NY 10034
United States
Tel +1 917 821 7050
anetmelo@yahoo.com

Arcana Academy
www.arcanaacademy.com
13323 W. Washington Blvd.
Los Angeles, CA
United States
Tel +1 310 279 5024
kensy.reissig@arcanaacademy.
com

Ariane Spanier Design
www.arianespanier.com
Oranienstraße 22
10999 Berlin
Germany
Tel +49 304 403 3923
mail@arianespanier.com

ARSONAL
www.arsonal.com
3524 Hayden Ave.
Culver City, CA 90232
United States
Tel +1 310 815 8824
info@arsonal.com

Atelier Bundi AG
www.atelierbundi.ch
Schlossstrasse 78
Boll Berne CH-3067
Switzerland
Tel +41 79 479 36 94
bundi@atelierbundi.ch

AV Print
www.avsquad.com
101 S. La Brea Ave., 2nd Floor
Los Angeles, CA 90036
United States
Tel +1 323 790 8888
PrintAccountTeam@avsquad.com

BEK Design
www.bek.com.tr
Tesvikiye Caddesi 49/9
Nisantasi Istanbul N/A 34365
Turkey
Tel +212 343 9910
kagan@bek.com.tr

BoltBolt
www.boltbolt.io
United States
hello@joopark.info

Braley Design
www.braleydesign.com
750 Shaker Drive, #202
Lexington, KY 40504
Tel +1 415 706 2700
braley@braleydesign.com

Bruketa&Zinic&Grey
www.bruketa-zinic.com
Nova Ves 17, Centar Kaptol 2nd
Floor
HR78319957057 Zagreb 10000
Croatia
Tel +385 992 117 507
jelena.mihelcic@grey.com

Carmit Design Studio
www.creativehotlist.com/challer
2208 Bettina Ave.
Belmont, CA 94002
United States
Tel +1 650 283 1308
carmit@carmitdesign.com

Chemi Montes
www.american.edu
4400 Massachusetts Ave. NW.
Washington D.C. 20016
United States
Tel +1 703 864 8767
cmontes@american.edu

Chikako Oguma Design
1-10-22-1403 Nakameguro
Meguro-ku
Tokyo 153-0061
Japan
Tel +81 90 6045 2037
koguma75@gmail.com

Code Switch
www.codeswitchdesign.com
262 Crescent St.
Northampton, MA 01060
United States
Tel +1 718 310 8966
jansabach@mac.com

Cold Open
www.coldopen.com
1313 Innes Place
Venice, CA 90291
United States
Tel +1 310 399 3307
reception@coldopen.com

DAEKI and JUN
www.b-d-b.xyz
Hannamdong Yongsan-gu
Seoul 04418
South Korea
win.daekiandjun@gmail.com

Dalian RYCX Design
www.rycxcn.com
A0-12, No. 419, Minzheng St.
Shahekou District
Dalian, Liaoning 116021
China
Tel +86 0411 8451 9866
rycxcn@163.com

Dan Cosgrove Design LLC
www.cosgrovedesign.com
410 S. Michigan Ave., Suite 609
Chicago, IL 60605
United States
Tel +1 312 765 8911
dan@cosgrovedesign.com

Dankook University
www.dankook.ac.kr/web/inter
national
College of Arts, 126, Jukjeon
Suji Yongin Gyeonggi 448-701
South Korea
Tel +82 31 8005 3106
finvox3@naver.com

Decker Design
www.deckerdesign.com
14 W. 23rd St., 3rd Floor
New York, NY 10010
United States
Tel +1 212 633 8588
shannonh@deckerdesign.com

dGwaltneyArt
www.dgwaltneyart.com
5437 Branchwood Way
Virginia Beach, VA 23464
United States
Tel +1 757 581 1701
dgwaltneyart@gmail.com

Elevate Design
www.elevatedesign.org
2600 Roseland Drive
Ann Arbor, MI 48103
United States
Tel +1 734 827 4242
salchow@msu.edu

Extended Whānau
www.extendedwhanau.com
20-22 Gundry St.
Auckland CBD, Auckland 1010
New Zealand
Tel +64 27 368 4582
tyrone@extendedwhanau.com

Freaner Creative
www.freaner.com
113 W. G St., No. 650
San Diego, CA 92101
United States
Tel +1 619 870 4699
arielfreaner@freaner.com

Gallery BI
www.gallerybi.com
#215, 216, 686, Cheonggye-
san-ro, Sujeong-gu
Seongnam-si, Gyeonggi-do
13105, Cheonansi Choongnam
31020
South Korea
Tel +82 105 276 5312
sunbi155@naver.com

Goodall Integrated Design
www.goodallintegrated.com
35 Tyrrel Ave.
Toronto, ON M6G 2G1
Canada
Tel +1 416 435 3653
derwyn@goodallintegrated.com

Gunter Rambow
www.gunter-rambow.com
Domplatz 16
D-18273 Guestrow
Germany
Tel +49 0 384 368 6503
GunterRambow@web.de

**Hansung University, Design &
Arts Institute**
www.hansung.ac.kr
116 Samseongyo-ro 16-gil
Seongbuk-gu, Seoul
South Korea
Tel +82 2 760 4114
gyqls776@naver.com

Harris Design
25 Frank Ave.
Farmingdale, NY 11735
United States
Tel +1 302 290 0225
jackharris@me.com

Hoyne
www.hoyne.com.au
Level 5, 99 Elizabeth St.
Sydney, NSW 2000
Australia
Tel +0419 290 768
hello@hoyne.com.au

Hufax Arts/FJCU
www.facebook.com/HufaxArts
13F., No.17, Lane 47, Section 1
Baofu Road, Yonghe Dist.,
New Taipei City 23444
Taiwan
Tel +88 693 399 1520
hufa@ms12.hinet.net

IF Studio
www.ifstudiony.com
306 W. 48th St., Apt 40C
New York, NY 10036
United States
Tel +1 203 550 1432
toshi@ifstudiony.com

Imboden Graphic Studio
www.melchiorimboden.ch
Eggertsbiel 1
Buochs NW 6374
Switzerland
Tel +41 79 402 38 92
mail@melchiorimboden.ch

João Machado Design
www.joaomachado.com
Rua Padre Xavier Coutinho, 125
Porto 4150-751
Portugal
Tel +351 934 835 598
geral@joaomachado.com

Kiyoung An Graphic Art Course Laboratory
www.facebook.com/ANkiyoung
KINDAI University
(E-campus, A-2F)
Sinkamikosaka 228-3,
Higashi-osaka Osaka 577-081
Japan
Tel +81 90 9319 9396
aky6815@hotmail.com

Leroy & Rose
www.leroyandrose.com
1522F Cloverfield Blvd.
Santa Monica, CA 90404
United States
Tel +1 310 310 8679
adriana@leroyandrose.com

Lisa Winstanley Design
www.lisawinstanley.com
52J Nanyang View
02-17 Singapore 639668
Singapore
Tel +65 8343 7608
lwinstanley@ntu.edu.sg

MARK
www.markbakersanchez.design
Dallas, TX
United States
markbakersanchez@outlook.com

Marlena Buczek Smith
www.marlenabuczek.com
New York, NY
United States
marlenabuczeksmith@gmail.com

Michael Pantuso Design
www.pantusodesign.com
820 S. Thurlow St.
Hinsdale, IL 60521
United States
Tel +1 312 318 1800
michaelpantuso@me.com

MOCEAN
www.moceanla.com
2440 S. Sepulveda Blvd.
Los Angeles, CA 90064
United States
Tel +1 310 481 0808
candi.vong@moceanla.com

Mythic
www.mythic.us
6201 Fairview Road, Suite 200
Charlotte, NC 28210
United States
Tel +1 980 500 0828
dshuford@mythic.us

Namseoul University
www.sunbi.kr
91 Daehak-ro, Seonghwan-eup,
Seobuk-gu
Cheonan-si, Chungc-
heongnam-do
South Korea
Tel +82 105 276 5312
sunbi155@naver.com

Noriyuki Kasai
2-42-1 Asahigaoka Nerima-ku
Tokyo 176-8525
Japan
Tel +81 3 5995 8691
kasai.noriyuki@nihon-u.ac.jp

Ola Procak
www.olaprocak.com
Poland
Tel +48 792 700 807
o.procka@gmail.com

Paone Design Associates
www.paonedesignassociates.
blogspot.com
242 S. 20th St.
Philadelphia, PA 19103
United States
Tel +1 215 893 0144
paonedesign@aol.com

Paul Rogers Studio
www.paulrogersstudio.com
320 San Miguel Road
Pasadena, CA 91105
United States
Tel +1 626 487 6848
paulrogersstudio@gmail.com

PEACE Inc.
www.4peace.co.jp
Japan
k.ueda@4peace.co.jp

PETROL Advertising
www.petrolad.com
443 N. Varney St.
Burbank, CA 91502
United States
bnessan@petrolad.com

Primoz Zorko
www.primozzorko.com
Puhova 1
1000 Ljubljana
Slovenia
Tel +386 40 291 733
hello@primozzorko.com

Purdue University
www.purdue.edu
552 Westwood St.
West Lafayette, IN 47907
United States
lzhang3@purdue.edu

Randy Clark
www.randyclark.myportfolio.com
88 Daxue Road, Ouhai District
Wenzhou, Zhejiang
China
Tel +86 5775 5870 000
randyclarkmfa@icloud.com

Rikke Hansen
www.wheelsandwaves.dk
Klovtoftvej 32
Roedding 6630
Denmark
Tel +452 331 3560
rh@wheelsandwaves.dk

Roger@Wong.Digital
www.rogerwong.me
2971 Via Alta Place
San Diego, CA 92108
United States
Tel +1 415 309 0790
roger@wong.digital

Ron Taft Brand Innovation & Media Arts
www.rontaft.com
2934 Beverly Glen Circle, #372
Los Angeles, CA 90077
United States
Tel +1 310 339 2442
ron@rontaft.com

Savannah College of Art & Design
www.scad.edu
P.O. Box 3146
Savannah, GA 31402
United States
Tel +1 912 525 6830
awards@scad.edu

Scott Laserow Posters
www.scottlaserowposters.com
1007 Serpentine Lane
Wyncote, PA 19095
United States
Tel +1 215 576 0722
slaserow@temple.edu

SJI Associates
www.sjiassociates.com
127 W. 24 St., 2nd Floor
New York City, NY 10011
United States
Tel +1 212 391 4140
david@sjiassociates.com

Studio Eduard Cehovin
www.designresearch.si
Ul. Milana Majcna
35 Ljubljana SI-1000
Slovenia
Tel +386 40 458 657
eduard.cehovin@siol.net

Studio Garbett
www.garbett.com.au
8 Hercules St., Studio 7
Surry Hills, NSW 2010
Australia
Tel +612 9212 3474
paul@naughtyfish.com.au

Studio Hinrichs
www.studio-hinrichs.com
2064 Powell St.
San Francisco, CA 94133
United States
Tel +1 415 543 1776
reception@studio-hinrichs.com

Studio Lindhorst-Emme+Hinrichs
www.lindhorst-emme-hinrichs.de
Wilhelm-Busch-Str. 18a
Gartenhaus Berlin 12043
Germany
Tel +49 030 71 30 19 30
mail@lindhorst-emme-hinrichs.
de

Studio XXY
California
United States
thexinyishao@gmail.com

Sun Design Production
China
1023484137@qq.com

Supremat
Microdistrict Jal-23, 5/1a
26 Bishkek 720038
Kyrgyzstan
Tel +996 221 129 489
dr.postovoi@gmail.com

The Refinery
www.therefinerycreative.com
Sherman Oaks Galleria
15301 Ventura Blvd., Bldg. D,
Suite 300
Sherman Oaks, CA 91403
United States
Tel +1 818 843 0004
claire.delouraille@therefinerycre
ative.com

TOTHEE DESIGN
China
1259708886@qq.com

Traction Factory
www.tractionfactory.com
247 S. Water St.
Milwaukee, WI 53204
United States
Tel +1 414 944 0900
tf_awards@tractionfactory.com

Tsushima Design
www.tsushima-design.com
1-17-204, 1-17, Matsukawa-cho,
Minami-ku
Hiroshima 7320826
Japan
Tel +81 08 2567 5586
info@tsushima-design.com

Underline Studio
www.underlinestudio.com
247 Wallace Ave., 2nd Floor
Toronto, ON M6H 1V5
Canada
Tel +1 416 341 0475
studiomanager@underlinestudio.
com

Wesam Mazhar Haddad
www.wesamhaddad.com
Fairfield, NJ 07004
United States
haddadwesam@hotmail.com

Yossi Lemel
www.yossilemel.com
13 Dubnov St.
Tel Aviv
Israel
Tel +00 972 545 360151
yossilemel1957@gmail.com

SILVER

203 Infographic Lab
www.203x.co.kr
92-3, 3rd Floor
Dongmak-ro, Mapo-gu, Seoul
04075
South Korea
Tel +82 010 4211 7715
pigcky@gmail.com

246 Graphics.
www.246.jp
Japan
matsuda@246.jp

ABC Made
www.abc.net.au
700 Harris St.
Ultimo, NSW 2007
Australia
Tel +139 994
clare_d@hotmail.com

Alan Rellaford Design
Chico, CA
United States
arellaford@gmail.com

Andrea Szabó
Hungary
szaboandreaetel@gmail.com

Andrew Sobol
www.elmhurst.edu
190 S. Prospect Ave.
Elmhurst, IL 60126
United States
Tel +1 630 617 3400
andrew.sobol@elmhurst.edu

Anna Leithauser
www.american.edu
4400 Massachusetts Ave. NW.
Washington, DC 20016
United States
Tel +1 202 885 1000
leithaus@american.edu

Anne M. Giangiulio Design
www.annegiangiulio.com
UTEP Department of Art
500 W. University Ave.
El Paso, TX 79968
United States
Tel +1 915 222 1134
annegiangiulio@gmail.com

Anolith
www.anolith.com
3515 Ringsby Court
Denver, CO 80216
United States
Tel +1 720 360 9865
garydayhilton@gmail.com

Ariane Spanier Design
www.arianespanier.com
Oranienstraße 22
10999 Berlin
Germany
Tel +49 304 403 3923
mail@arianespanier.com

ARSONAL
www.arsonal.com
3524 Hayden Ave.
Culver City, CA 90232
United States
Tel +1 310 815 8824
info@arsonal.com

Atelier Bundi AG
www.atelierbundi.ch
Schlossstrasse 78
Boll Berne CH-3067
Switzerland
Tel +41 79 479 36 94
bundi@atelierbundi.ch

Atelier Radovan Jenko
Slovenia
design@radovanjenko.si

Atelier Starno
www.starno.com
9 Endeavor Cove
Corte Madera, CA 94925
United States
Tel +1 415 279 7301
ag@starno.com

Attic Child Press, Inc.
www.viktorkoen.com
310 E. 23rd St., #11J
New York, NY 10010
United States
Tel +1 212 254 3159
viktor@viktorkoen.com

Aufuldish & Warinner
www.aufwar.com
183 The Alameda
San Anselmo, CA 94960
United States
Tel +1 415 721 7921
bob@aufwar.com

AV Print
www.avsquad.com
101 S. La Brea Ave., 2nd Floor
Los Angeles, CA 90036
United States
Tel +1 323 790 8888
PrintAccountTeam@avsquad.com

Aydada Inc.
www.shaoyangchen.com
New York, NY
United States
Tel +1 929 655 1965
shaoyangchencn@gmail.com

Bailey Lauerman
www.baileylauerman.com
1299 Farnam St., 9th Floor
Omaha, NE 68102
United States
Tel +1 402 514 9400
sfaden@baileylauerman.com

BEK Design
www.bek.com.tr
Tesvikiye Caddesi 49/9
Nisantasi Istanbul N/A 34365
Turkey
Tel + 212 343 9910
kagan@bek.com.tr

Bernice Wong
www.bernicewong.com
New York, NY
United States
hello@bernicewong.com

Brain Bolts
www.brainbolts.com
3760 Britting Ave.
Boulder, CO 80305
United States
Tel +1 303 543 7521
eric@brainbolts.com

Braley Design
www.braleydesign.com
3469 Lannette Lane
Lexington, KY 40503
United States
Tel +1 415 706 2700
braley@braleydesign.com

Brandon
www.thebrandonagency.com
51-53 Broad St.
Charlotte, NC 29401
United States
Tel +1 843 916 2000
schildress@thebrandonagency.
com

Carmit Design Studio
www.creativehotlist.com/challer
2208 Bettina Ave.
Belmont, CA 94002
United States
Tel +1 650 283 1308
carmit@carmitdesign.com

CASALEX
www.howteeann.com
New York, NY
United States
hocheon01@gmail.com

CCC + JC. Jacinta & Carlos
www.carlosjacinta.myporttolio.
com
R. Do Pomar Nº1, Gondesende
Parque Natural de Montesinho
Bragança 5300-561
Portugal
Tel +91 470 9378
carlos.costa@ipb.pt

Célie Cadieux
www.celiecadieux.com
124 Rue de Tolbiac
Paris 75013
France
hello@celiecadieux.com

Chargefield
www.chargefield.com
50 Carroll St.
Toronto, ON M4M 3G3
Canada
Tel +1 888 446 2658
john@chargefield.com

Christopher Scott Designer
www.christopherscottdesigner.
com
120 Jade St.
Ames, IA 50010
United States
Tel +1 515 708 8382
christopherscottdesigner@gmail.
com

Claudia Chung
www.claudiachung.com
Brooklyn, NY
United States
claudia800806@gmail.com

Code Switch
www.codeswitchdesign.com
262 Crescent St.
Northampton, MA 01060
United States
Tel +1 718 310 8966
jansabach@mac.com

Cold Open
www.coldopen.com
1313 Innes Place
Venice, CA 90291
United States
Tel +1 310 399 3307
reception@coldopen.com

Craig Frazier Studio
www.craigfrazier.com
157 Throckmorton Ave., #D
Mill Valley, CA 94941
United States
Tel +1 415 389 1475
studio@craigfrazier.com

Creative Energy
www.cenergy.com
3206 Hanover Road
Johnson City, TN 37604
United States
Tel +1 423 926 9494
wgriffith@cenergy.com

Cul-box
China
art008.hi@163.com

CURIOUS
www.curiouslondon.com
126 Marina St., Leonards On Sea
East Sussex, TN38 0BN
United Kingdom
Tel +1 798 071 5445
gary@curiouslondon.com

DAEKI and JUN
www.b-d-b.xyz
Hannamdong Yongsan-gu
Seoul 04418
South Korea
win.daekiandjun@gmail.com

Daisuke Kashiwa
www.kashiwadaisuke.net
#401 Kozawa Bldg. 43 Furusawa
Asao-ku Kawasaki City Kanaga-
wa 2150026
Japan
Tel +81 80 3556 4640
info@kashiwadaisuke.net

Dankook University
www.dankook.ac.kr/web/inte
rnational
College of Arts, 126, Jukjeon
Suji Yongin Gyeonggi 448-701
South Korea
Tel +82 31 8005 3106
finxox3@naver.com

Danyang Ma
www.danyangma.com
2840 Jackson Ave., Apt 4E
Long Island City, NY 11101
United States
danyangm0717@gmail.com

Dennard, Lacey & Associates
www.dennardlacey.com
4220 Proton Road, Suite 150
Dallas, TX 75244
United States
Tel +1 972 233 0430
james@dennardlacey.com

Design SubTerra
1590 Canyon Road
Providence, UT 84332
United States
Tel +1 435 792 3101
rain9@xmission.com

Diotop
www.otsukichihiro.com
Super Studio Kitakagaya,
Studio 4
Osaka City, 5-4-64 Kitakagaya,
Suminoe-ku, 5590011
Japan
info@odo-design.com

Drive Communications
www.drivecom.com
237 W. 16th St., 2nd Floor
New York, NY 10011
United States
Tel +1 212 989 5103
mail@drivecom.com

EGGRA
www.eggra.com
St. 141 No. 17
Tetovo 1200
North Macedonia
Tel +38 970 389 144
eggra.pars@gmail.com

Elevate Design
www.elevatedesign.org
2600 Roseland Drive
Ann Arbor, MI 48103
United States
Tel +1 734 827 4242
salchow@msu.edu

Estudio Pep Carrió
www.pepcarrio.com
C/ Génova, 11
7ºD Madrid 28004
Spain
Tel +34 913 080 668
info@pepcarrio.com

Freaner Creative
www.freaner.com
113 W. G St., No. 650
San Diego, CA 92101
United States
Tel +1 619 870 4699
arielfreaner@freaner.com

Goodall Integrated Design
www.goodallintegrated.com
35 Tyrrel Ave.
Toronto, ON M6G 2G1
Canada
Tel +1 416 435 3653
derwyn@goodallintegrated.com

Gottschalk+Ash Int'l
www.ga-z.com
Böcklinstrasse 26
Zurich 8032
Switzerland
Tel +41 44 382 18 50
s.loetscher@ga-z.com

Gravdahl Design
www.gravdahldesign.com
406 E. Lake St.
Fort Collins, CO 80524
United States
Tel +1 970 482 8807
john@gravdahldesign.com

Gunter Rambow
www.gunter-rambow.com
Domplatz 16
D-18273 Guestrow
Germany
Tel +49 0 384 368 6503
GunterRambow@web.de

Harris Design
25 Frank Ave.
Farmingdale, NY 11735
United States
Tel +1 302 290 0225
jackharris@me.com

Hiroyuki Matsuishi Design Office
www.matsuishi-design.com
Letoit Chuou C201 Koga City,
2-10-20
Fukuoka 811-3103
Japan
Tel +08 05 212 6448
matsuishihiro@gmail.com

Hively Designs
www.davidhabben.com
3012 W. 2400 N.
Lehi, UT 84043
United States
Tel +1 801 362 5995
hello@davidhabben.com

Holger Matthies
www.holgermatthies.com
Wrangelstraße 13
20253 Hamburg
Germany
Tel +49 40 420 2641
info@matthiesholger.com

Hoyne
www.hoyne.com.au
Level 5, 99 Elizabeth St.
Sydney, NSW 2000
Australia
Tel +0419 290 768
hello@hoyne.com.au

Hufax Arts/FJCU
www.facebook.com/HufaxArts
13F., No.17, Lane 47, Section 1
Baofu Road, Yonghe Dist., New
Taipei City 23444
Taiwan
Tel +88 693 399 1520
hufa@ms12.hinet.net

Hyungjoo Kim Design Lab
www.cla.purdue.edu/academic/
rueffschool/ad/vcd/Faculty.html
Rueff School of Design, Art, and
Performance
552 Westood St. W.
Lafayette, IN 47907 US
United States
Tel +1 765 494 3071
hakim@purdue.edu

IBEX Studio
New Jersey
United States
thomaslbrand@yahoo.com

IF Studio
www.ifstudiony.com
306 W. 48th St., Apt. 40C
New York, NY 10036
United States
Tel +1 203 550 1432
toshi@ifstudiony.com

Imboden Graphic Studio
www.melchiorimboden.ch
Eggertsbiel 1
Buochs NW 6374
Switzerland
Tel +41 79 402 38 92
mail@melchiorimboden.ch

INNOCEAN USA
www.innoceanusa.com
180 5th St., Suite 200
Huntington Beach, CA 92648
United States
Tel +1 714 861 5371
awardshows@innoceanusa.com

Jihe Culture & Art Planning Co., Ltd.
www.hysong.me
65 Rio Robles E., Apt. #1403
San Jose, CA 95134
United States
Tel +1 408 416 8700
hysong950203@gmail.com

Jillian Coorey
www.kent.edu
800 E. Summit St.
Kent, OH 44242
United States
Tel +1 330 672 3000
jcoorey@kent.edu

João Machado Design
www.joaomachado.com
Rua Padre Xavier Coutinho, 125
Porto 4150-751
Portugal
Tel +351 934 835 598
geral@joaomachado.com

Kari Piippo Ltd.
www.piippo.com
Katajamäenkatu 14
Mikkeli 50170
Finland
Tel +3585 0566 1621
kari@piippo.com

Kashlak
www.instagram.com/ivankashlak
Kv. Razsadnika-Koniovica, Bl.
26A, Ap. 26
Sofia Sofia 1330
Bulgaria
Tel +35 9897 027 809
kashlak.art@gmail.com

Lang Xuan
China
luye20020901@163.com

Legis Design
273 Ramona Ave.
Sierra Madre, CA 91024
United States
legis@pa2.so-net.ne.jp

Leo Lin Design
11F, No. 64, 700th Lane
Chung-Cheng Road
Hsintien, Taipei 231
Taiwan
Tel +886 2 8218 1446
leoposter@yahoo.com.tw

Leroy & Rose
www.leroyandrose.com
1522F Cloverfield Blvd.
Santa Monica, CA 90404
United States
Tel +1 310 310 8679
adriana@leroyandrose.com

Lisa Winstanley Design
www.lisawinstanley.com
52J Nanyang View
02-17 Singapore 639668
Singapore
Tel +65 8343 7608
lwinstanley@ntu.edu.sg

Love Letters
Utah
United States
herhomeemail@gmail.com

Marcos Minini Design
www.marcosminini.com
Dr. Manoel Pedro 227 Apt. 172
Curitiba PR 80035-030
Brazil
Tel +55 41 999 710 860
minini@marcosminini.com

MARK
www.markbakersanchez.design
Dallas, TX
United States
markbakersanchez@outlook.com

Marlena Buczek Smith
www.marlenabuczek.com
New York, NY
United States
marlenabuczeksmith@gmail.com

Martin French Studio
www.martinfrench.com
511 NW. Broadway
Portland, OR 97209
United States
Tel +1 503 926 2809
studio@martinfrench.com

May & Co.
www.mayandco.com
6316 Berwyn Lane
Dallas, TX 75214
United States
Tel +1 214 536 0599
dougm@mayandco.com

Meng Lan
California
United States
lanmeng1014@outlook.com

Mikey Lavi
www.mvlaviolette.com
Montreal, QC
Canada
mv.laviolette@gmail.com

Mikhail Lychkovskiy
www.lychkovskiy.ru
Minsk
Belarus
privet@lychkovskiy.ru

Mink
www.mink.agency
Sidra Tower, Office #1005
Sufouh Gardens,
Dubai 922202
United Arab Emirates
Tel +97 150 250 4177
moe@mink.agency

Mirko Ilic Corp.
www.mirkoilic.com
41 Union Square W., Room 824
New York, NY 10003
United States
Tel +1 917 957 6040
studio@mirkoilic.com

MOCEAN
www.moceanla.com
2440 S. Sepulveda Blvd.
Los Angeles, CA 90064
United States
Tel +1 310 481 0808
candi.vong@moceanla.com

Monokromatic
www.monokromatic.com
Priv. 10 A Sur 1507 A Col.
Motolinia
Puebla 72538
Mexico
Tel + 44 222 127 1581
knife555@hotmail.com

Müessese
www.muessese.com.tr
İstanbul
Turkey
aykutgenc@muessese.com.tr

Naoto Ono Creative
www.naotoono.com
New York, NY
United States
ono@naotoono.com

Nogami Design Office
www.nogamidesignoffice.com
4-17-9-716 Kikawahigashi
Yodogawa-ku
Osaka 532-0012
Japan
Tel +81 90 3033 9317
ndo@kf6.so-net.ne.jp

Nordyke Design
www.johnnordyke.com
49 Craigmoor Road
West Hartford, CT 06107
United States
nordyke@hartford.edu

Noriyuki Kasai
2-42-1 Asahigaoka Nerima-ku
Tokyo 176-8525
Japan
Tel +81 3 5995 8691
kasai.noriyuki@nihon-u.ac.jp

Ola Procak
www.olaprocak.com
Poland
Tel +48 792 700 807
o.procka@gmail.com

Only Child Art
www.andrebarnett.myportfolio.com
912 Independence Ave. SE.
Washington, D.C. 20003
United States
Tel +1 202 577 6814
barnettandre@hotmail.com

Paone Design Associates
www.paonedesignassociates.
blogspot.com
242 S. 20th St.
Philadelphia, PA 19103
United States
Tel +1 215 893 0144
paonedesign@aol.com

PEACE Inc.
www.4peace.co.jp
Japan
k.ueda@4peace.co.jp

PETROL Advertising
www.petrolad.com
443 N. Varney St.
Burbank, CA 91502
United States
bnessan@petrolad.com

PosterTerritory
www.olgaseverina.com
Los Angeles, CA
United States
posterterritory@gmail.com

PPK USA
www.uniteppk.com
1102 N. Florida Ave.
Tampa, FL 33602
United States
Tel +1 352 398 3911
kgoucher@uniteppk.com

Premium Media
www.premiummedia.com.au
5 Campbell Pde
Bondi Beach, NSW 2026
Australia
Tel +02 8003 4185

Purdue University
www.purdue.edu
552 Westwood St.
West Lafayette, IN 47907
United States
lzhang3@purdue.edu

PytchBlack
www.pytchblack.com
500 W. 7th St., Suite 1720
Fort Worth, TX 76102
United States
Tel +1 817 782 9519
aryanez@pytchblack.com

Randy Clark
www.randyclark.myportfolio.com
88 Daxue Road, Ouhai District
Wenzhou, Zhejiang
China
Tel +86 577 5587 0000
randyclarkmfa@icloud.com

Raphael Geroni Design
www.raphaelgeroni.com
Poughkeepsie, NY 12601
United States
Tel +1 215 313 2900
hello@raphaelgeroni.com

Raven Mo Design
www.ravenmo.info
New York, NY
United States
ravensrmo@gmail.com

Res Eichenberger Design
www.reseichenberger.ch
Neptunstrasse 25
Zurich 8032
Switzerland
Tel +414 3499 8336
studio@reseichenberger.ch

Rikke Hansen
www.wheelsandwaves.dk
Klovtoftvej 32
Roedding 6630
Denmark
Tel +452 331 3560
rh@wheelsandwaves.dk

**Ron Taft Brand Innovation &
Media Arts**
www.rontaft.com
2934 Beverly Glen Circle, #372
Los Angeles, CA 90077
United States
Tel +1 310 339 2442
ron@rontaft.com

Rose
www.rosedesign.co.uk
The Old School 70 St.
Marychurch St., London SE16
4HZ
United Kingdom
Tel +44 020 7394 2800
hello@rosedesign.co.uk

Ryan Slone Design
www.ryanslonedesign.com
901 Kings Cross
Cave Springs, AR 72718
United States
Tel +1 479 445 8360
rslone@uark.edu

Scott Laserow Posters
www.scottlaserowposters.com
1007 Serpentine Lane
Wyncote, PA 19095
United States
Tel +1 215 576 0722
slaserow@temple.edu

Šesnić & Turković
www.sesnicturkovic.com
Krajiška 11
Zagreb 10000
Croatia
Tel +385 01 5587 880
sesnic.turkovic@gmail.com

Simon Peter Bence
www.spx.hu
Cinege ut 1-3., A.
Budapest 1121
Hungary
simonpeterbence@gmail.com

SJI Associates
www.sjiassociates.com
127 W. 24 St., 2nd Floor
New York City, NY 10011
United States
Tel +1 212 391 4140
david@sjiassociates.com

Skolos-Wedell
www.skolos-wedell.com
177 Everett Ave.
Providence, RI 02906
United States
Tel +1 617 291 8888
nancy@skolos-wedell.com

SpotCo
www.mirkoilic.com
41 Union Square W.,
Room 824
New York, NY 10003
United States
Tel +1 917 957 6040
studio@mirkoilic.com

Steiner Graphics
www.renesteiner.com
155 Dalhousie St., Suite 1062
Toronto, ON M5B 2P7
Canada
Tel +1 647 285 1658
rene@steinergraphics.com

STUDIO DUY
www.duydao.net
Vietnam
duydao95@gmail.com

Studio Eduard Cehovin
www.designresearch.si
Ul. Milana Majcna
35 Ljubljana SI-1000
Slovenia
Tel +386 40 458 657
eduard.cehovin@siol.net

Studio Hinrichs
www.studio-hinrichs.com
2064 Powell St.
San Francisco, CA 94133
United States
Tel +1 415 543 1776
reception@studio-hinrichs.com

STUDIO INTERNATIONAL
www.studio-international.com
Buconjiceva 43 Buconjiceva
43/III
Zagreb HR-10 000
Croatia
Tel +385 1 37 60 171
boris@studio-international.com

Studio Lindhorst-Emme+Hinrichs
www.lindhorst-emme-hinrichs.de
Wilhelm-Busch-Str. 18a
Gartenhaus Berlin 12043
Germany
Tel +49 030 71 30 19 30
mail@lindhorst-emme-hinrichs.
de

Studio Pekka Loiri
www.posterswithoutborders.
com/Pekka-Loiri
Messitytonkatu 1C 43
Helsinki 00180
Finland
Tel +358 503 512104
loiripekka3@gmail.com

Sun Design Production
China
1023484137@qq.com

Supremat
Microdistrict Jal-23, 5/1a
26 Bishkek 720038
Kyrgyzstan
Tel +996 221 129 489
dr.postovoi@gmail.com

T&P Designs
www.tiffanyjoyprater.com
5213 Walden Way
Flowery Branch, GA 30542
United States
Tel +1 217 512 9266
studio@tiffanyjoyprater.com

Taichi Tamaki
www.taichitamaki.com
Japan
taichi.tamaki@icloud.com

Ted Wright Illustration & Design
www.twrightart.wixsite.com
477 Amber Lake Court
Imperial, MO 63052
United States
Tel +1 314 607 9901
twrightart@aol.com

Terashima Design Co.
www.tera-d.net
3F, Iwasa Bldg., Kita 3, Higashi
5, Chuo-ku
Sapporo Hokkaido 060-0033
Japan
Tel +81 11 241 6018
tera@tera-d.net

The Refinery
www.therefinerycreative.com
Sherman Oaks Galleria
15301 Ventura Blvd., Bldg. D,
Suite 300
Sherman Oaks, CA 91403
United States
Tel +1 818 843 0004
claire.delouraille@therefinerycre-
ative.com

Thomas Kühnen
www.thomaskuehnen.de
Kassenberg 47 Mülheim an der
Ruhr
NRW 45479
Germany
Tel +49 0 172 255 7620
hallo@thomaskuehnen.de

ThoughtMatter
www.thoughtmatter.com
10 W. 24th St., 5th Floor
New York, NY 10010
United States
Tel +1 212 994 8500
martha@thoughtmatter.com

Toyotsugu Itoh Design Office
www.facebook.com/toyotsu
guoffice
402 Royal Villa Tsurumai
4-17-8 Tsurumai, Showa-ku
Nagoya,
Aichi Prefecture 466 0064
Japan
Tel +81 52 731 9747
toyo-ito@ya2.so-net.ne.jp

Tsushima Design
www.tsushima-design.com
1-17-204, 1-17, Matsukawa-cho,
Minami-ku
Hiroshima 7320826
Japan
Tel +81 08 2567 5586
info@tsushima-design.com

Underline Studio
www.underlinestudio.com
247 Wallace Ave., 2nd Floor
Toronto, ON M6H 1V5
Canada
Tel +1 416 341 0475
studiomanager@underlinestudio.
com

Vanderbyl Design
www.vanderbyl.com
511 Tokay Lane
St. Helena, CA 94574
United States
Tel +1 415 543 8447
michael@vanderbyl.com

Vaziri Studio
www.vaziri.studio
1800 N. Stanton St., Apt 706
El Paso, TX 79902
United States
Tel +1 530 220 3060
alireza.v@gmail.com

Venti Caratteruzzi
www.venticaratteruzzi.com
Via Principe di Villafranca 83
Palermo PA 90141
Italy
Tel +39 328 462 2494
carlo@venticaratteruzzi.com

Xindi Lyu
www.xindilyu.myportfolio.com
New York, NY
United States
xindilyu@gmail.com

Yanming Chen
United States
ezjoane@gmail.com

Yichun Lin Design
www.yichunlincollection.com
3285 33rd St., Apt. A3
Astoria, NY 11106
United States
Tel +1 415 529 0376
yichunlin098@gmail.com

Yossi Lemel
www.yossilemel.com
13 Dubnov St.
Tel Aviv
Israel
Tel +00 972 545 360151
yossilemel1957@gmail.com

WINNERS BY COUNTRY

Visit Graphis.com to view the work within each country, state, or province.

New Talent Annual 2023

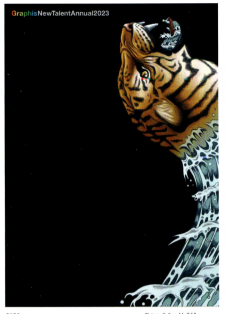

2023
Hardcover: 272 pages
200-plus color illustrations
Trim: 8.5 x 11.75"
ISBN: 978-1-954632-16-5
US $75

Awards: Graphis presents 12 Platinum, 169 Gold, and 344 Silver awards, along with 638 Honorable Mentions.
Platinum-winning Instructors: Advertising: Mark Allen. Design: Elaine Alderette, Brad Bartlett, Brian Boyd, Gayle Donahue, Mads Greve, Seung-Min Han, Réka Holló-Szabó, Miguel Lee, Douglas May, Miles Mazzie, Dong-Joo Park, Søren Patger, Brian Rea, Paul Rogers, Carlos Roncajolo, Simon Sticker, Carter Tindall, Judit Tóth, and Cardon Webb. Photography: Manolo García.
Content: This book contains award-winning entries in Advertising, Design, Photography, and Film/Video. We also present A Decade of New Talent, featuring Platinum-winning works from 2013. All entries are organized by discipline like our professional annuals.

Photography Annual 2023

2023
Hardcover: 256 pages
200-plus color illustrations
Trim: 8.5 x 11.75"
ISBN: 978-1-954632-18-9
US $75

Awards: Graphis presents 12 Platinum, 101 Gold, and 218 Silver awards, along with 53 Honorable Mentions.
Platinum Winners: Per Breiehagen, Ross Brown, Alexandra Carr, Andreas Franke, Terry Heffernan, Takahiro Igarashi, John Madere, Eric Melzer, R.J. Muna, Howard Schatz, and Tatijana Shoan.
Content: This book is full of exceptional work by our masterful judges, our Platinum, Gold, and Silver award winners, and our Honorable Mentions. It also includes a retrospective on our Platinum 2013 Photography winners, a list of international photography museums and galleries, and an In Memoriam list of photographers that have passed away this year.

Advertising Annual 2023

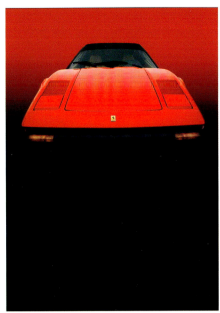

2022
Hardcover: 224 pages
200-plus color illustrations
Trim: 8.5 x 11.75"
ISBN: 978-1-954632-15-8
US $75

Awards: Graphis presents 12 Platinum, 104 Gold, and 72 Silver awards, along with 31 Honorable Mentions.
Platinum Winners: ARSONAL, Centre for Design Research, Dalian RYCX Advertising, Eversana Intouch, Hufax Arts, Ken-Tsai Lee Design Lab, Partners + Napier, PETROL Advertising, Ron Taft Design, and VSA Partners.
Content: This book includes amazing Platinum, Gold, and Silver Award-winning print and video advertisements, as well as Honorable Mentions. Also featured is a selection of award-winning judge's work and our annual In Memoriam for the advertising talent we've lost over the last year.

Design Annual 2023

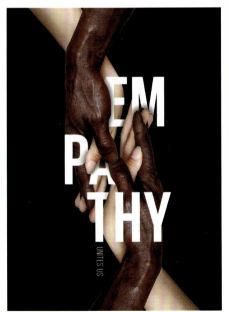

2022
Hardcover: 272 pages
200-plus color illustrations
Trim: 8.5 x 11.75"
ISBN: 978-1-954632-14-1
US $75

Awards: Graphis presents 15 Platinum, 117 Gold, and 404 Silver awards, along with 162 Honorable Mentions.
Platinum Winners: Mike Hughes Creative Direction + Design, Sol Benito, Dankook University, Stranger&Stranger, and ARSONAL, Bailey Lauerman, Carmit Design Studio, Clinton Carlson Design, INNOCEAN USA, McCandliss & Campbell/Wainscot Media, PepsiCo Design & Innovation, and Studio A.
Content: This book includes award-winning work from the judges, as well as Platinum, Gold, and Silver-winning work from internationally renowned designers and design firms. Honorable Mentions are presented, and a list of designers that we have lost this past year and a directory of design museums are also included.

Packaging 10

2022
Hardcover: 240 pages
200-plus color illustrations
Trim: 8.5 x 11.75"
ISBN: 978-1-954632-12-7
US $75

Awards: Graphis presents 12 Platinum, 100 Gold, 204 Silver, and 249 Honorable Mentions for innovative work in product packaging.
Platinum Winners: Michele Gomes Bush (Next), Chad Roberts (Chad Roberts Design Ltd.), XiongBo Deng (Shenzhen Lingyun Creative Packaging Design Co., Ltd.) and Lu Chen (Xiaomi), Vishal Vora (Sol Benito), Mattia Conconi (Gottschalk+Ash Int'l), and Frank Anselmo (New York Mets), Ivan Bell (Stranger & Stranger), Brian Steele (SLATE), and the team at PepsiCo Design & Innovation.
Content: This book contains award-winning packaging from the judges, as well as international Platinum, Gold, and Silver-winning packaging designs from designers and design firms from around the world. Honorable Mentions are presented, and a feature of award-winning work from our Packaging 9 Annual is also included.

Protest Posters 2

2021
Hardcover: 256 pages
200-plus color illustrations
Trim: 8.5 x 11.75"
ISBN: 978-1-954632-04-2
US $75

Awards: Graphis presents 12 Platinum, 137 Gold, 176 Silver awards, and 94 Honorable Mentions for outstanding talent in photography.
Platinum Winners: Presenting Platinum winners Alireza Nosrati Studio, Andrew Sloan, Dogan Arslan Design, IF Studio, Katarzyna Zapart, Marlena Buczek Smith, Randy Clark, Scott Laserow Posters, Wesam Haddad, and Yossi Lemel.
Judges: Andrea Castelletti, Paul Garbett, Wesam Mazhar Haddad, Woody Pirtle, and Marlena Buczek Smith, and Chikako Oguma.
Content: This book is a source of inspiration with work from talented poster designers that addresses a diverse series of international issues going on in the world today.

Books are available at graphis.com/store